LOST FISH

What we take for granted might not be here for our children. . . .
It takes time to connect the dots, I know that.
But I also know that there can be a day of reckoning
when you wish you had connected the dots more quickly.

Al Gore, *An Inconvenient Truth*, 2006

INTRODUCTION BY ELIZABETH KOLBERT

LOST FISH

*Anthologies of the Work
of the Comte de Lacépède*

ASSOULINE

INTRODUCTION

Sometime in the early 1740s, the naturalist Georges-Louis Leclerc de Buffon conceived an audacious plan. Buffon, then in his early thirties, had recently been named the director of the Jardin du Roi in Paris, and in that capacity had been charged with creating a catalog for the king's collection of natural specimens. Such catalogs usually consisted of lists of curiosities; Buffon decided instead to create a complete encyclopedia of all minerals and living things. The project, he estimated, would take a decade to complete. Over the next forty years, he published thirty-six volumes. Still, the work was unfinished when he died, nearly fifty years after he began it.

The decades Buffon spent laboring over *Histoire naturelle* were a time of enormous interest in natural history in Europe; indeed, the pursuit of the subject as a scientific discipline is often said to have originated during this period. While Buffon was toiling away in Paris, the Swedish botanist Carolus Linnaeus was engaged in an equally ambitious project some nine

hundred miles to the north, in Uppsala. Linnaeus first outlined his system of taxonomy—known today, of course, as Linnaean taxonomy—in 1735, in an eleven-page pamphlet titled *Systema Naturae*. He continued to expand and revise *Systema Naturae* until, in the thirteenth edition, published in 1770, it ran to more than three thousand pages.

The questions that preoccupied Buffon and Linnaeus were those raised by nature's extraordinary diversity. (Even though, or perhaps because, Buffon and Linnaeus were interested in similar issues, each considered the other to be his intellectual inferior, and wrote disparagingly of his rival's work.) During this period, the Europeans were in the process of exploring—and exploiting—the farthest reaches of the globe, and unfamiliar and fascinating plants and animals were constantly being discovered. Both Buffon and Linnaeus maintained far-flung networks of correspondents who shipped them novel specimens for study. (Linnaeus sent his students, whom he called his "apostles," on collecting missions all over the world, and a few of them never returned.) Why, the two great naturalists wanted to know, were certain organisms confined to certain habitats? What explained their resemblances? What about their differences? What about variations within a species? And how could one possibly account

for species that showed up in the fossil record but that no living being had seen? Linnaeus decided that all of nature reflected God's plan for creation as a balanced and harmonious system. (A favorite saying of his was, "Deus creavit, Linnaeus disposuit," or "God created, Linnaeus organized.") He also reckoned the number of species in the world to number no more than forty thousand.

Buffon, by contrast, came to a more secular conclusion, one in keeping with the principles of the French Enlightenment. Fundamental forces, no more or less divine than gravity, were always at work, shaping and reshaping the natural world. "The great worker of Nature is time," Buffon wrote.

Toward the end of his life, Buffon hired a young man with a long name to be the "keeper" of the king's natural history collection. Bernard-Germain-Étienne de La Ville-sur-Illon, the Comte de Lacépède, was from Agen, in southwestern France, and had been educated by his father in concert with a local bishop. A precocious child, he began at an early age to experiment with electricity and to write operas. In 1777 he moved to Paris with the intention of becoming a professional composer. When this effort failed, he turned his attention to science. In 1781 he published *Essai sur l'électricité*

naturelle et artificielle; the following year, he published the first of what would be two volumes of *Physique générale et particulière*. Though most of the scientific establishment in Paris was unimpressed, Buffon, by this point in his midseventies, admired Lacépède's enthusiasm and intellectual instincts and saw in him a potential protégé. He proposed to Lacépède that he take on the task of completing *Histoire naturelle*. Lacépède's first contribution, *Histoire naturelle des quadrupèdes ovipares*, based on notes that Buffon had given him, appeared in 1788, just before the older man died. Lacépède's second volume, *Histoire naturelle des serpents*, was published the following year.

Following the Revolution, the Jardin du Roi, like practically every other Parisian institution, was consumed by politics. Together with several other prominent naturalists, Lacépède drew up plans to reconfigure the garden along republican lines. But before these schemes could be realized, he was forced to resign. In the spring of 1793, he fled Paris to avoid arrest as a counterrevolutionary.

Lacépède spent the Terror living in Leuville, south of Paris. (According to some reports, Robespierre himself asked after Lacépède, and when

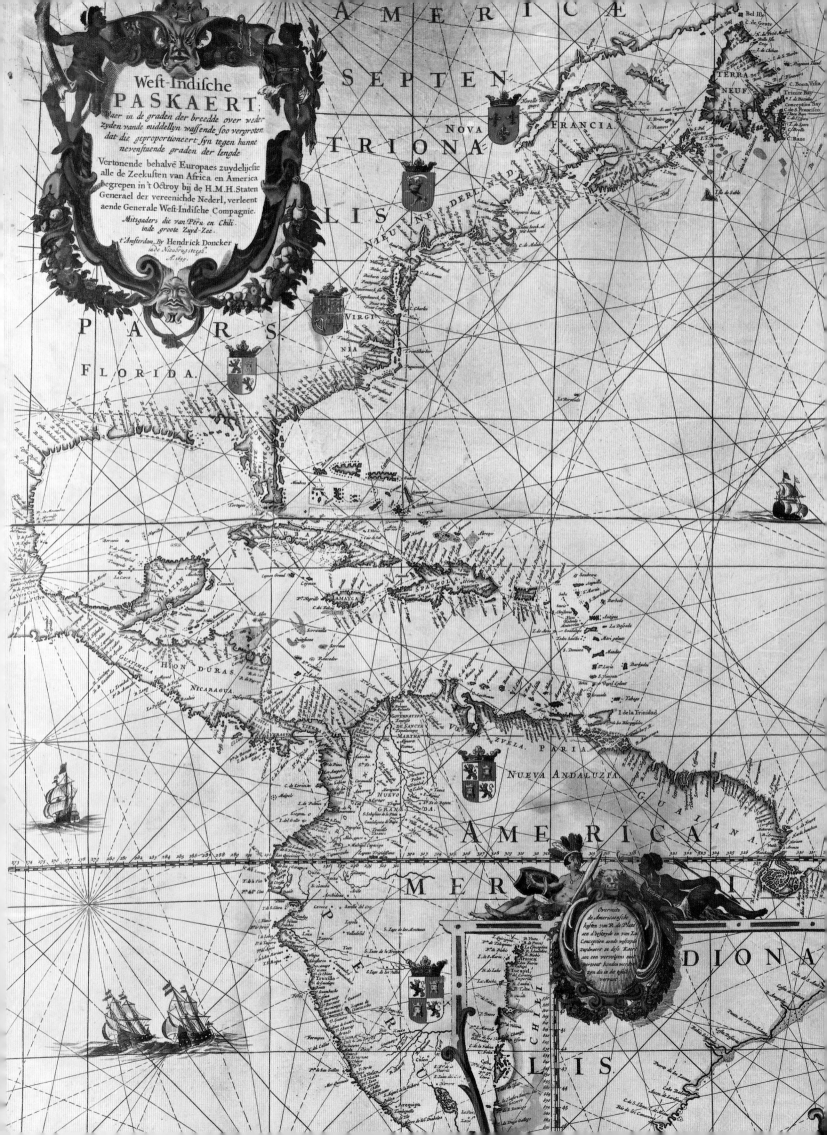

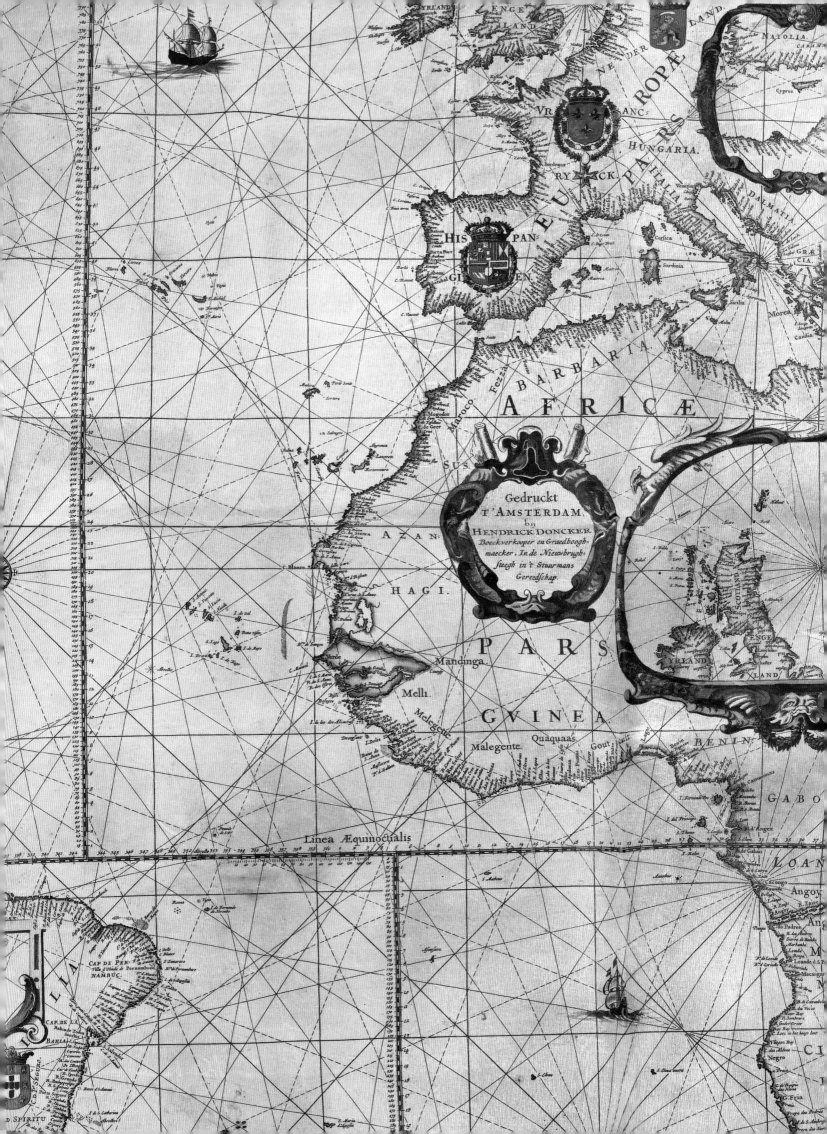

EUROPÆ PARS

NEDERLAND

VRANCK RYNCK

HUNGARIA

ITALIA

DALMATIA

GRÆCIA

HISPAN GIEN

NATOLIA

Cyprus

Candia

Corsica

Sardinia

Sicilia

Morea

BARBARIA

Fezza

AFRICÆ

Maroco

SUS

AZAN

HAGI

PARS

GVINEA

Mandinga

Melli

Malegette

Malegente

Quaquaas

Gout

BENIN

GABO

SCOTLAND

YRLANDT

ENGE LANDT

Gedruckt
T'Amsterdam,
by
HENDRICK DONCKER
Boeckverkooper en Graedbooghmaecker, In de Nieuwbrughsteegh in 't Stuurmans
Gereedschap.

C. Blanco

Verde

Linea Æquinoctialis

LOAN

Angov

CAP DE PER
NAMBUC
Ville d'Olinda de Pernambuco

CAP. DE LA
BAHIA

D. SPIRITU

BRASILIA

Negro

told he was off in the country, declared, "Good! He ought to stay there!") Lacépède devoted most of his enforced leisure to studying fish. Following Robespierre's execution, in 1794, Lacépède returned to Paris, where his former colleagues had managed to create for him a chair in zoology at the newly established Muséum d'histoire naturelle. Lacépède published *Histoire naturelle des poissons* in five volumes between 1798 and 1803; it remained the definitive work on ichthyology for the next twenty years. His *Histoire naturelle des cétacés*, devoted to aquatic mammals, appeared in 1804. The book that you are now holding is drawn from a later edition of these works, published in Paris by F. D. Pillot a few years after Lacépède's death in 1826. Its text comes from the original volumes, as well as from other sources; and the richly colored plates, hand-tinted by what their publisher described as the "best artisans," date from 1832.

Like his mentor, Lacépède greatly expanded the number of identified species. Previous works of ichthyology had, for example, listed some eight hundred species; *Histoire naturelle des poissons* listed more than twelve hundred. Also like Buffon, Lacépède favored lofty, value-laden language; naturalists, he believed, should try in their writing to guide readers toward

a moral appreciation of nature. "What can better elevate our thoughts, invigorate our intelligence, and make the mind attentive . . . than the spectacle, so great and varied, presented to us by the system of numerous fish habitats?" he wrote in *Histoire naturelle des poissons*.

At the start of the nineteenth century—fifty years before *The Origin of Species*—the scientific community was troubled by many of the same questions that had vexed Buffon and Linnaeus. While it was becoming clear that the composition of the natural world had changed over time, it was still unclear how, or why. Lacépède proposed a process of imperceptibly slow "metamorphosis"—driven by what, he wasn't quite sure. Over the course of many millennia, the properties of a species could become so altered, he wrote, that it could "find itself, in its ultimate configuration and properties, further removed from its initial state than a different species." In this case, it could "be said that the species has metamorphosized into a new one." Lacépède saw humans as unable to exert much influence on this process of metamorphosis. Yet, presciently, he anticipated that they would drive some of the organisms that he had described to extinction.

"These enormous species," he wrote, referring to the many types of whales then being hunted for their oil, "will cease to be the victims of [man's] interest only when they have ceased to exist."

As Lacépède and his followers suspected, there is always more to know. Today, of course, it would be unthinkable for one person to set out to catalog the entire natural world. Currently the number of species that inhabit the earth is estimated to be at least ten million, and possibly as many as a hundred million. The oceans in particular are a constant source of discovery. In 2004 a team of American geneticists announced that, by sequencing the genetic material found in water drawn from the Sargasso Sea, they had discovered at least eighteen hundred unnamed species (most of them microorganisms). In 2008 a group of Australian scientists announced that they had found nearly three hundred previously unknown species of corals, starfishes, sponges, and crabs in the deep waters off Antarctica. While Lacépède cataloged roughly twelve hundred species in *Histoire naturelle des poissons*, today the list of marine fish species runs to more than fifteen thousand.

But if works like Lacépède's show how much has been discovered about the diversity of life, they also have the opposite effect: to illustrate how much has been lost. Now, two hundred years later, the major preoccupation of naturalists is not classification but conservation. The earth, it is generally agreed, is suffering a biodiversity crisis. "Biodiversity is a finite resource," Boris Worm, a marine biologist at Dalhousie University in Halifax, Nova Scotia, has observed. And if we continue on our present course, "we are going to end up with nothing left."

Such is the human impact on marine ecosystems that no part of the oceans remains unaffected. Overfishing, dredging, bottom trawling, agricultural runoff, industrial pollution, climate change—these are only some of the threats to life in the sea. Even as ocean temperatures rise, owing to global warming, the increased concentration of carbon dioxide in the atmosphere is causing the seas to become more acidic, threatening corals and shell-forming organisms. (Carbon dioxide dissolves in water to form a weak acid.) A 2006 study of marine fish stocks published in *Science* found that nearly one-third of all species fished for human consumption had "collapsed," meaning the number being caught today is just one-tenth of what it was at its recorded

maximum. The catch of Atlantic cod, for example, is now only 1 or 2 percent of what it was fifty years ago. The same survey predicted that without drastic action, almost all the fish and shellfish species now harvested for food will collapse by the middle of this century.

The prospects for freshwater fish are not much better. A team of scientists from the United States, Canada, and Mexico recently concluded that fish that once were plentiful in North American streams, rivers, and lakes are disappearing, with close to 40 percent of all species in jeopardy. A recent survey by the International Union for Conservation of Nature (IUCN), meanwhile, lists nearly a quarter of all cetacean species as endangered. In 2007 biologists in China searching for the Yangtze river dolphin, or baiji, failed to find even one. (The baiji has been declared "functionally extinct.") Of the nearly two hundred species pictured in this volume, the IUCN classifies twenty as threatened, endangered, or critically endangered.

Many scientists believe that biodiversity is being lost so quickly, and so pervasively, that the world is now in the midst of a mass extinction. If so, this would be the sixth mass extinction in the planet's history. (The most recent was the end-Cretaceous event, sixty-five million years ago, which killed off

the dinosaurs.) E. O. Wilson, perhaps the most famous living biologist, has described the current situation as "desperate."

"The biotas continue to fall before our remorseless expansion, in ever-rising numbers across ever-broader arrays of plants and animals," he has written. "Where originally it was mostly large land-dwelling animals that were afflicted, now fishes, amphibians, insects, and plants are, for the first time, vanishing in large numbers. The dawnless night of extinction is also descending upon rivers, lakes, estuaries, coral reefs, and even the open seas."

What, if anything, can be done to arrest this process? Just as Buffon and Lacépède exhorted their contemporaries to appreciate nature's wonders, biologists today urge us to preserve those that survive. Many measures have been suggested, from preserving so-called biodiversity hotspots to paying indigenous people *not* to cut down local forests. All these proposals, however, depend on a change in the way that people regard the natural world—not as a means, but as an end. The value of the book that you are holding is not just that it is beautiful, though it is, but that it shows the world as it was, and as it might become. As you read it, consider all the magnificent creatures shown here that are gone. Then imagine living in a world where none remain.

A NATURAL HISTORY OF FISH

Discourse on the Nature of Fish

[...] The diversity of families, the great number of species, the prodigious fecundity of individuals, the easy proliferation in all climates, the varied usefulness of every part—in what class of animals other than fish would we find not only these claims to our attention, but also a more abundant foodstuff for man, a resource less destructive of other resources, a material more in demand for industry, and preparations more widely circulated by trade? [...]

What good reasons for studying the history of these remarkable and extremely numerous inhabitants of the earth's waters!

Let us then travel to the shores of the sea, to the edge of the principal empire of these still too-little-known animals. Let us choose, in order better to see them, observe their movements and appreciate their habits,

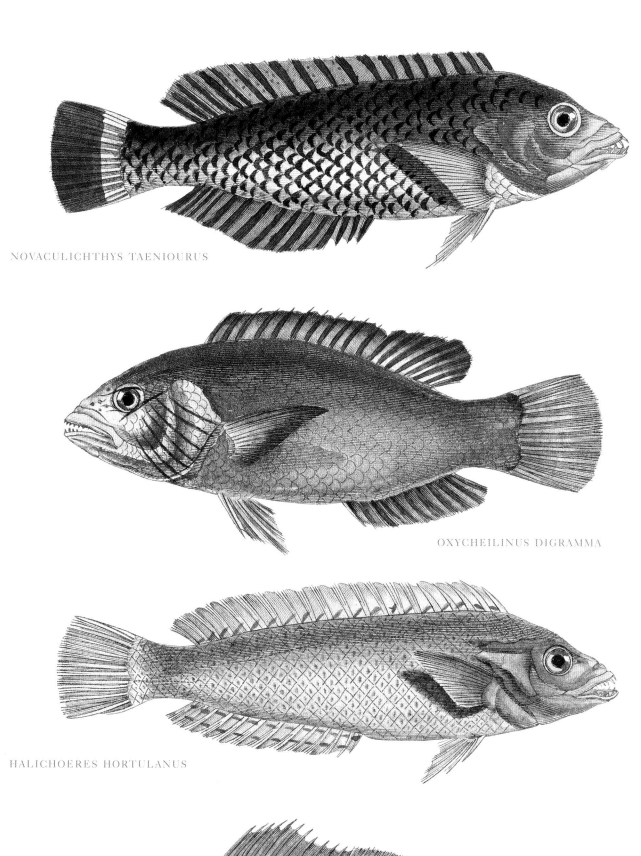

NOVACULICHTHYS TAENIOURUS

OXYCHEILINUS DIGRAMMA

HALICHOERES HORTULANUS

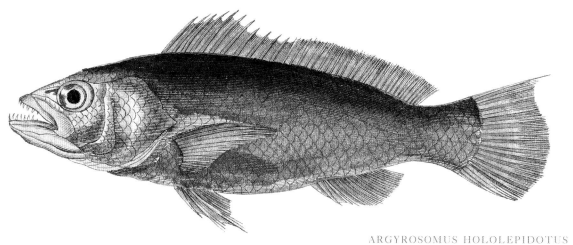

ARGYROSOMUS HOLOLEPIDOTUS

those so to speak "privileged" beaches where a warmer temperature, a mixture of fresh and salt water, more convenient shelter, or more suitable or abundant foodstuffs attract a greater number of fish [...] Let us in our minds rise up high enough above all the seas to apprehend more easily their entirety and to discern a greater number of their inhabitants; let us imagine the globe which, turning beneath our feet, successively shows us all its inundated surface and displays the red-blooded creatures that live within the aqueous fluid that surrounds it; and so that none of these beings escapes our scrutiny, let us probe right to the Ocean's very depths, travel down its abysses, and follow, right to their most obscure retreats, the animals we wish to examine.

[...] Fecundity, beauty, and very long life: these are the three remarkable attributes of the principal inhabitants of the earth's waters. Therefore ancient Greek mythology—perhaps more enlightened than was once thought concerning the principles behind its creations, and always so genial in its imagery—placed the goddess of love's cradle amid the sea, and represented Venus emerging from the waves surrounded by fish gleaming with gold and azure. We should not be surprised by the fact that the ancient Greeks studied fish much more than they observed other animals; they knew them better and preferred them for their dining table over even the most sought-after birds. They passed on this preference

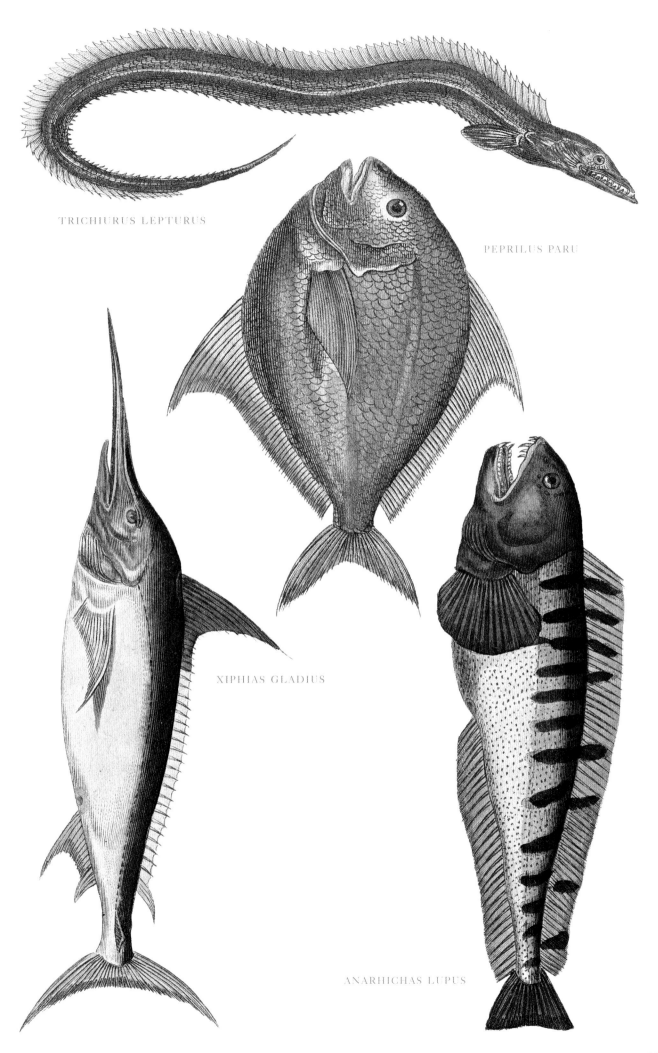

TRICHIURUS LEPTURUS

PEPRILUS PARU

XIPHIAS GLADIUS

ANARHICHAS LUPUS

19

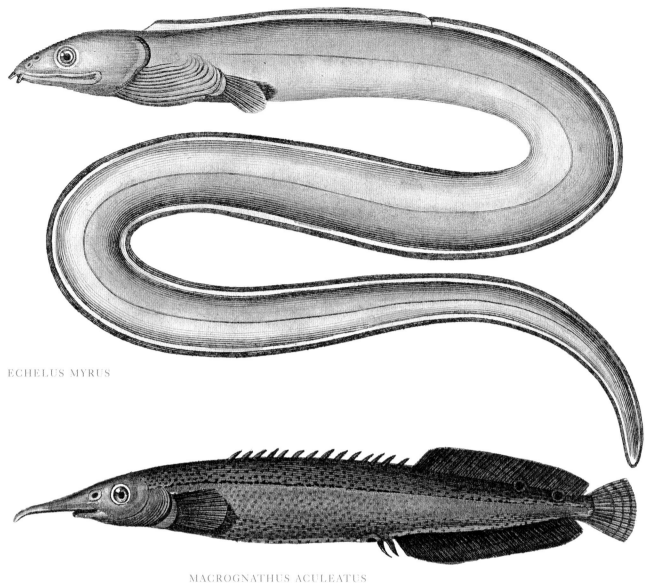

ECHELUS MYRUS

MACROGNATHUS ACULEATUS

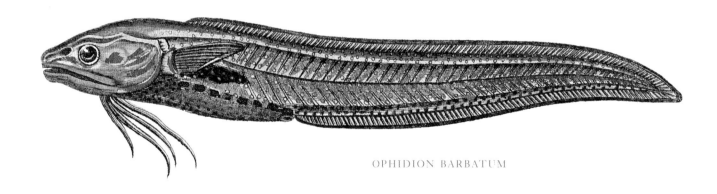

OPHIDION BARBATUM

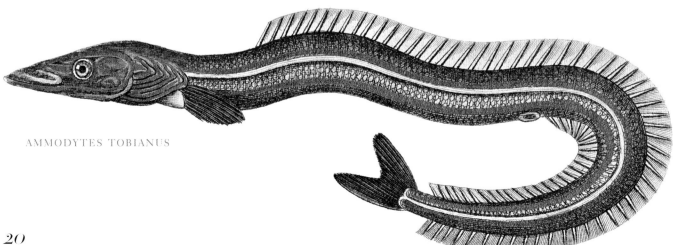

AMMODYTES TOBIANUS

20

and specialist knowledge not only to modern Greeks, who have long been influenced by it, but also to the Romans, who displayed this predilection even when the hardest servitude, the most vile corruption, and the most senseless luxury weighed down on the degraded heads of the world's conquerors (Horace, Juvenal, Martial, and Pliny). [...]

When contemplating the entire space occupied by this fluid through which the fishes swim, what distance must our gaze travel! What an immensity, from the equator to the earth's two poles, from the Ocean's surface down to its deepest depths! And apart from the vast seas, great rivers, tributaries, streams, and fountains, not to mention lakes, marshes, pools, and ponds, contain a more or less considerable quantity of the animals we wish to examine.

[...] What can better elevate our thoughts, invigorate our intelligence and make the mind attentive [...] than the spectacle, so great and so varied, presented to us by the system of innumerable fish habitats? [...]

This domain, whose limits are so remote, has, however, only been granted to fish considered as forming but one class. If we examine them group by group, we will see that almost all the families among these creatures each seems to prefer a particular area. At first glance, it is difficult to see how the aquatic environment can provide enough diversity for the different genera, and even sometimes the different species, of fish

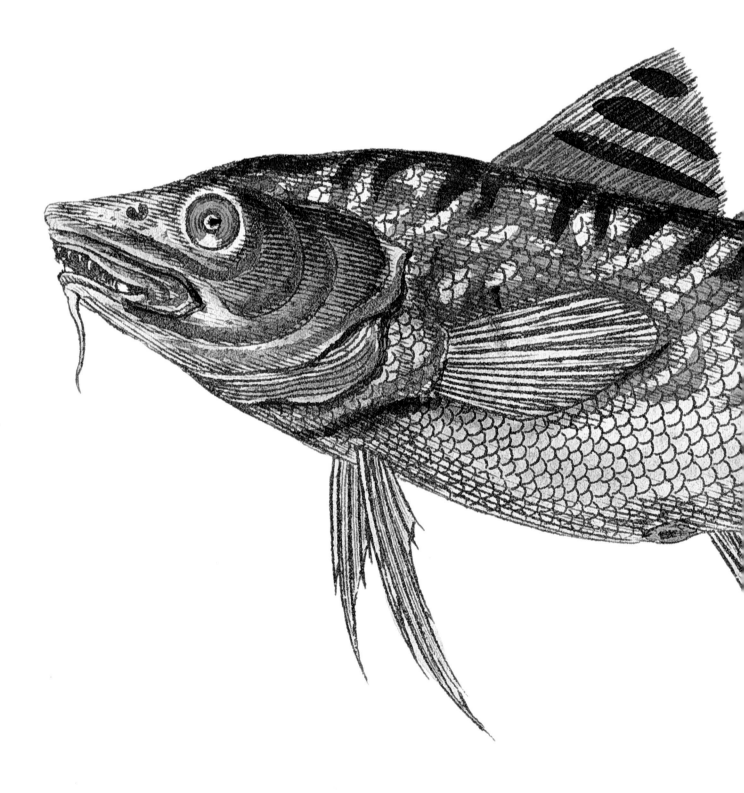

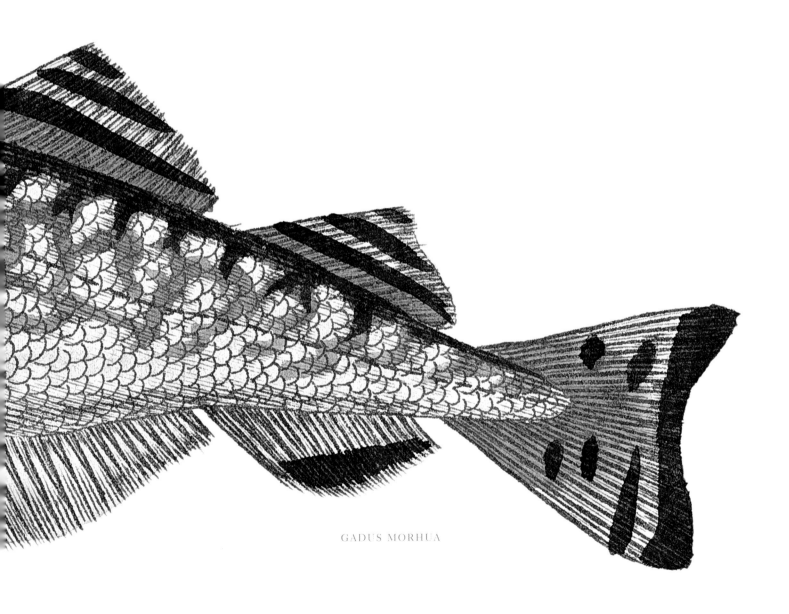

GADUS MORHUA

to be retained by a sort of special attraction at one particular beach rather than another. Consider, however, that the waters of the sea, although more evenly heated at different latitudes than the air, provide highly varied temperatures, especially along the shores. Some, burned by a nearby sun, give off an ardent heat, while others are covered with snow, frost, and ice. Lakes, great rivers, and their tributaries, however, are subject to much greater disparities of heat and cold. There exist vast natural reservoirs at the summits of the highest mountains, more than two thousand meters above sea level, to which fish travel up via the rivers that flow out of them, and where these very animals live, reproduce, and prosper.[1] The waters of nearly all these lakes, rivers, and tributaries are very fresh and light, while those of the seas are saline and heavy. We now add, ignoring this division between the ocean and the rivers, that some waters are clear and limpid, while others are dirty and silty; that the latter are completely calm, quiet and, so to speak, immobile, while the former are churned by currents, overwhelmed by tides, precipitated in cascades, thrown in torrents, or at any rate driven at more or less rapid or constant speeds. Taking into account all the different degrees of speed, purity, saltiness, and temperature of these waters, we will be overwhelmed by the infinite number of combinations these four variations can produce, and we will no longer ask how the seas and continents can provide so many varied

[1] Note written in Bagnières on 13 Nivôse, Year V [January 2, 1797], and addressed to Lacépède, by Ramond, associate member of the National Institute, professor of natural history in Tarbes, most favorably known to the public for his *Journeys in the Alps and the Pyrenees.*

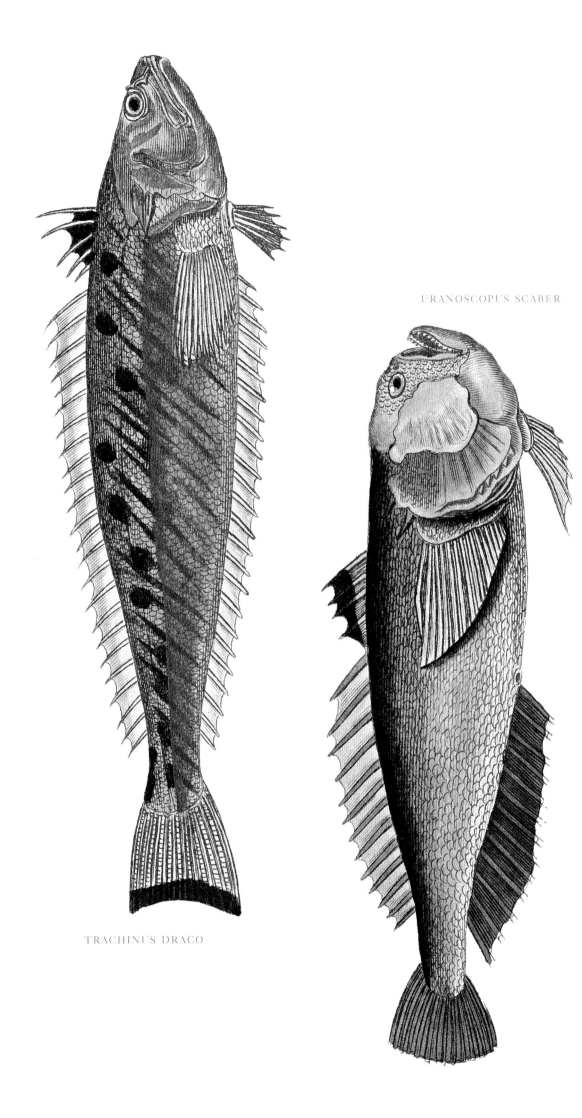

URANOSCOPUS SCABER

TRACHINUS DRACO

25

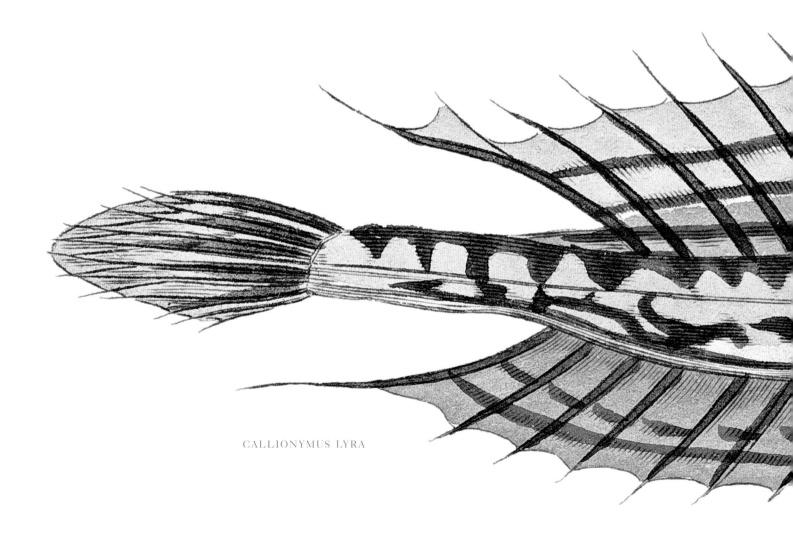

CALLIONYMUS LYRA

26

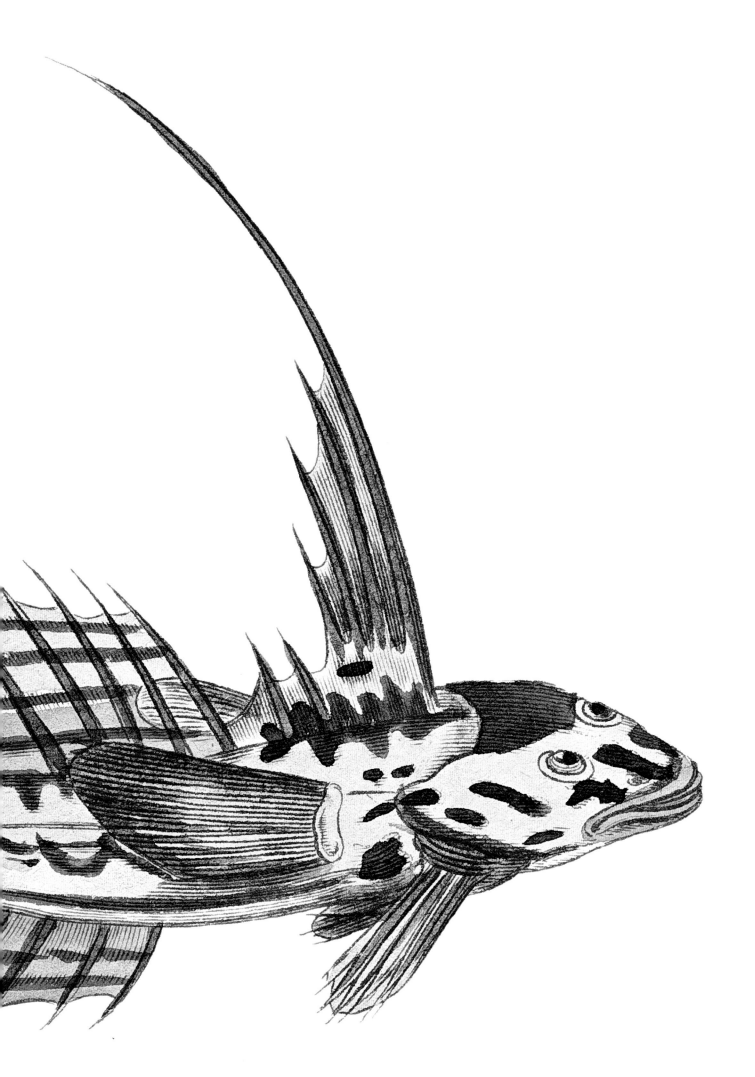

27

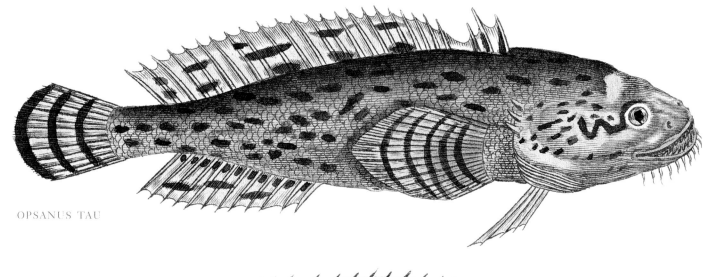

OPSANUS TAU

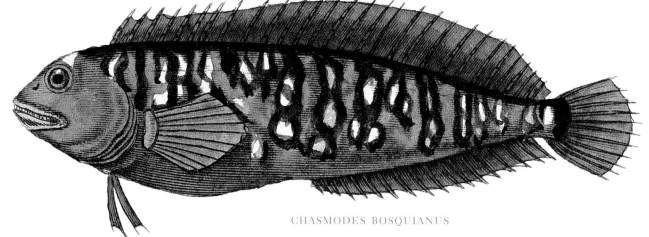

CHASMODES BOSQUIANUS

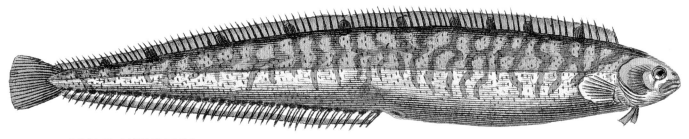

PHOLIS GUNNELLUS

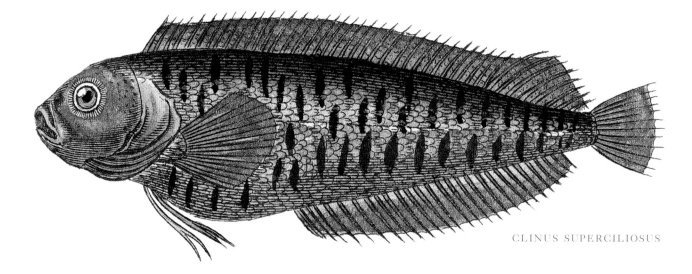

CLINUS SUPERCILIOSUS

28

habitats and such a great number of choice abodes for fish.

But since the duty of those who cultivate the different branches of natural science is to use its fruits to increase man's delights, relieve his pains and diminish his ills, we shall not end this work without having demonstrated, in a general discourse and in separate articles, all that commerce and industry owe, and could yet further owe, to the products furnished by the multitudinous class of fish. We will prove that there is almost no part of these animals that is not useful to the arts, and sometimes even to the art of healing. We will show their scales arraying the stuccowork of palaces with a silvery brilliance and providing beauty with false but lustrous pearls; their skin, their membranes and most of all their swim bladder being transformed into the glue that is required by so many products and demanded by so many processes, and that medicine has not disdained to use; their bones and their spines feeding several animals along very extensive shores; their oil lighting so many cabins and softening so many materials; their eggs, their milk and their flesh, necessary for the luxury of sumptuous banquets, and yet also a consolation on the poor man's humble table. We will explain the attentions through which their different species may become more fertile, more agreeable to the taste, more healthful, and more suited to diverse climates; how they can be introduced into regions where they were hitherto unknown;

they can be introduced into regions where they were hitherto unknown; how they may serve to embellish our homes and bring a new delight into the midst of our solitude.

What extension, moreover, can the important art of fishing not undergo, this art without which a nation would enjoy neither safe navigation, nor prosperous commerce, nor naval might; and, as a result, neither wealth nor power! What multitudinous population would not be maintained by the enormous harvest that every year can be asked of the seas, the great rivers and their tributaries, the lakes, the fishponds, and even the smallest streams! The earth's waters can feed many more men than the land.

B.G.E. DE LA VILLE-SUR-ILLON,
COMTE DE LACÉPÈDE

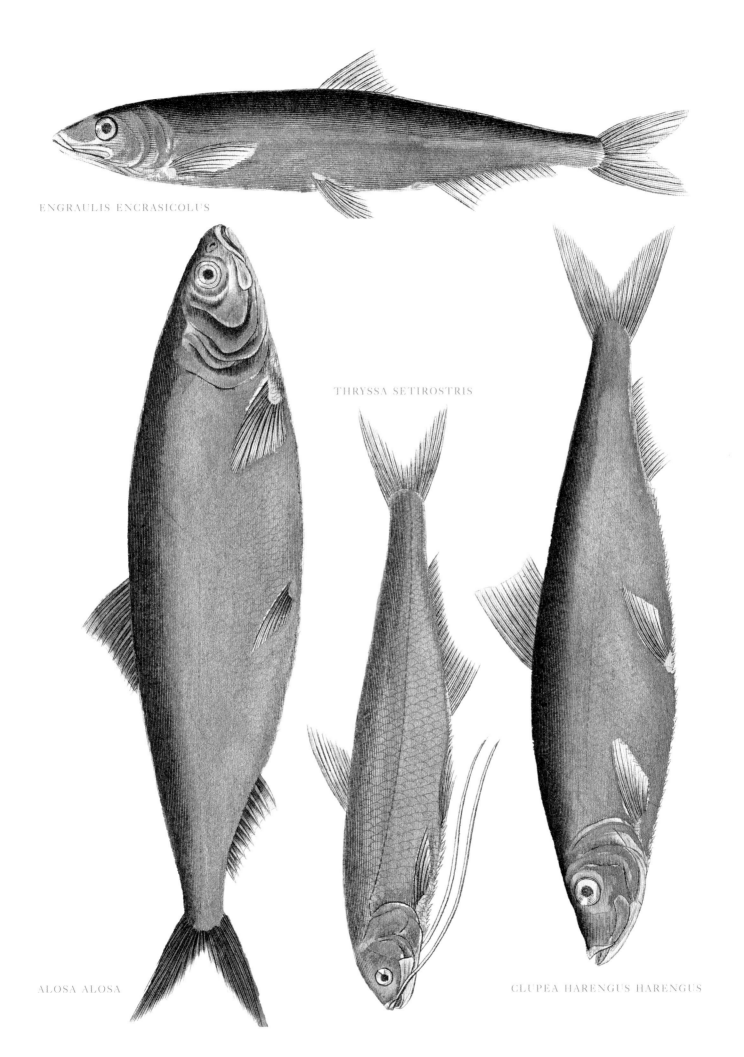

ENGRAULIS ENCRASICOLUS

THRYSSA SETIROSTRIS

ALOSA ALOSA

CLUPEA HARENGUS HARENGUS

SOLENOSTOMUS PARADOXUS

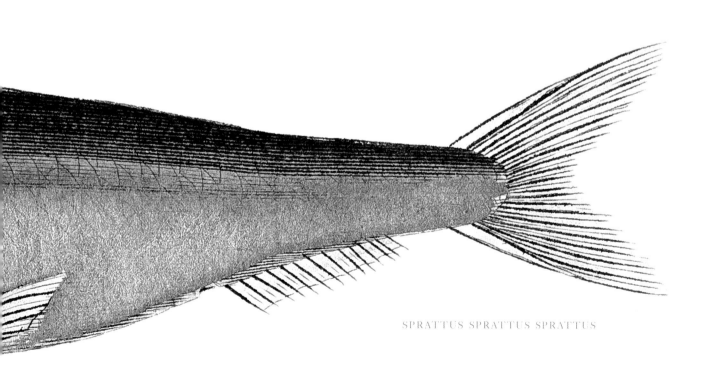

SPRATTUS SPRATTUS SPRATTUS

33

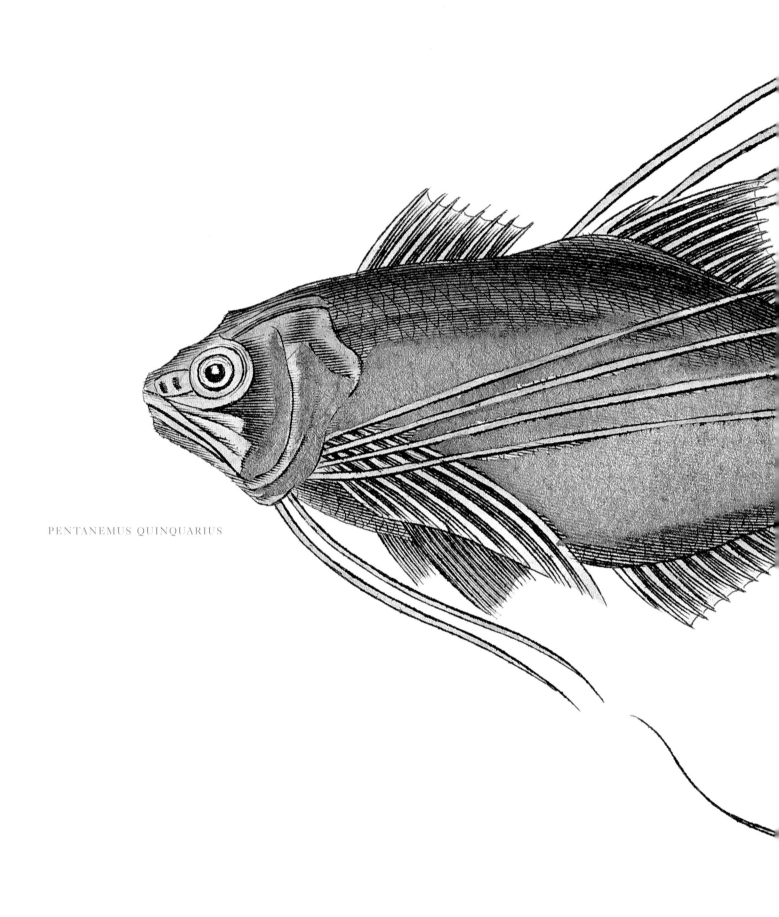

PENTANEMUS QUINQUARIUS

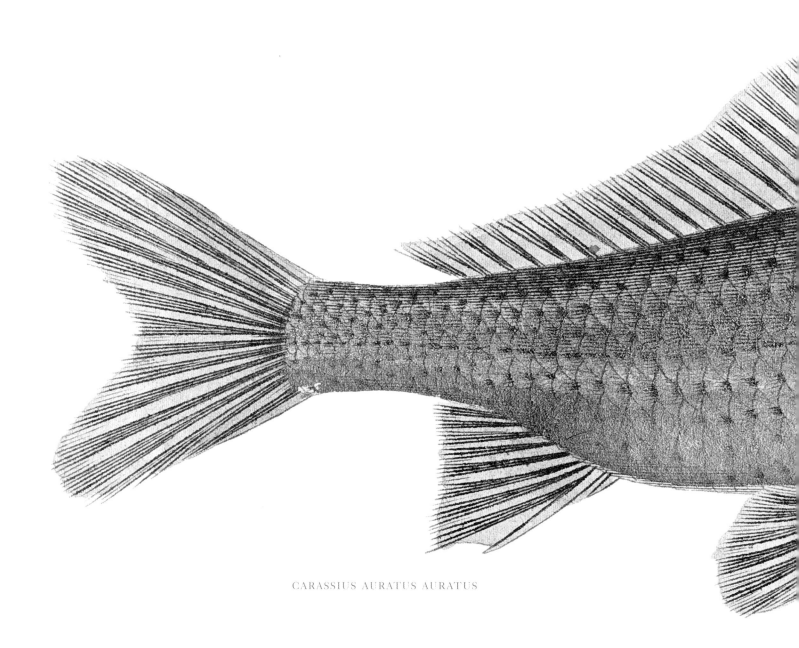

CARASSIUS AURATUS AURATUS

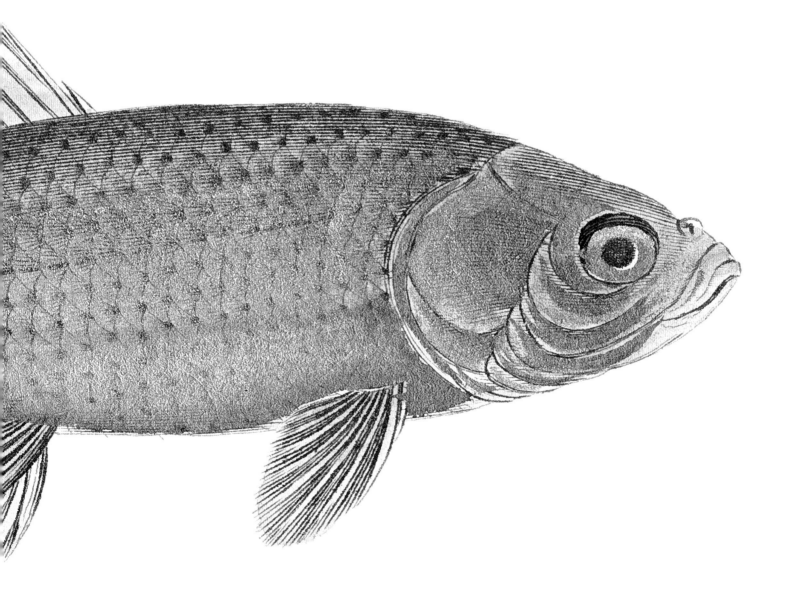

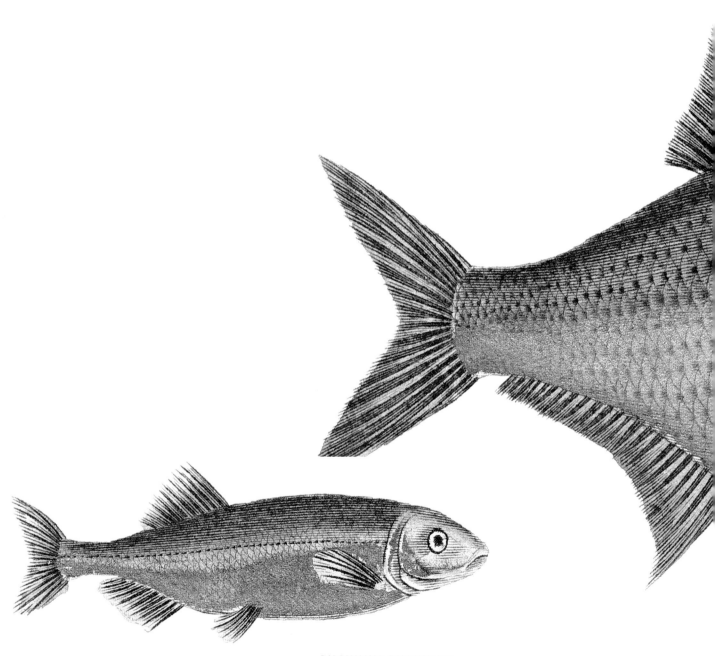

PHOXINUS PHOXINUS

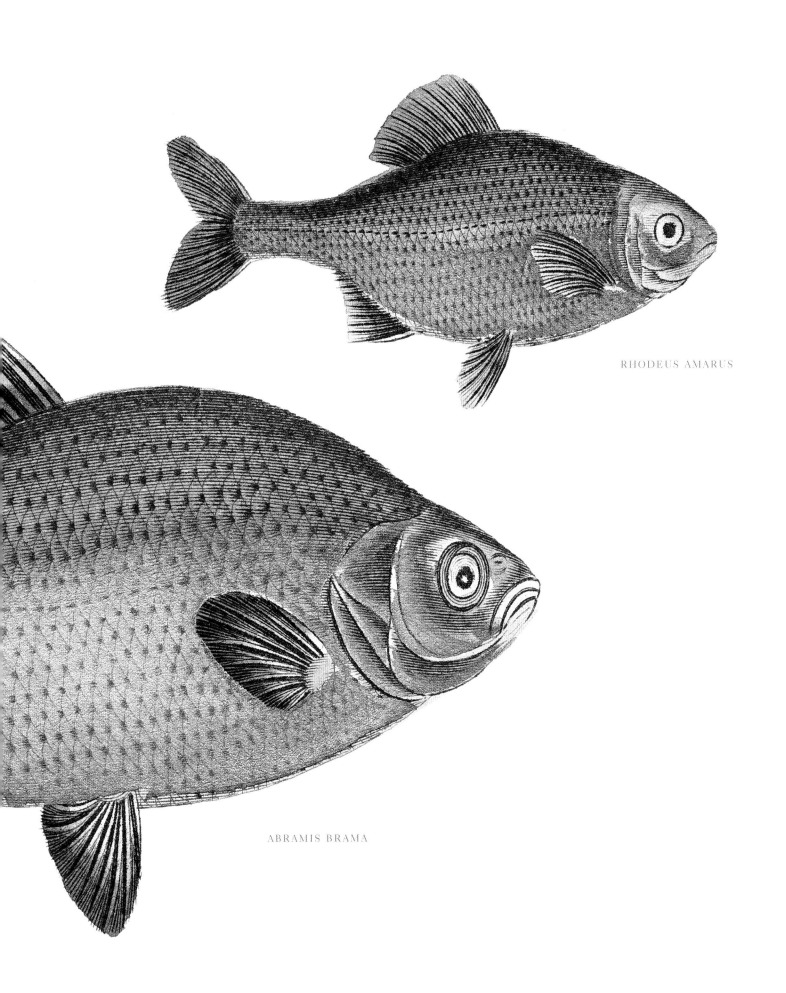

RHODEUS AMARUS

ABRAMIS BRAMA

39

"Beauty is a fragile gift."

OVID, *Ars Amatoria*

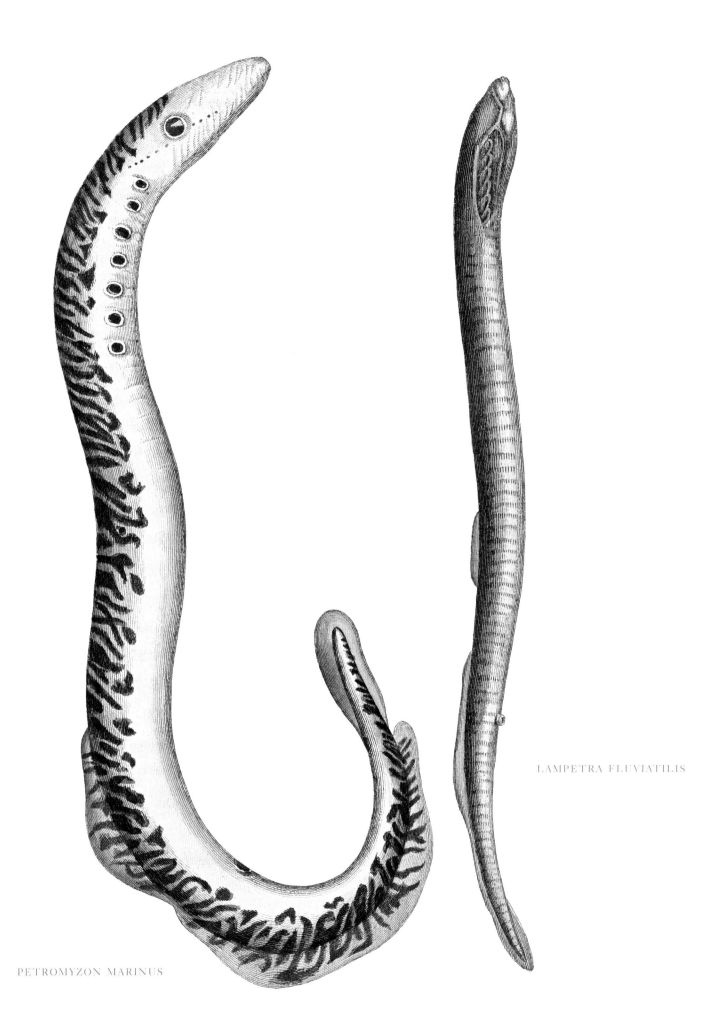

PETROMYZON MARINUS

LAMPETRA FLUVIATILIS

11

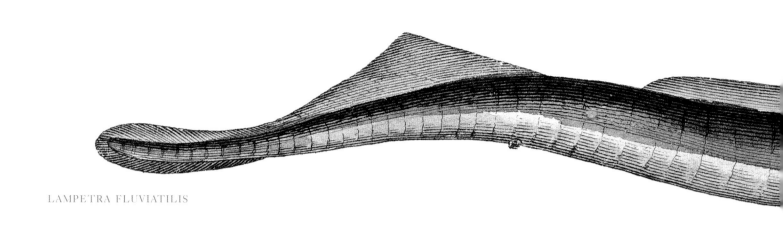

LAMPETRA FLUVIATILIS

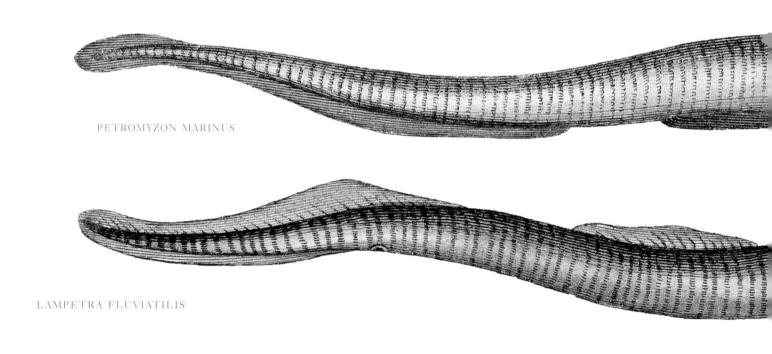

PETROMYZON MARINUS

LAMPETRA FLUVIATILIS

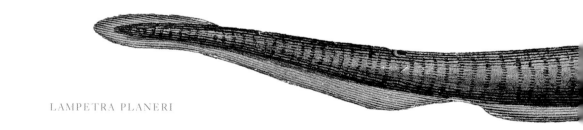

LAMPETRA PLANERI

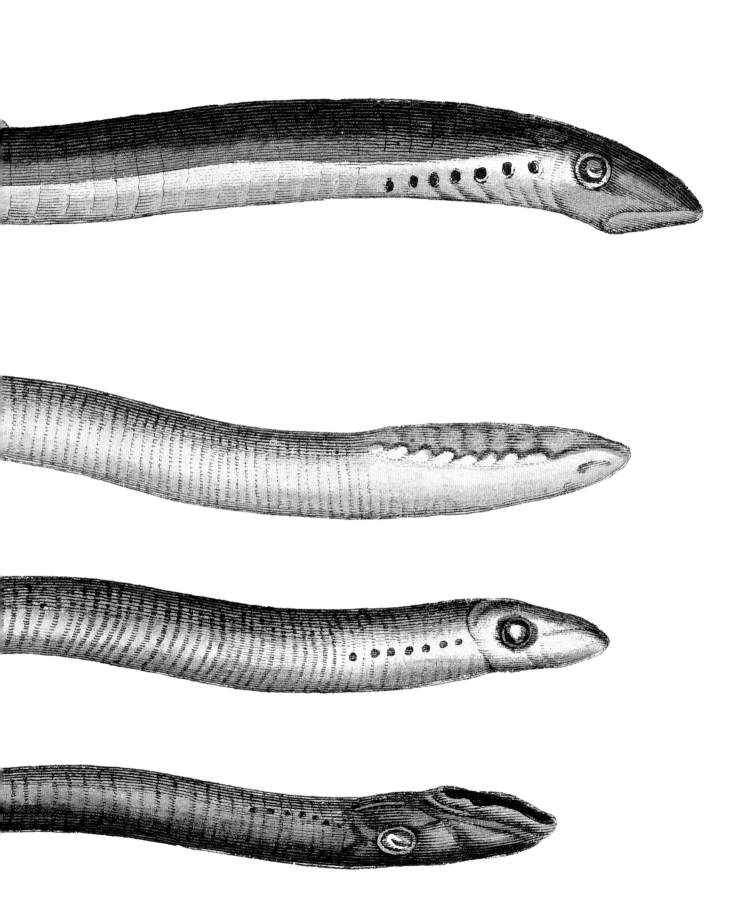

43

66 The sea, once it casts its spell, holds one in its net of wonder forever.

JACQUES YVES COUSTEAU

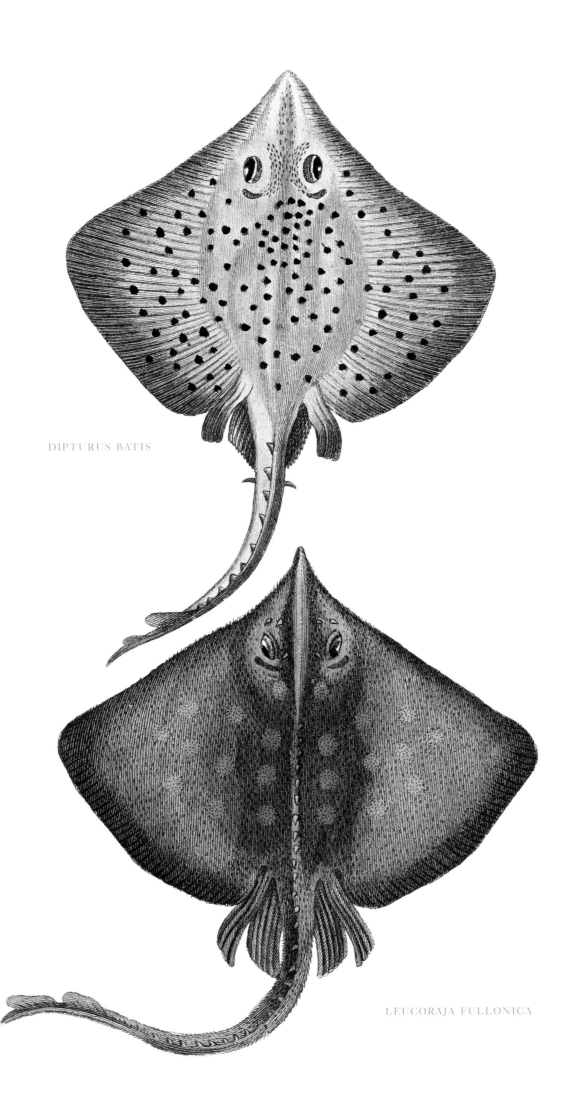

DIPTURUS BATIS

LEUCORAJA FULLONICA

45

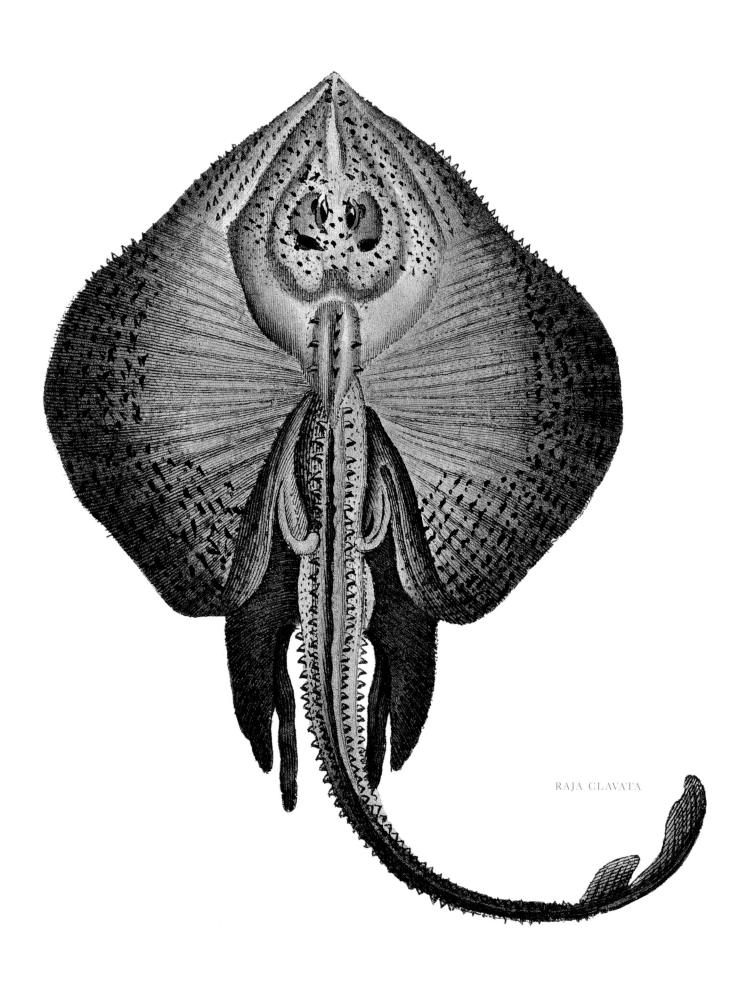

RAJA CLAVATA

46

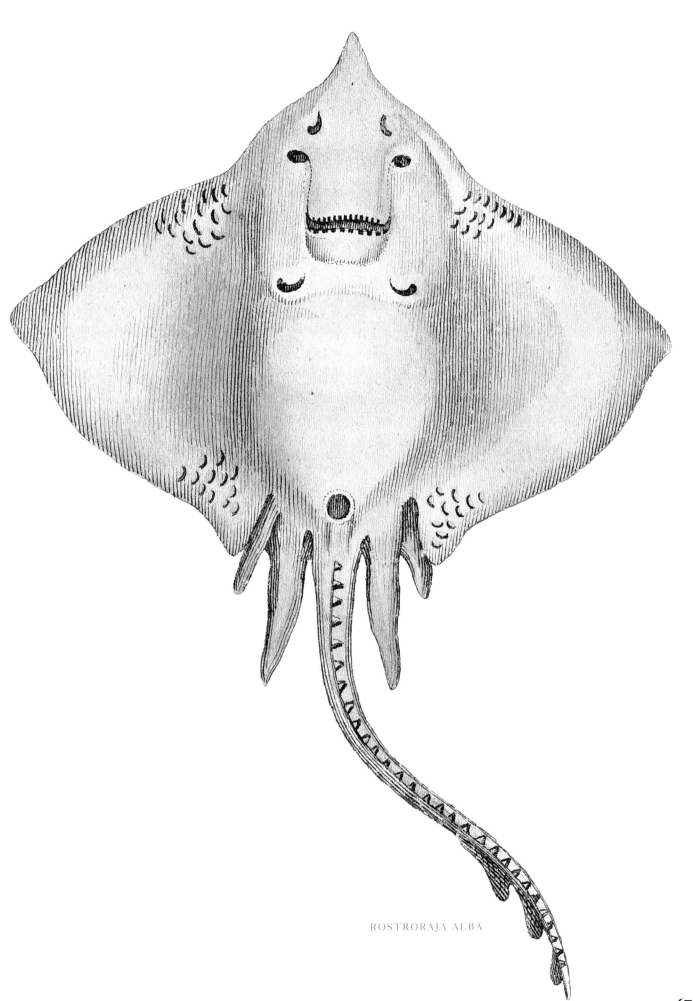

ROSTRORAJA ALBA

17

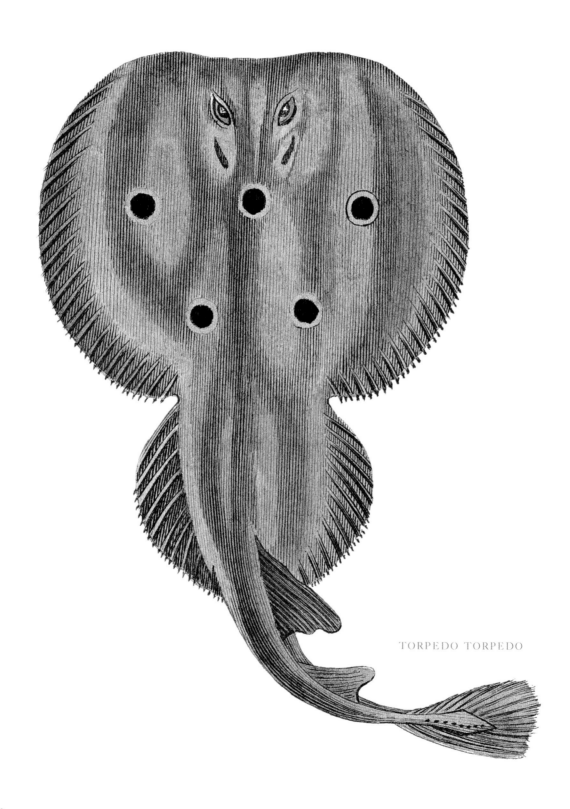

TORPEDO TORPEDO

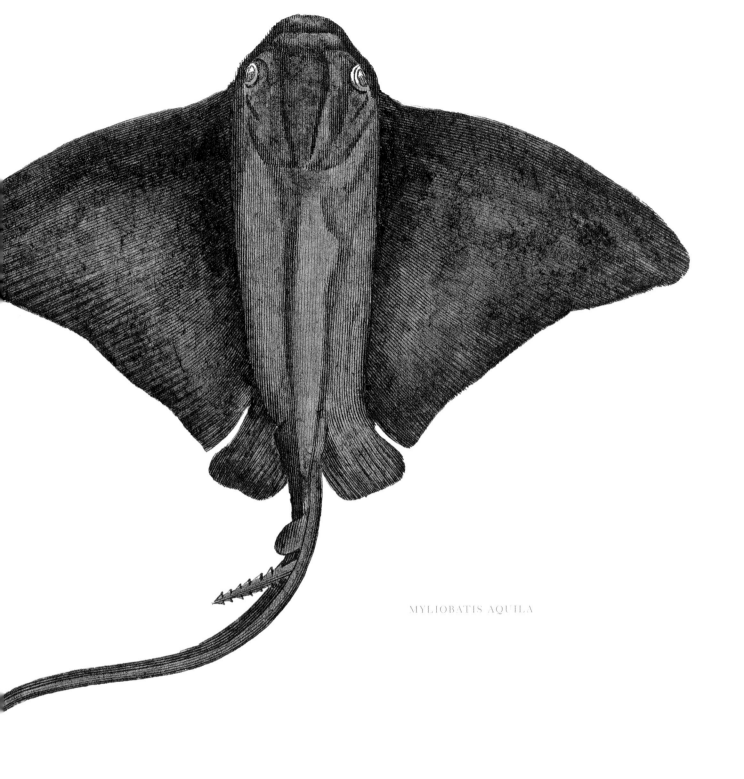

MYLIOBATIS AQUILA

49

" The diversity of families, the great number of species, the prodigious fecundity of individuals, the easy proliferation in all climates, the varied usefulness of every part—in what class of animals other than fish would we find not only these claims to our attention, but also a more abundant foodstuff for man, a resource less destructive of other resources, a material more in demand for industry, and preparations more widely circulated by trade? "

COMTE DE LACÉPÈDE

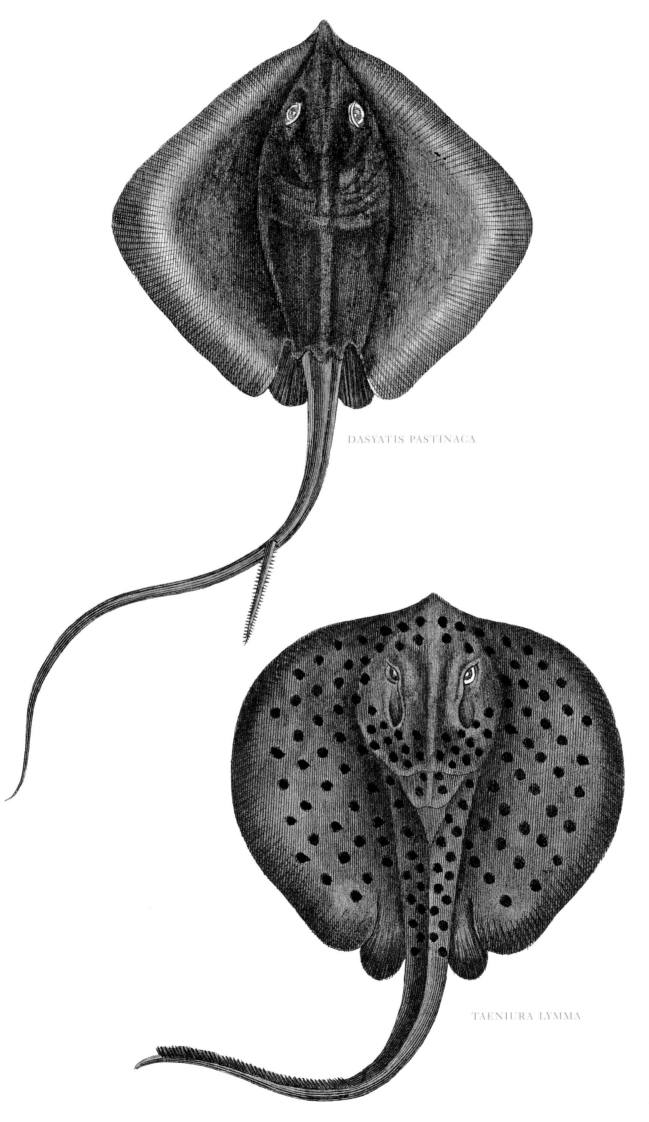

DASYATIS PASTINACA

TAENIURA LYMMA

51

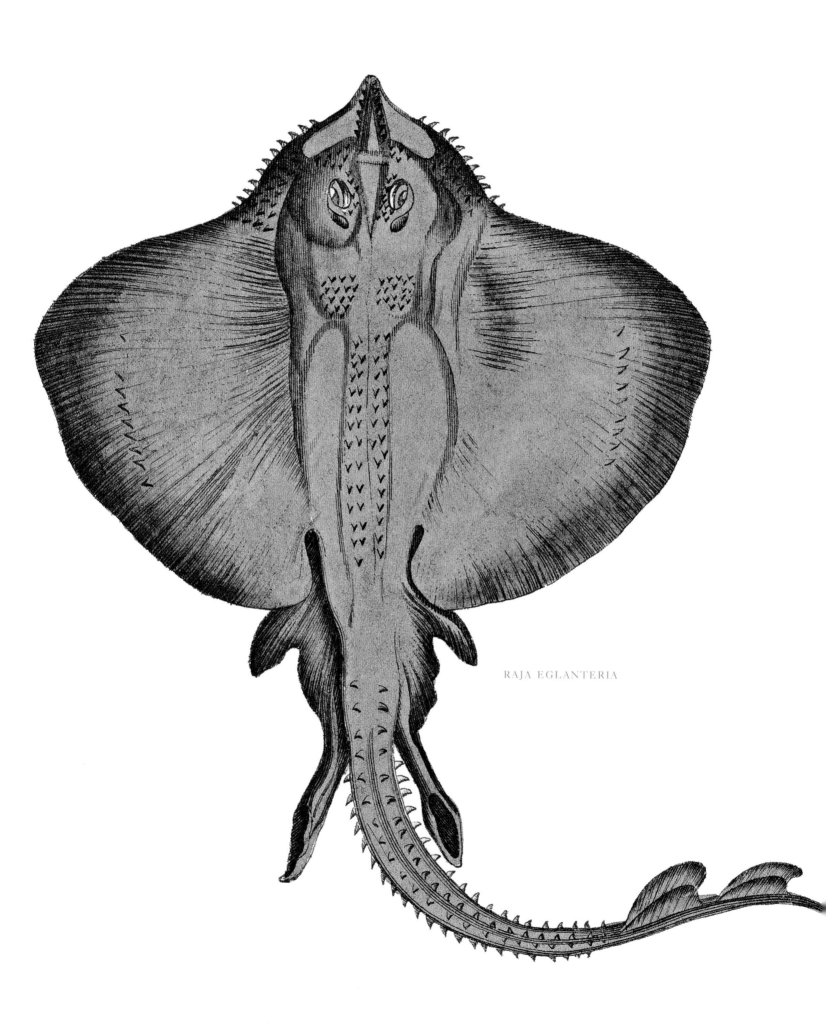

RAJA EGLANTERIA

52

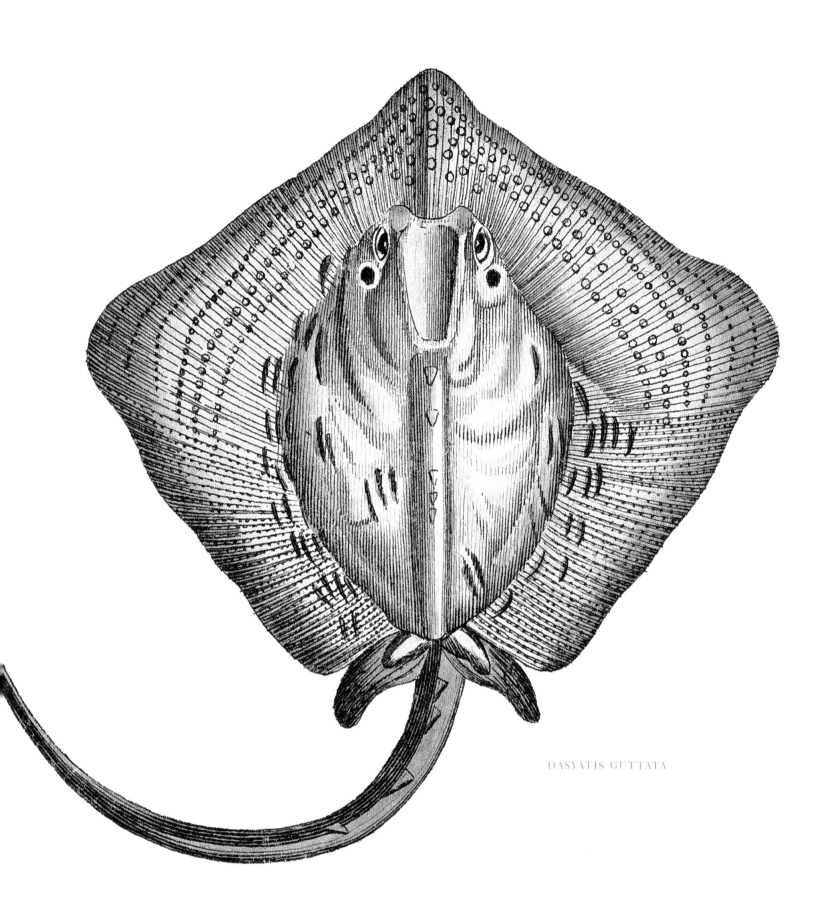

DASYATIS GUTTATA

53

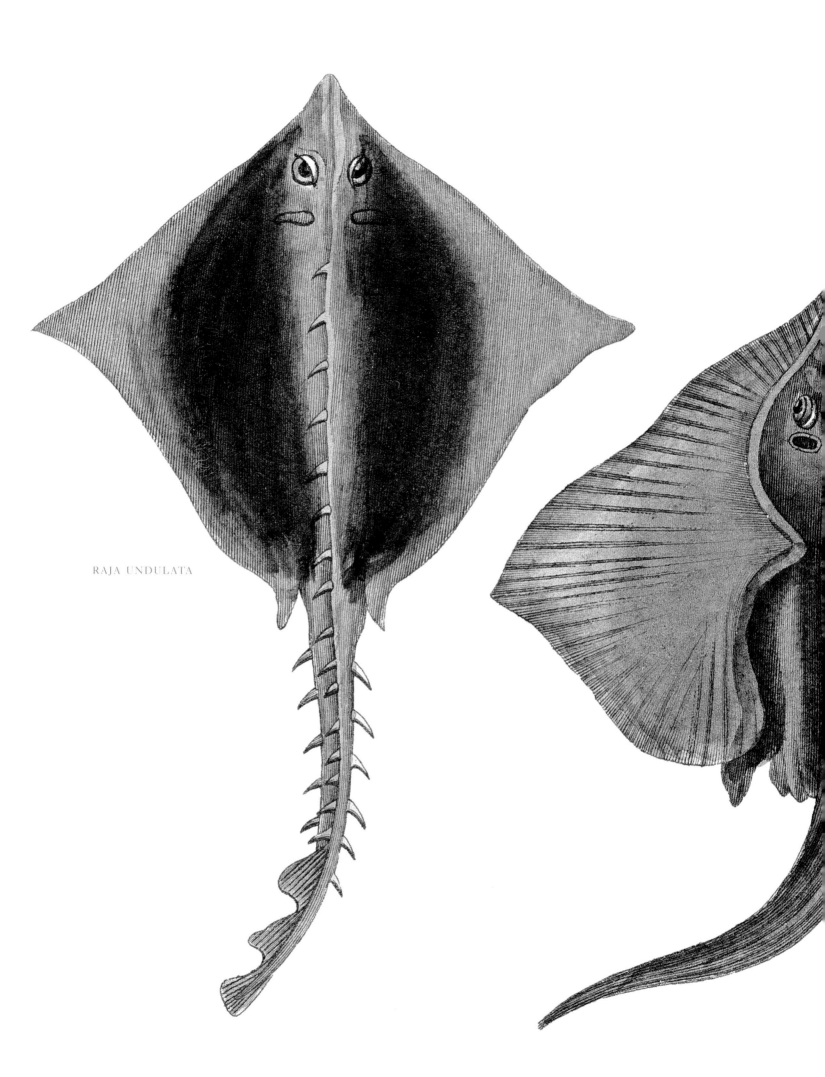

RAJA UNDULATA

54

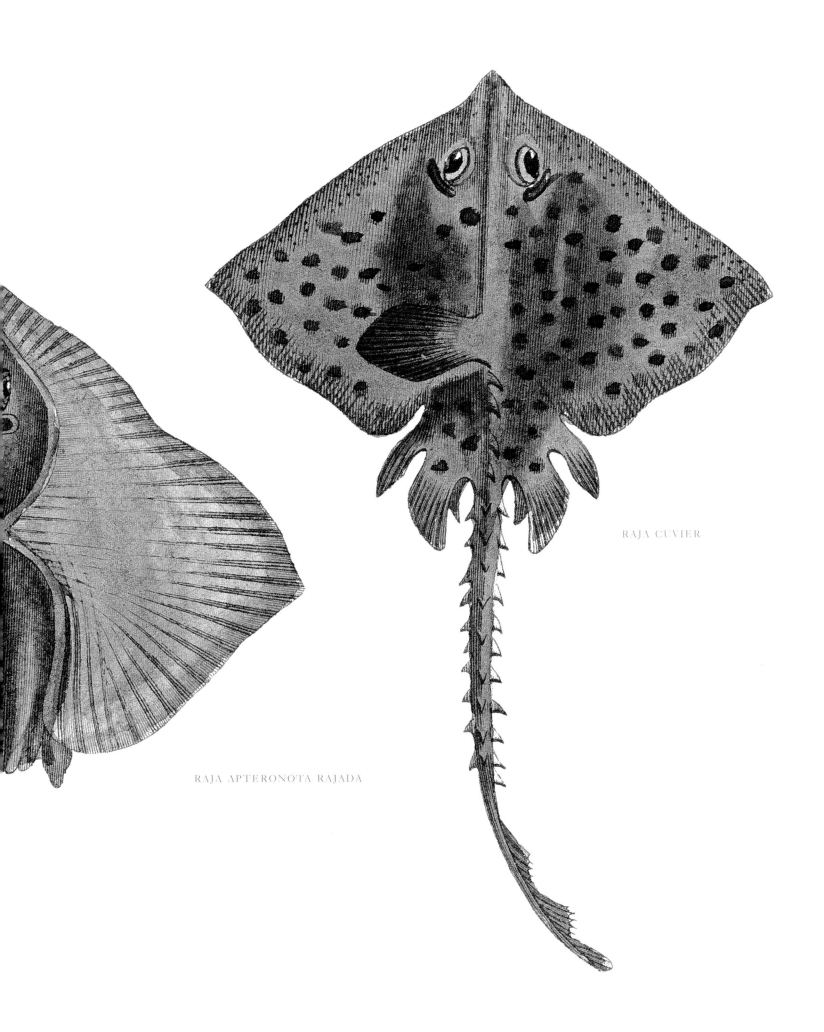

RAJA CUVIER

RAJA APTERONOTA RAJADA

55

" The ocean covers 71 percent of the Earth's surface and contains 97 percent of the planet's water, yet more than 95 percent of the underwater world remains unexplored. "

NATIONAL OCEANIC AND ATMOSPHERIC ADMINISTRATION

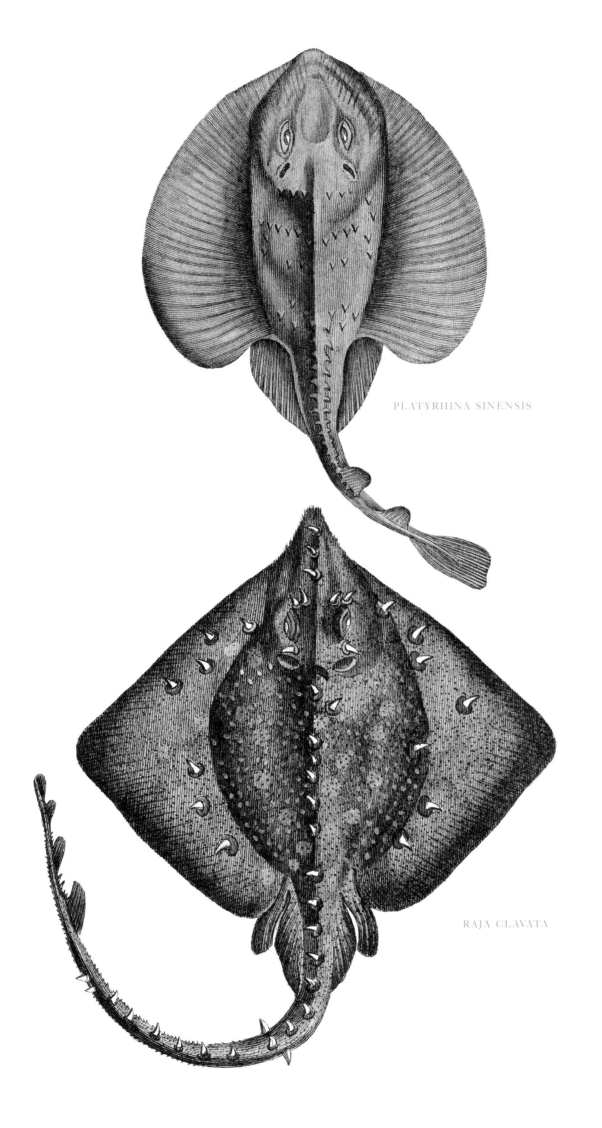

PLATYRHINA SINENSIS

RAJA CLAVATA

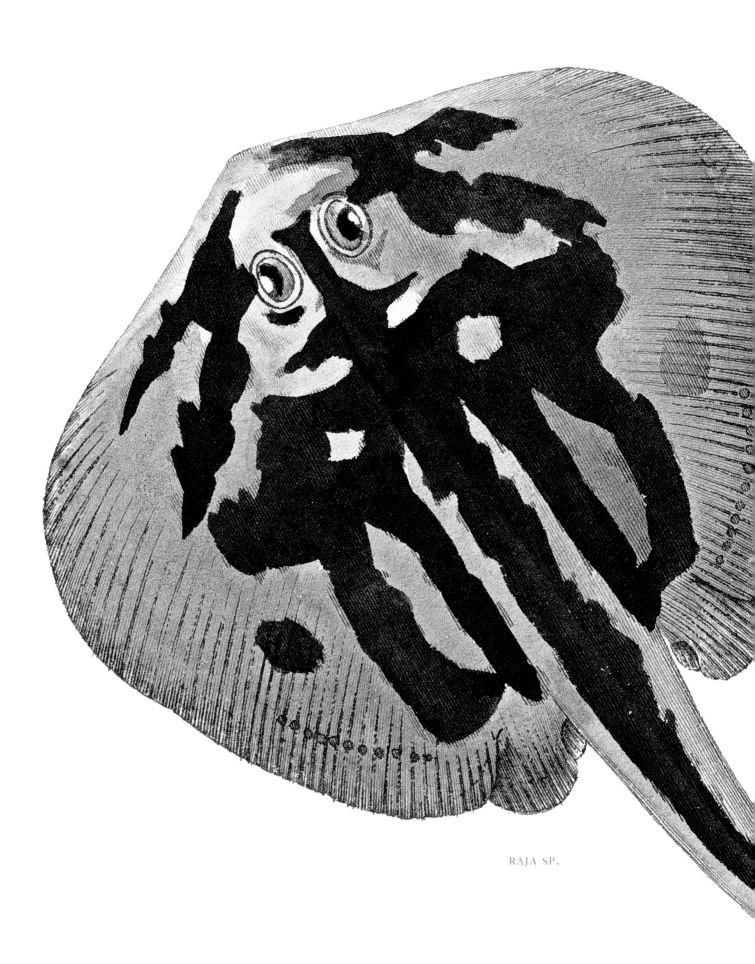

RAJA SP.

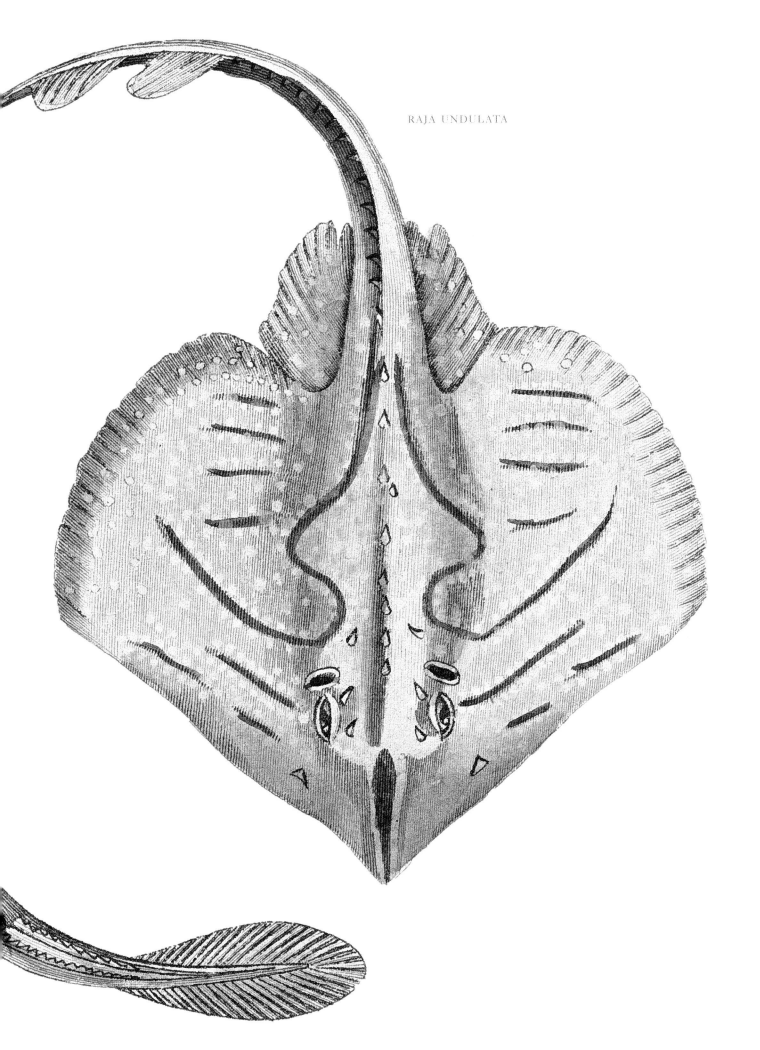

RAJA UNDULATA

59

" Pouring forth its seas everywhere, then, the ocean envelops the earth and fills its deeper chasms. "

NICOLAS COPERNICUS

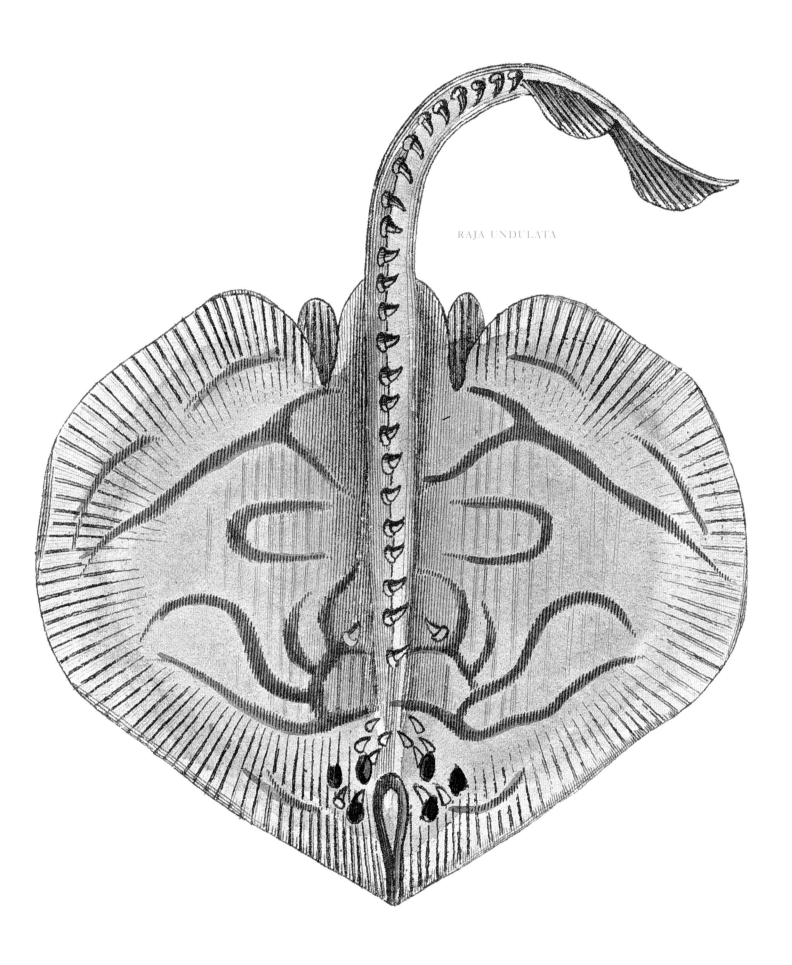

RAJA UNDULATA

61

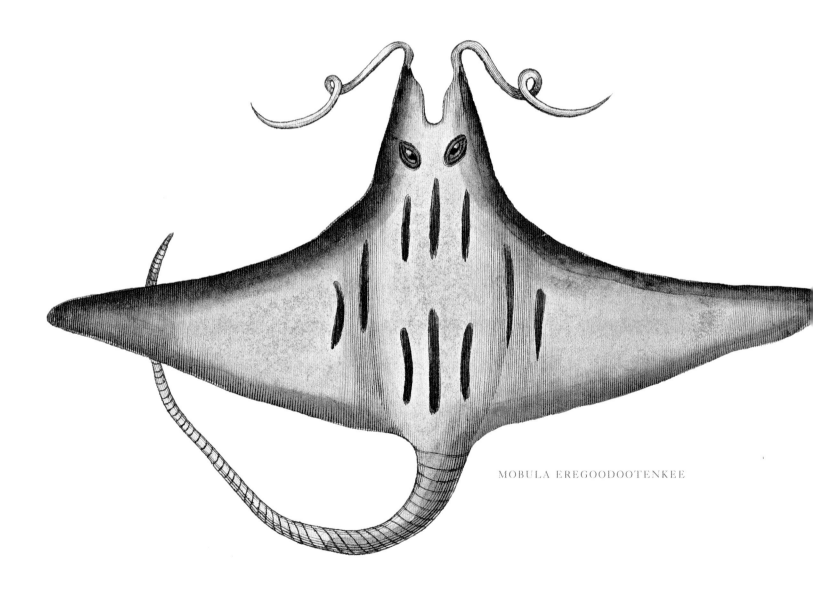

MOBULA EREGOODOOTENKEE

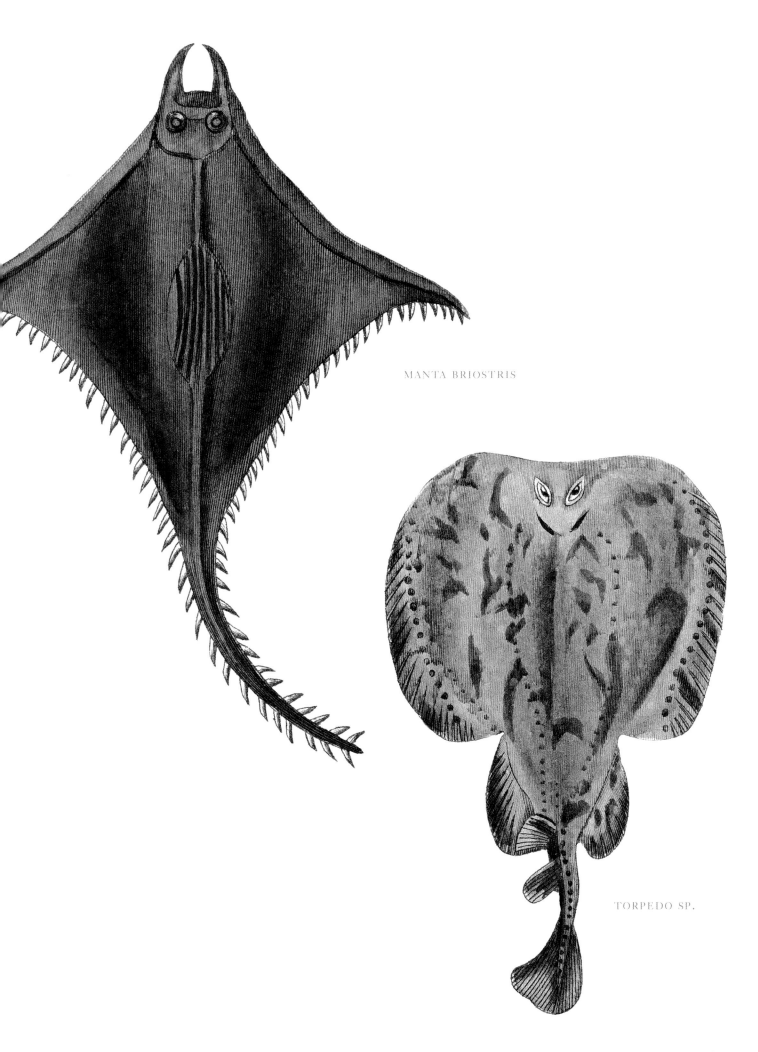

MANTA BRIOSTRIS

TORPEDO SP.

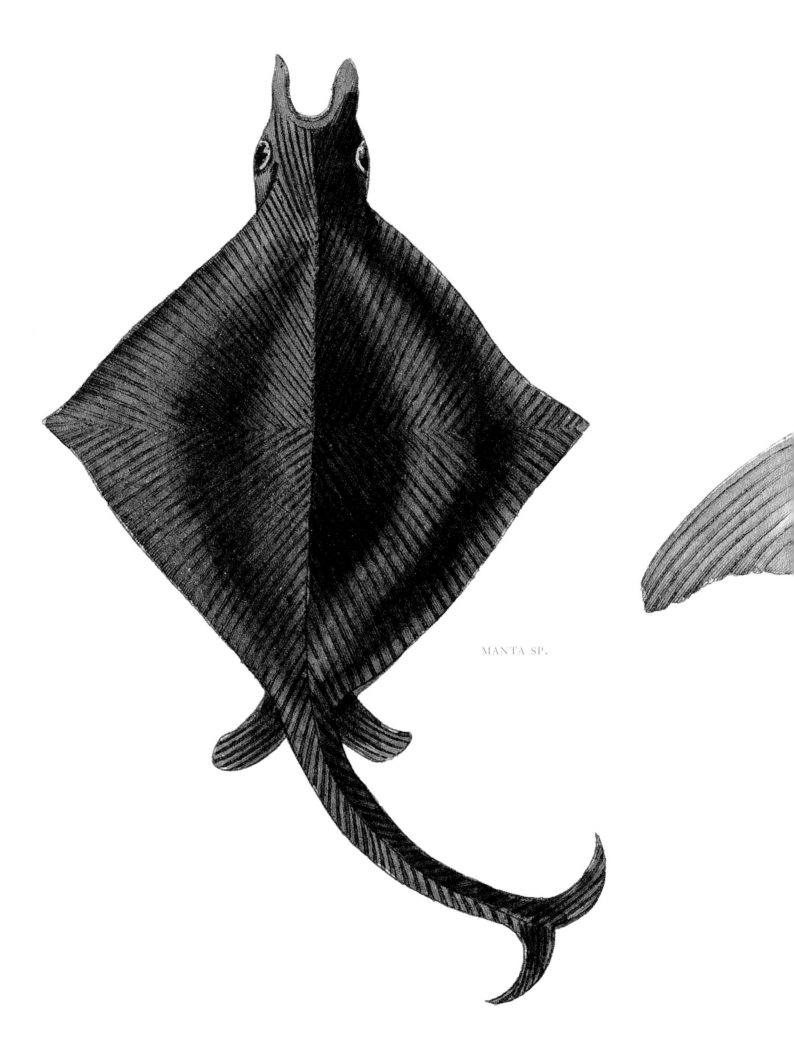

MANTA SP.

64

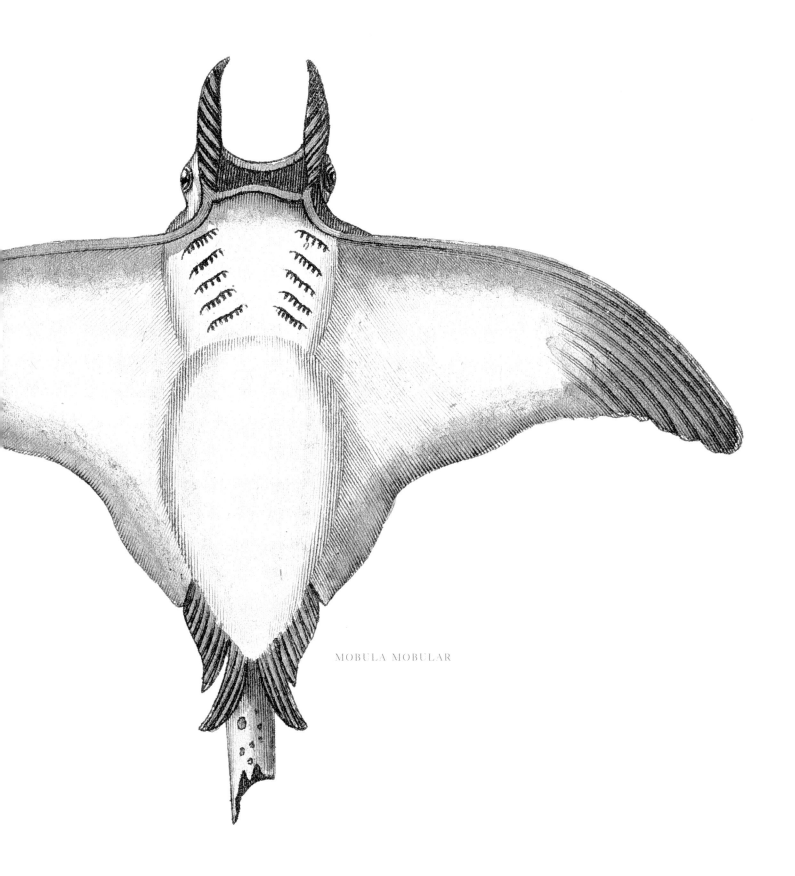

MOBULA MOBULAR

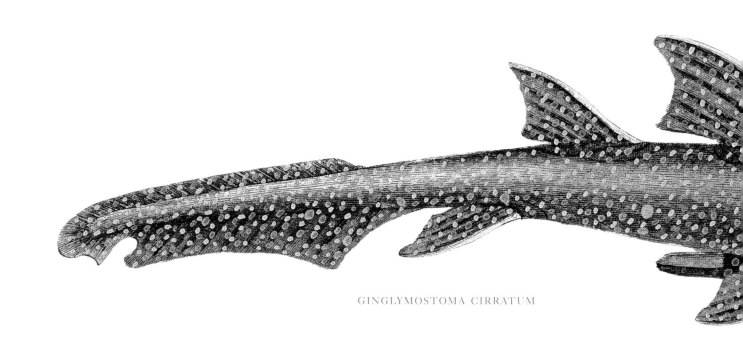

GINGLYMOSTOMA CIRRATUM

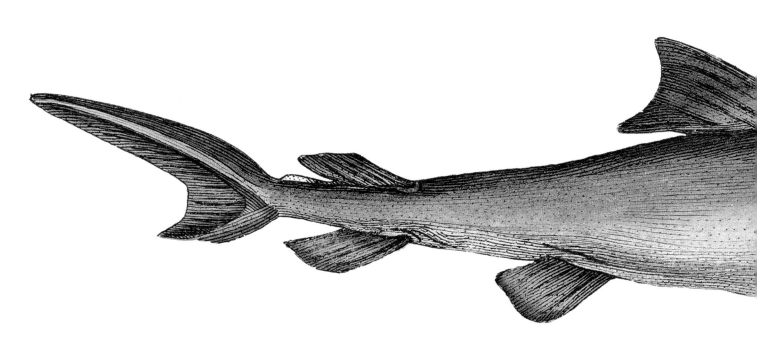

PRIONACE GLAUCA

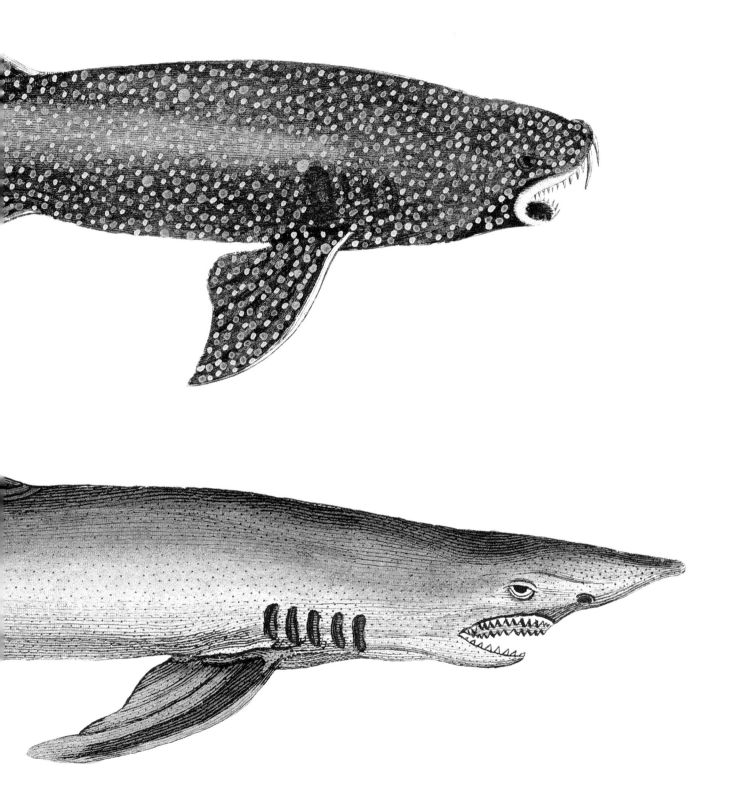

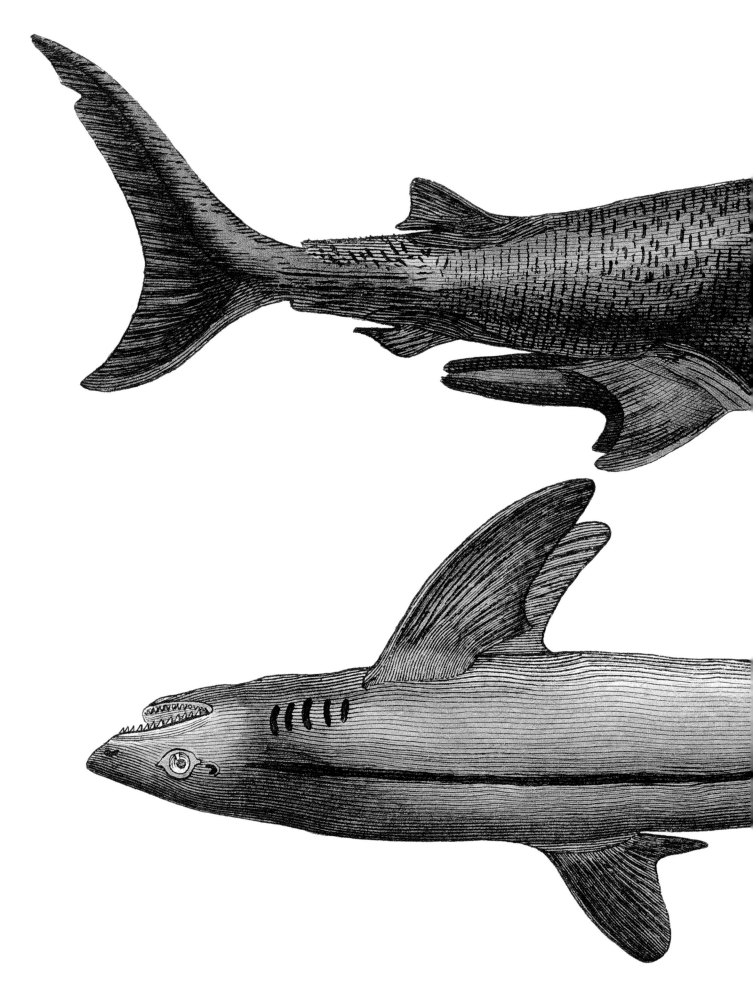

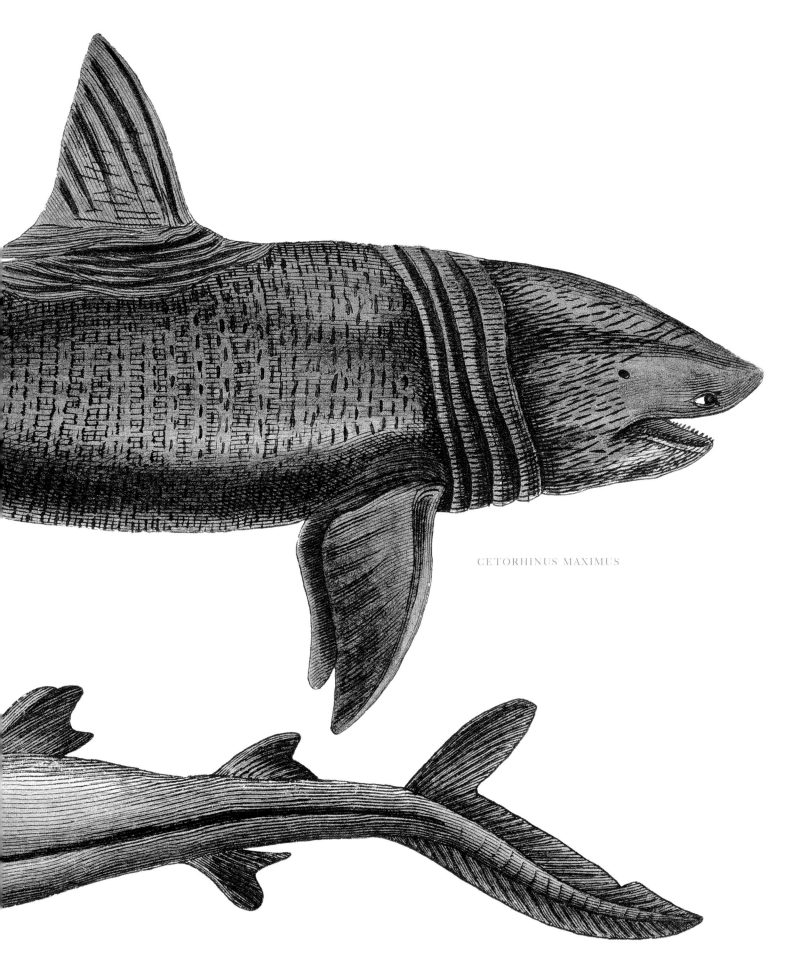

CETORHINUS MAXIMUS

CARCHARODON CARCHARIAS

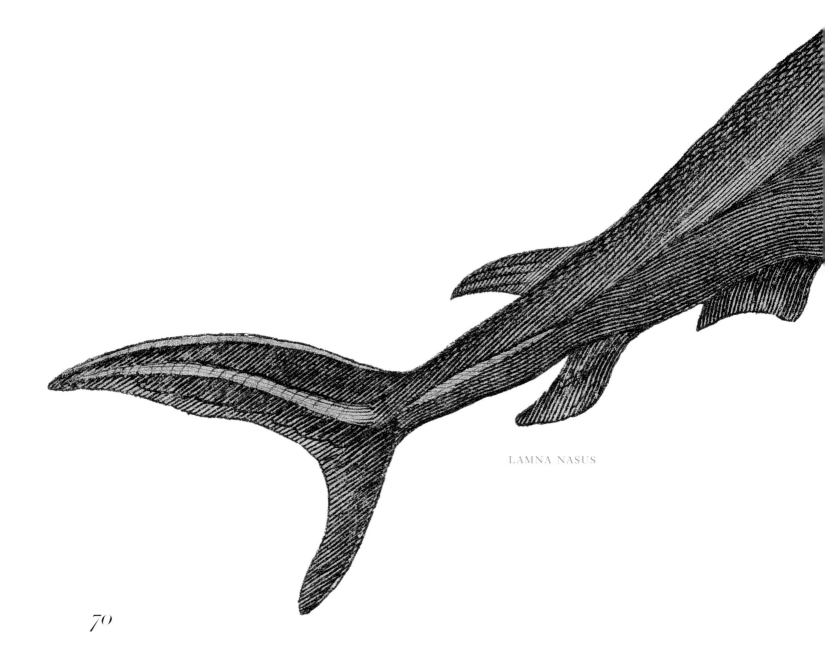

LAMNA NASUS

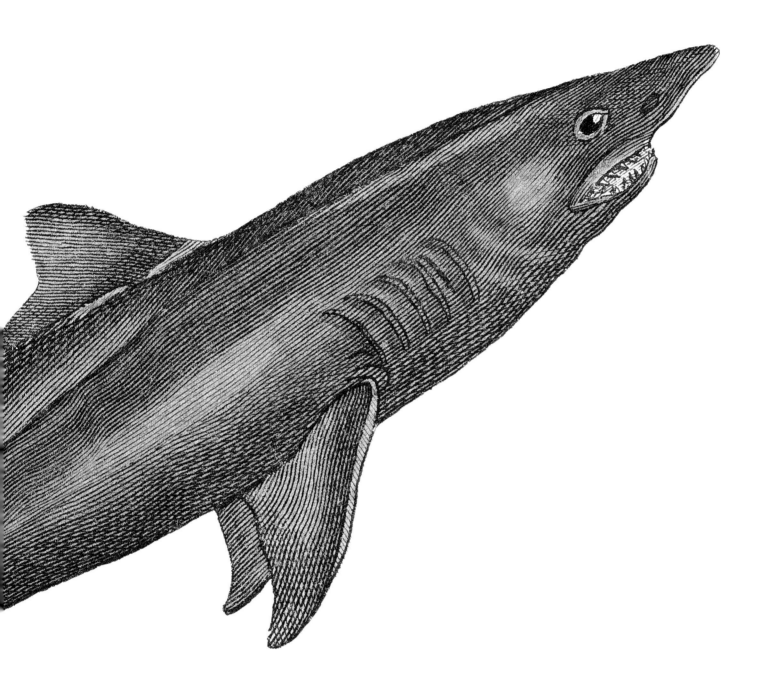

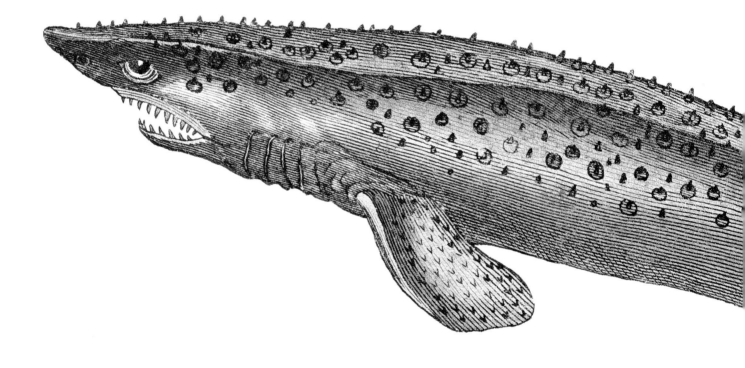

> **All that is told of the sea has a fabulous sound to an inhabitant of the land, and all its products have a certain fabulous quality, as if they belonged to another planet, from seaweed to a sailor's yarn, or a fish story. In this element the animal and vegetable kingdoms meet and are strangely mingled.** "

HENRY DAVID THOREAU

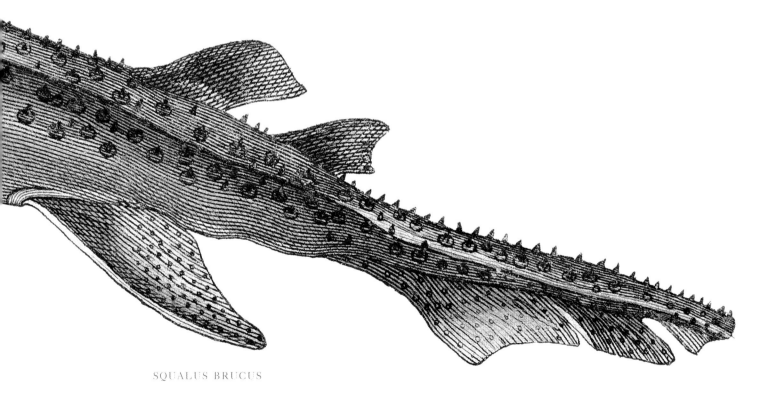

SQUALUS BRUCUS

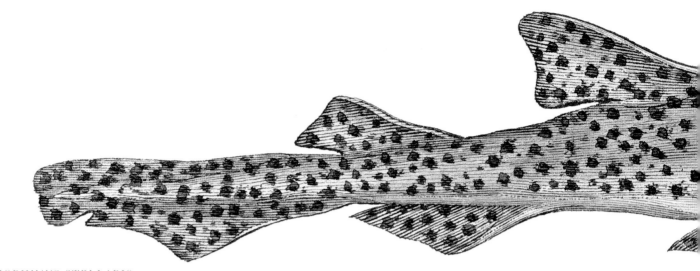

SCYLIORHINUS STELLARIS

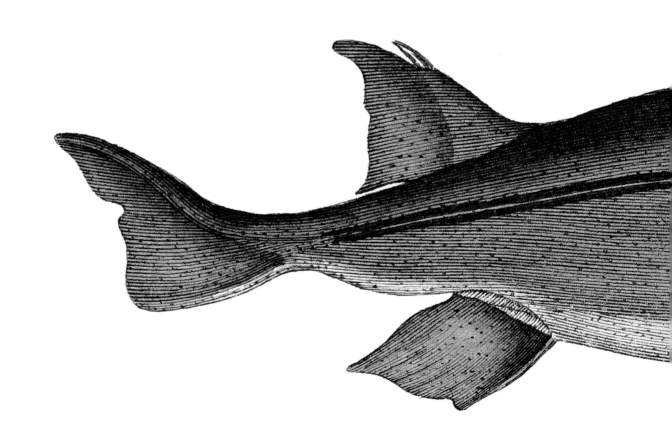

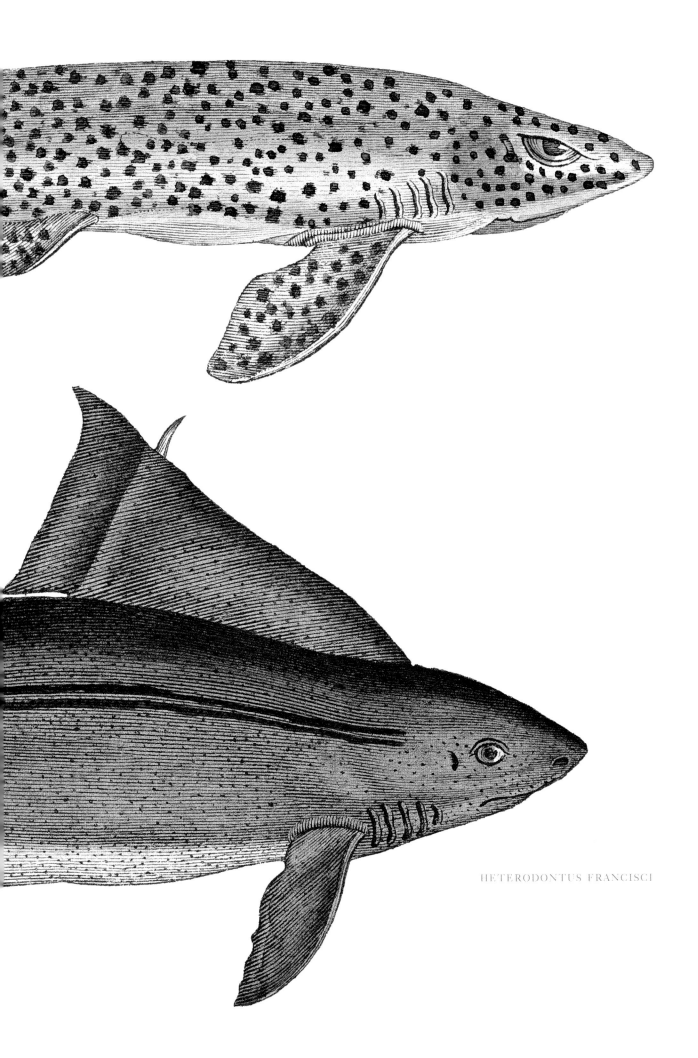

HETERODONTUS FRANCISCI

75

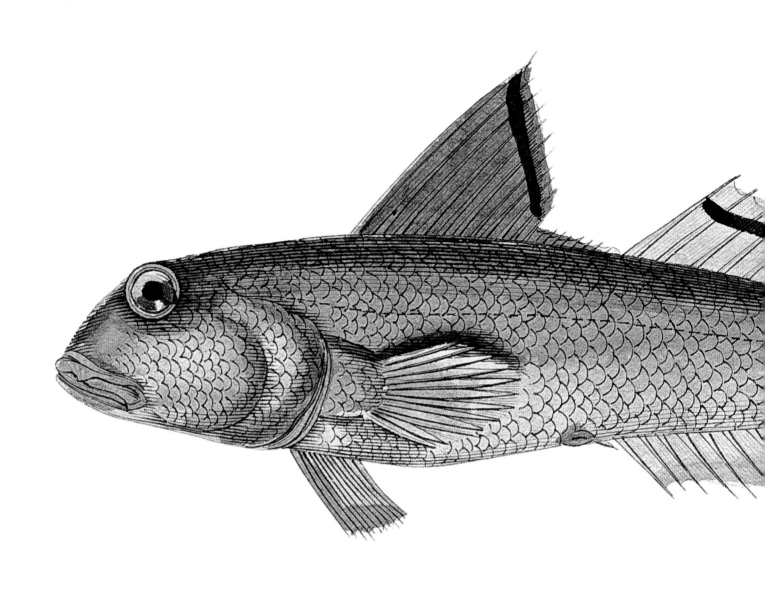

GOBIOIDES BROUSSONNETII

PERIOPHTHALMUS BARBARUS

GOBIUS PLUMIERI

79

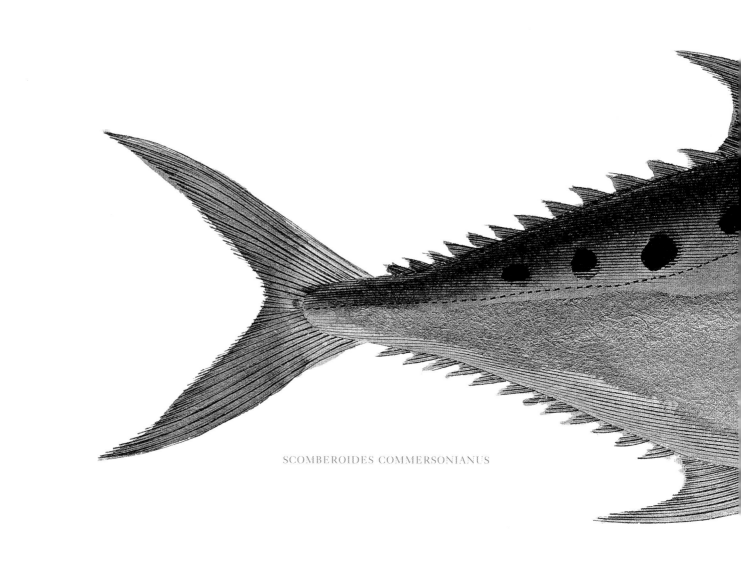

SCOMBEROIDES COMMERSONIANUS

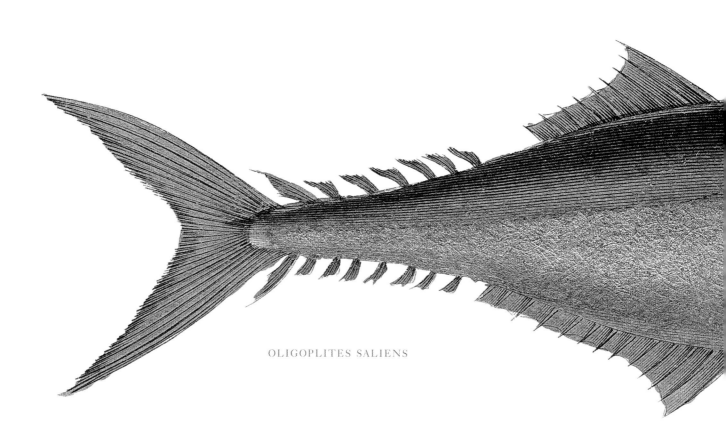

OLIGOPLITES SALIENS

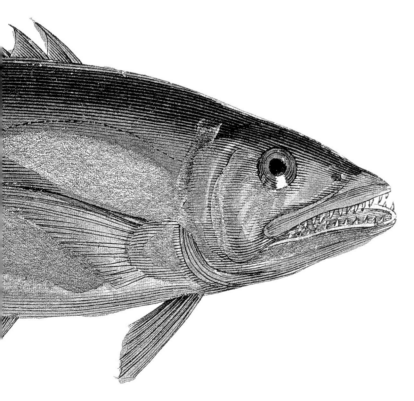

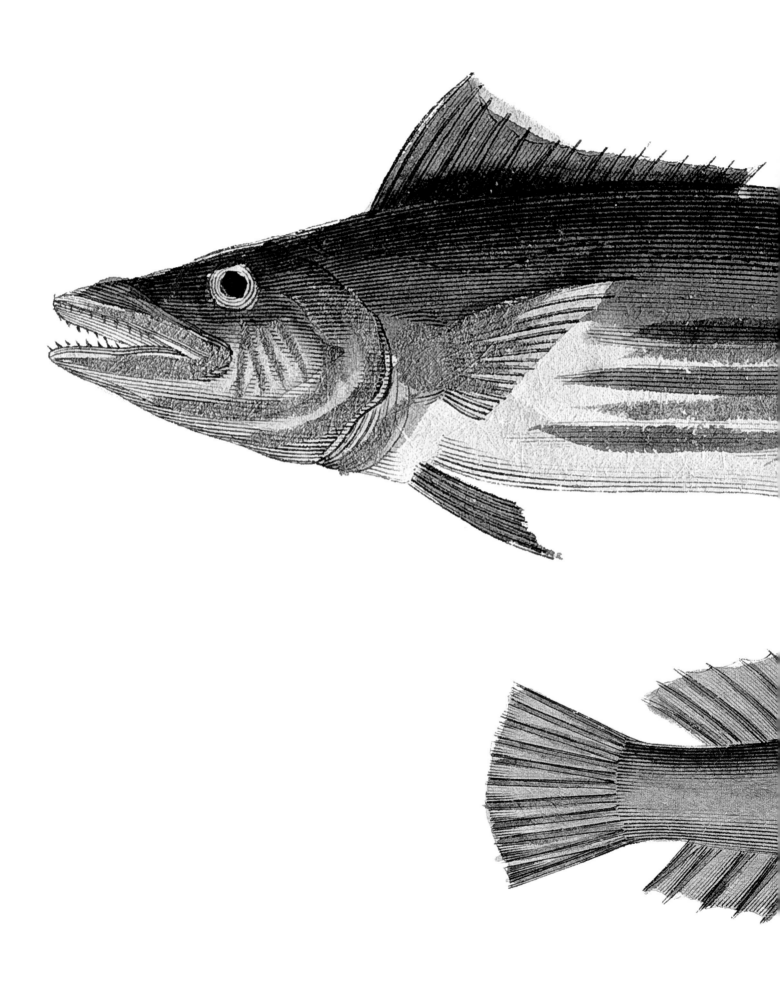

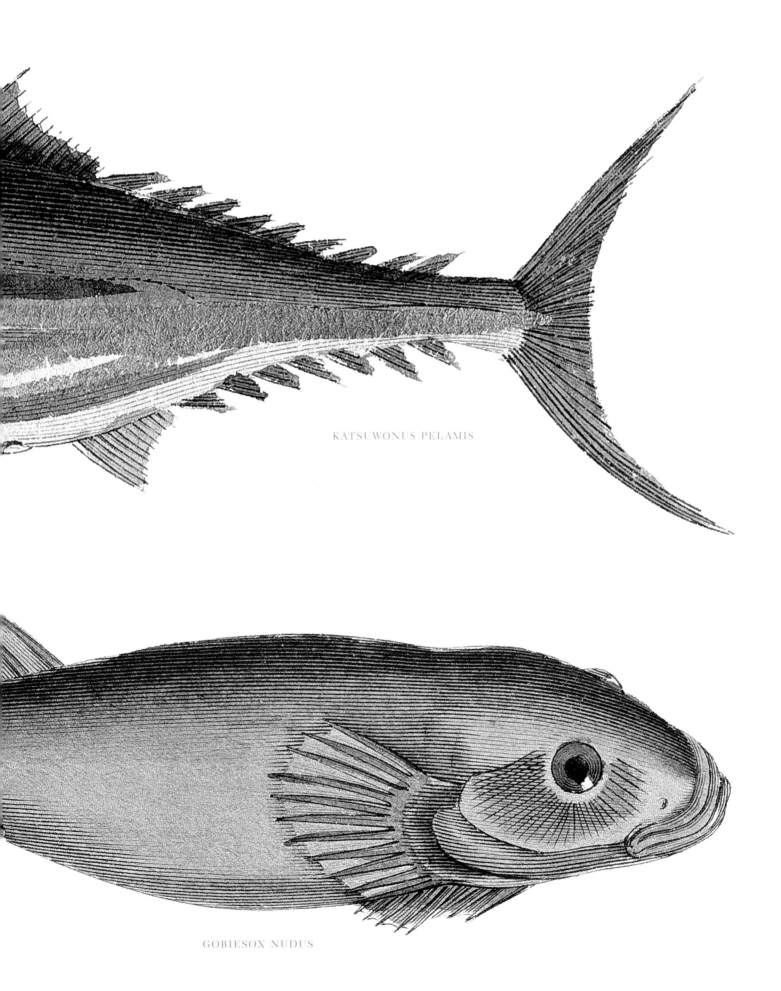

KATSUWONUS PELAMIS

GOBIESOX NUDUS

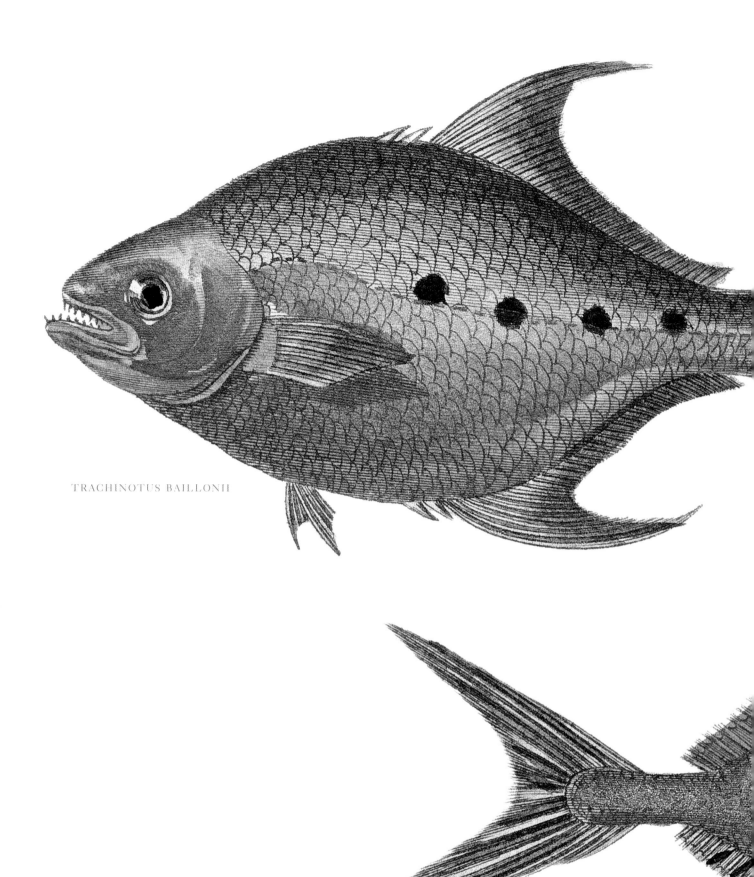

TRACHINOTUS BAILLONII

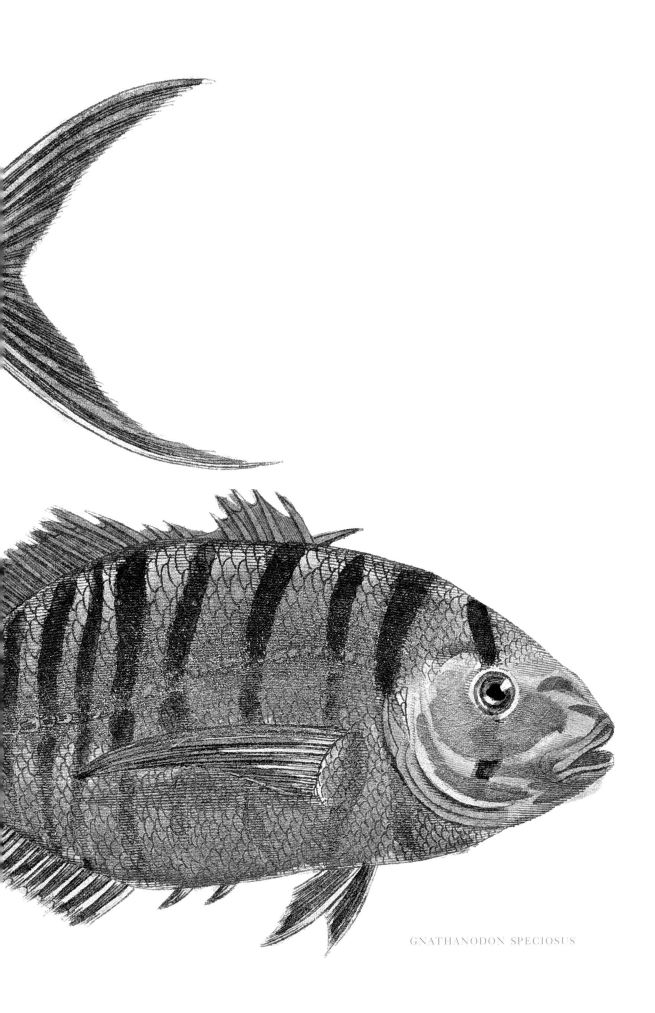

GNATHANODON SPECIOSUS

85

TRACHINOTUS BLOCHII

86

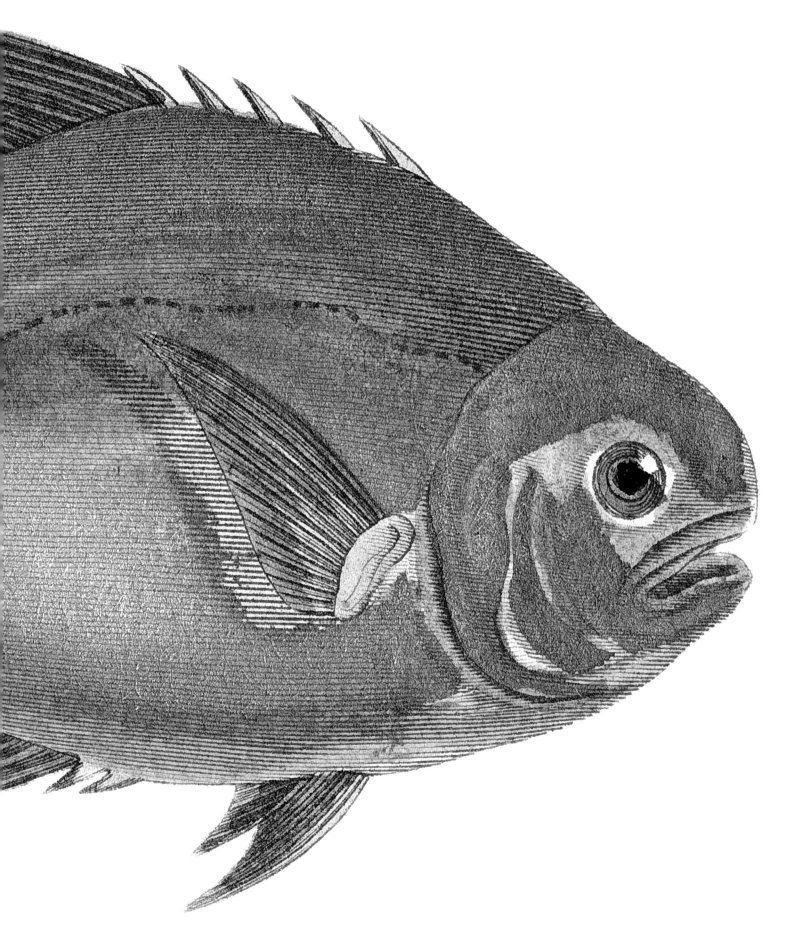

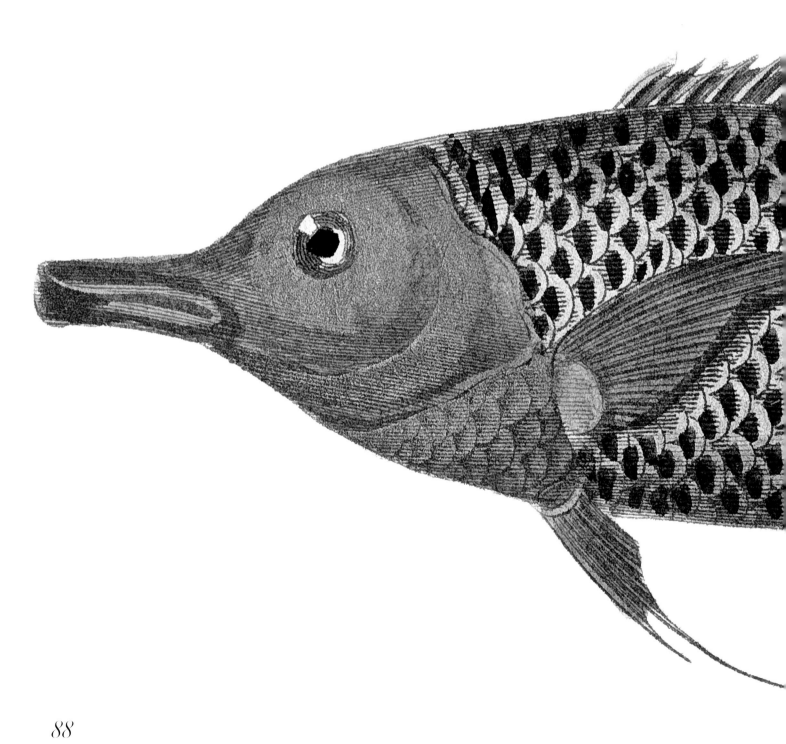

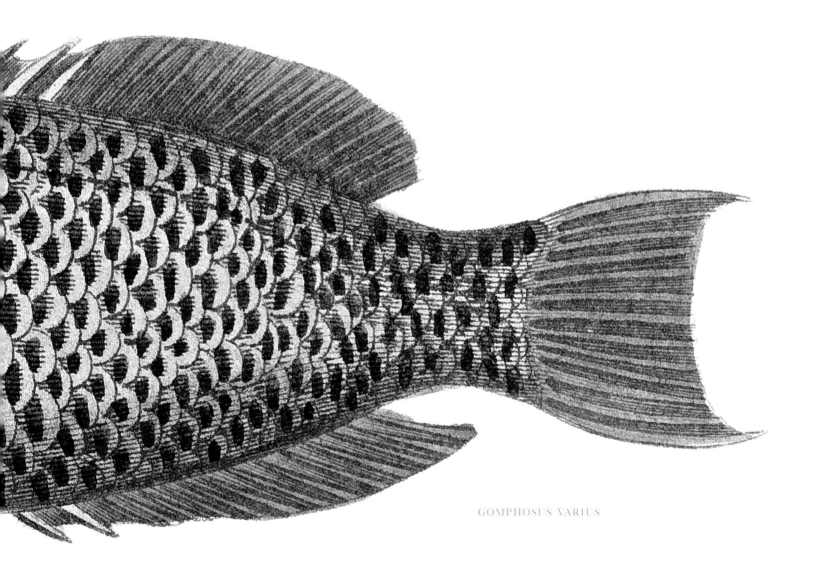

GOMPHOSUS VARIUS

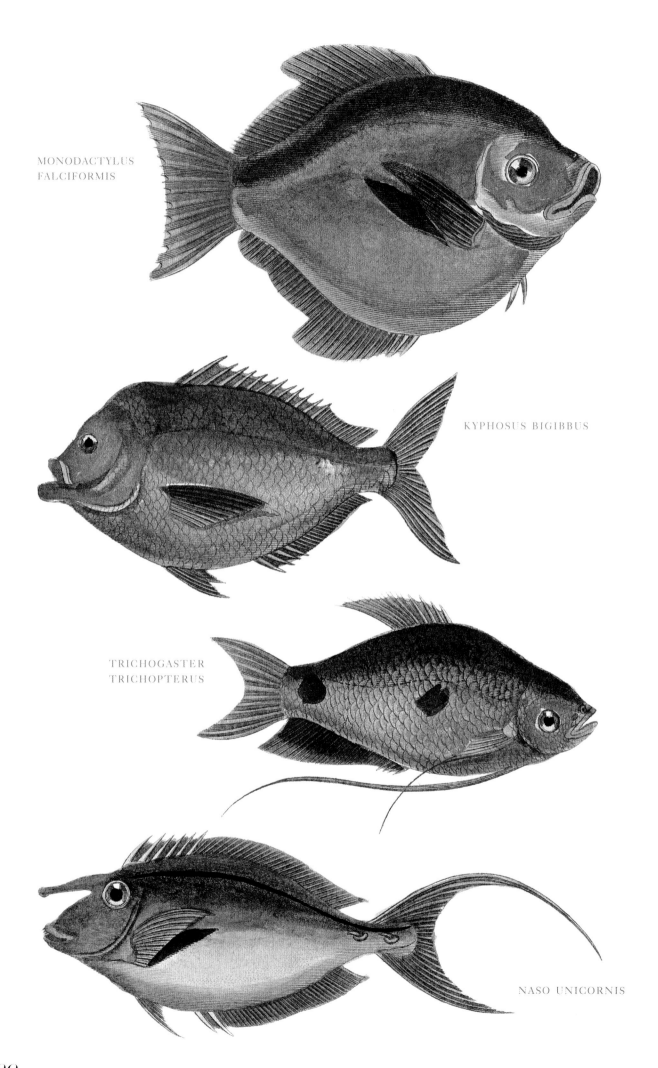

MONODACTYLUS
FALCIFORMIS

KYPHOSUS BIGIBBUS

TRICHOGASTER
TRICHOPTERUS

NASO UNICORNIS

" Ocean: A body of water occupying about two-thirds of a world made for man—who has no gills. **"**

AMBROSE BIERCE

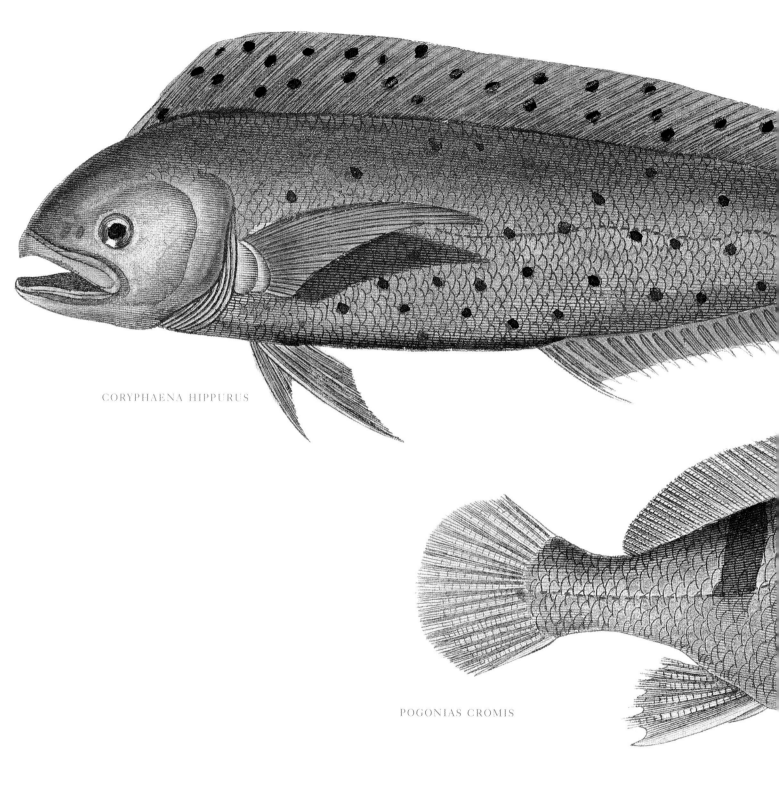

CORYPHAENA HIPPURUS

POGONIAS CROMIS

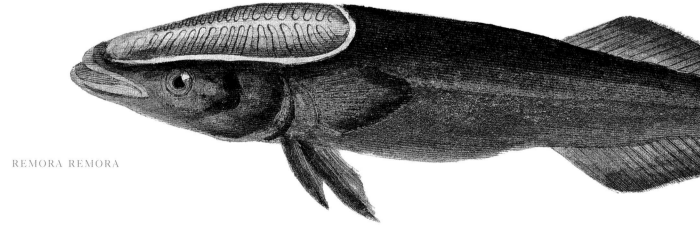

REMORA REMORA

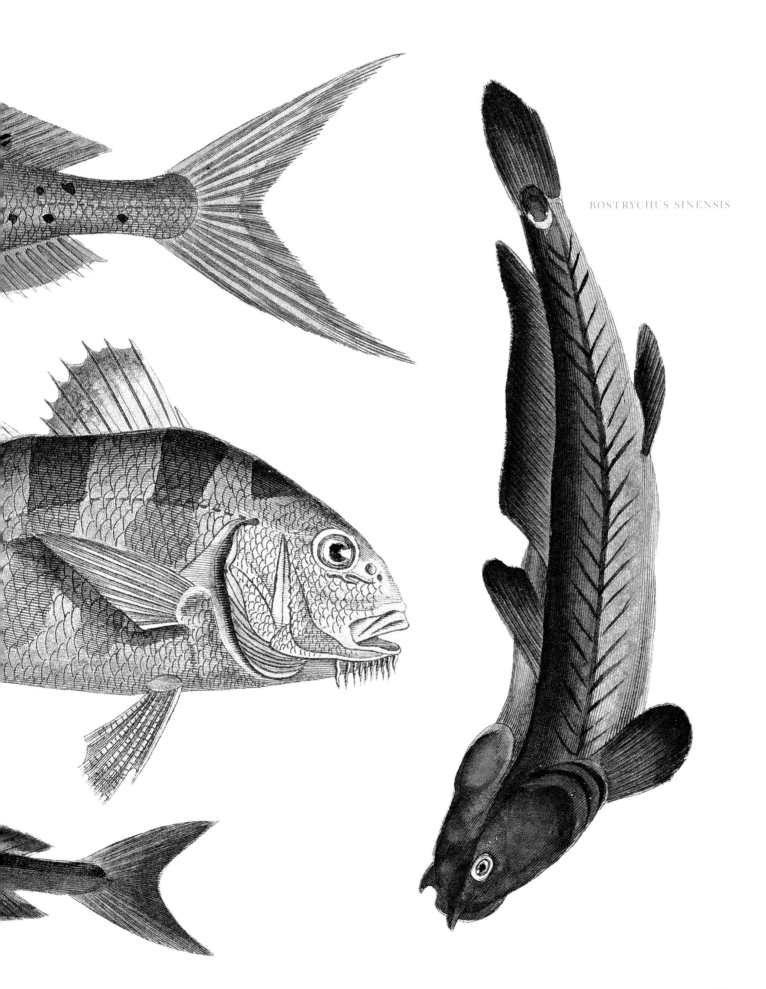

BOSTRYCHUS SINENSIS

" Study nature, love nature, stay close to nature. It will never fail you. "

FRANK LLOYD WRIGHT

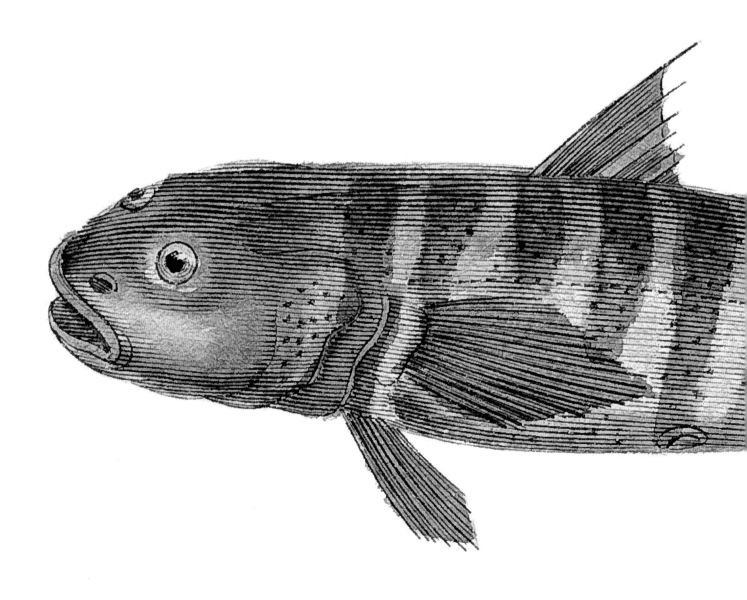

GOBIOSOMA BOSC

95

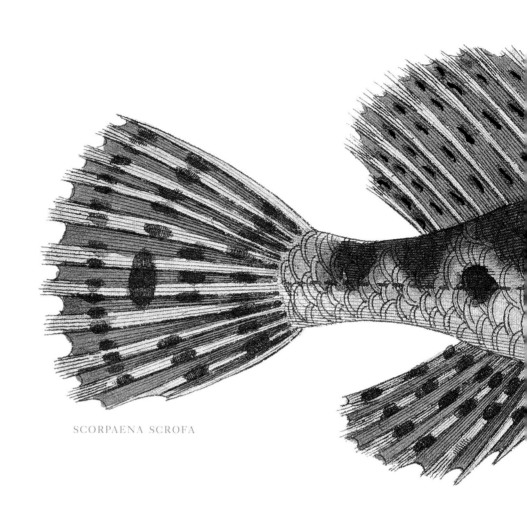

SCORPAENA SCROFA

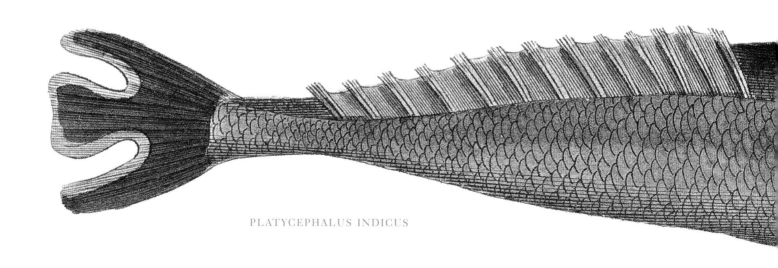

PLATYCEPHALUS INDICUS

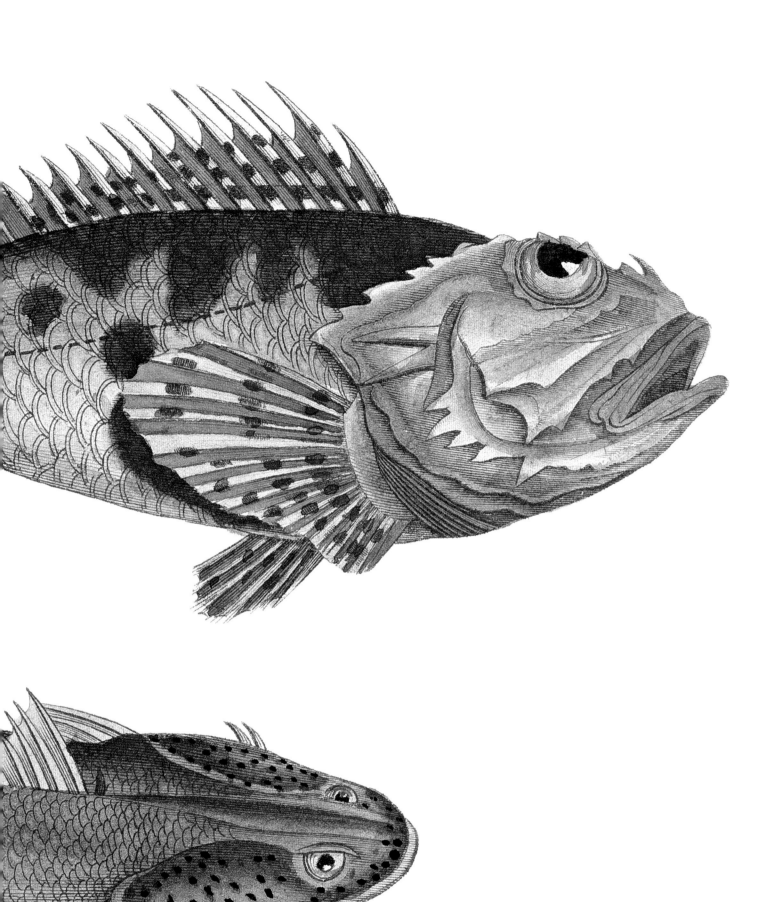

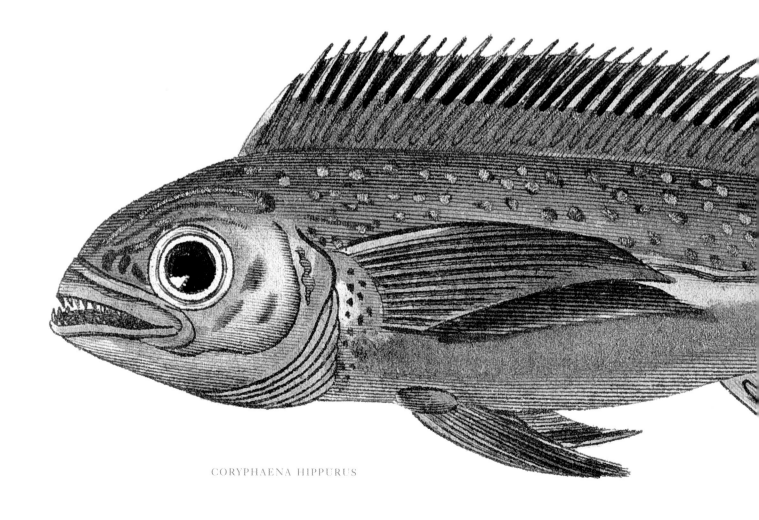

CORYPHAENA HIPPURUS

"The happiness of the bee and the dolphin is to exist. For man it is to know that and to wonder at it."

JACQUES YVES COUSTEAU

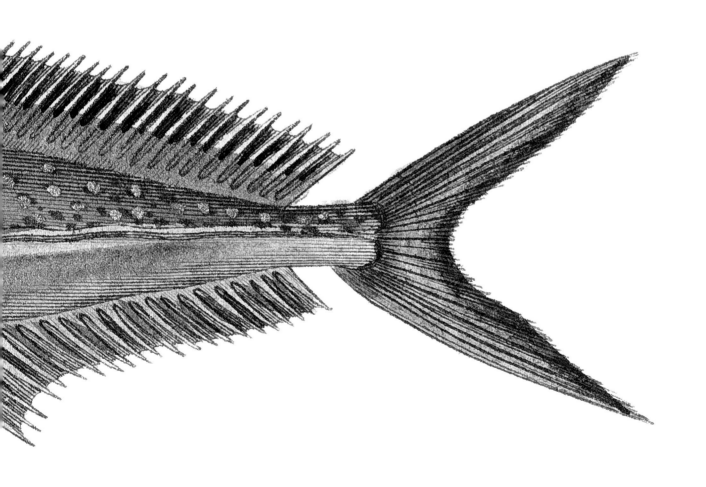

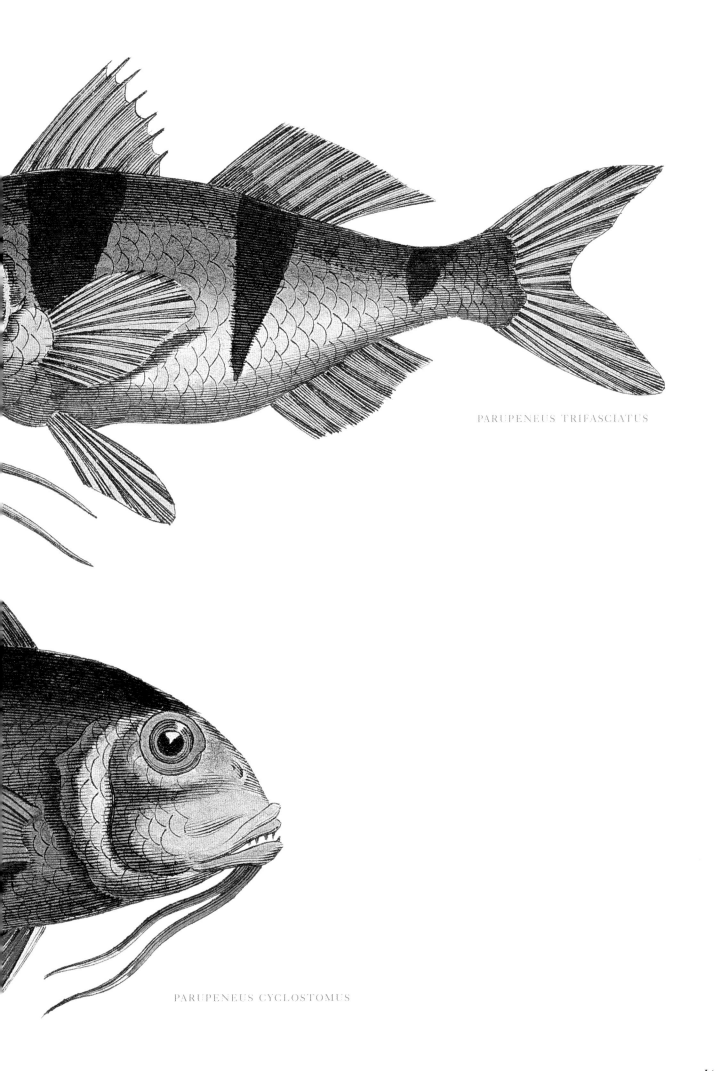

PARUPENEUS TRIFASCIATUS

PARUPENEUS CYCLOSTOMUS

> **What I see in Nature is a magnificent structure that we can comprehend only very imperfectly, and that must fill a thinking person with a feeling of humility. This is a genuinely religious feeling that has nothing to do with mysticism.**

ALBERT EINSTEIN

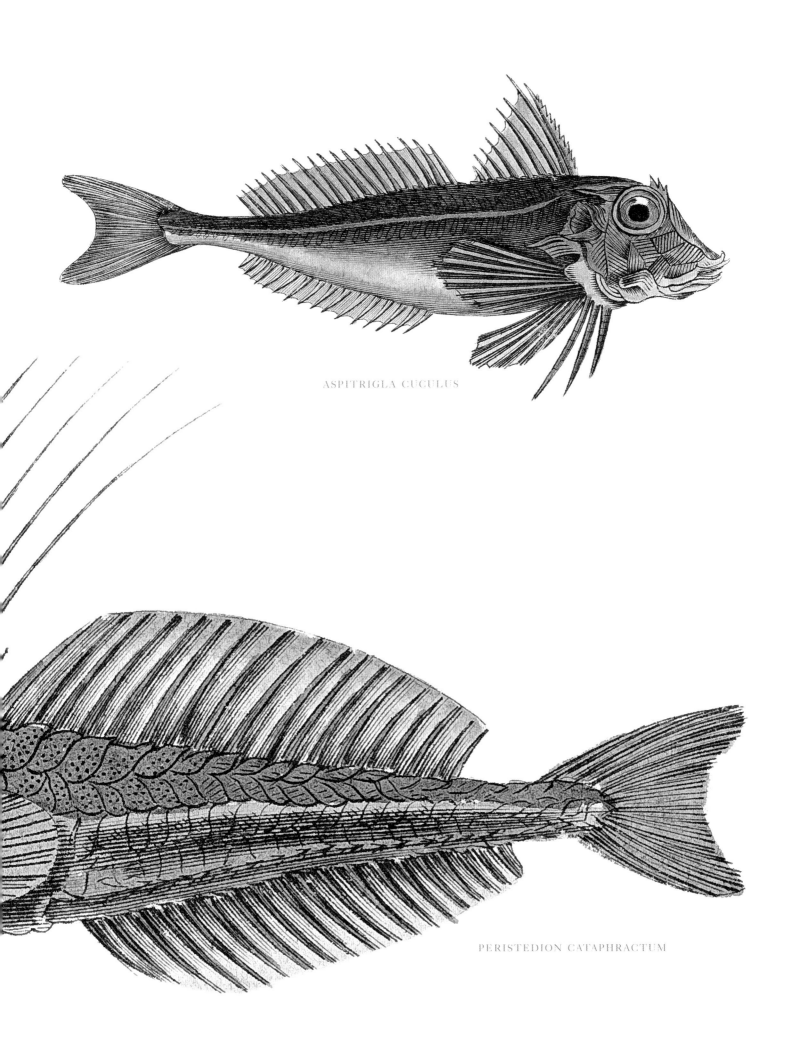

ASPITRIGLA CUCULUS

PERISTEDION CATAPHRACTUM

"I believe in God, only I spell it Nature."

FRANK LLOYD WRIGHT

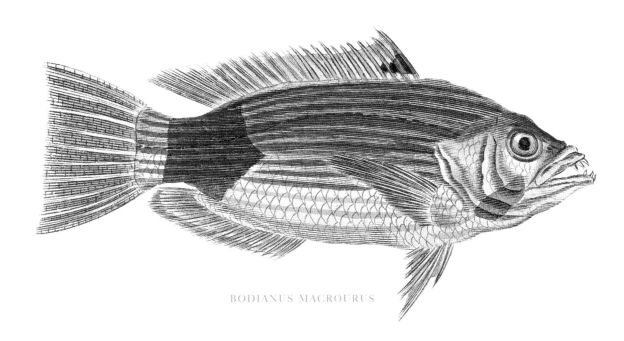

BODIANUS MACROURUS

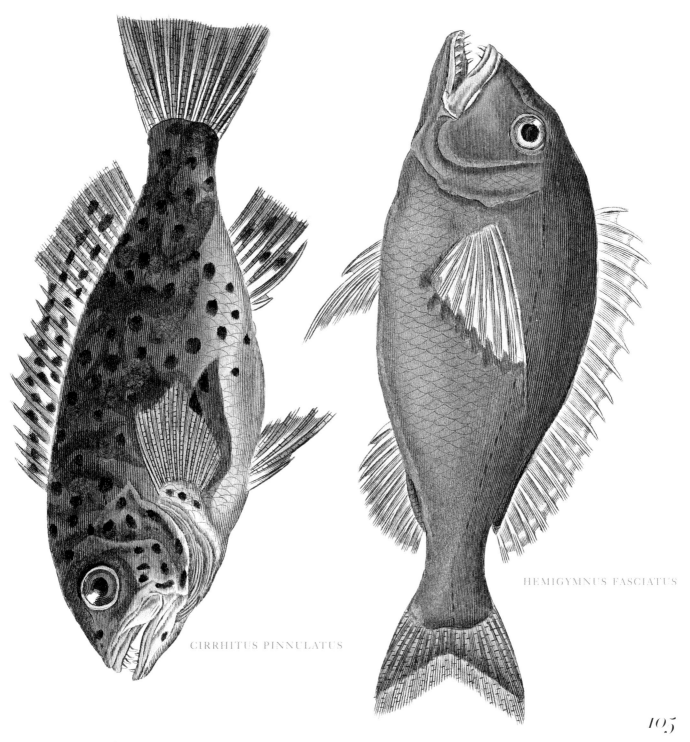

CIRRHITUS PINNULATUS

HEMIGYMNUS FASCIATUS

105

"No human being, however great, or powerful, was ever so free as a fish."

JOHN RUSKIN, *The Two Paths*

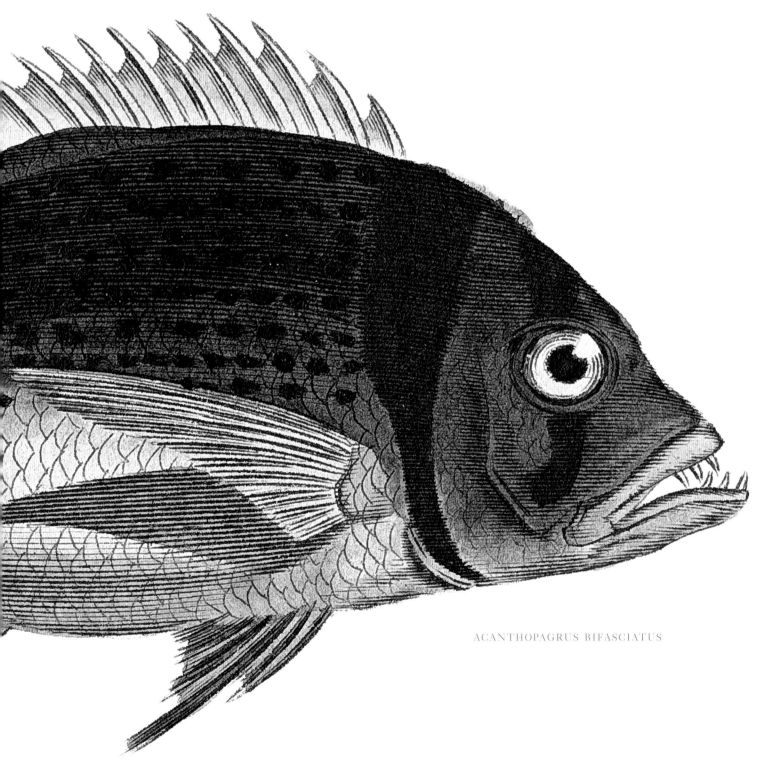

ACANTHOPAGRUS BIFASCIATUS

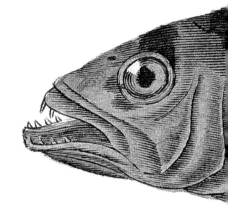

66 Many men go fishing all of their lives without knowing it is not the fish they are after. 99

HENRY DAVID THOREAU

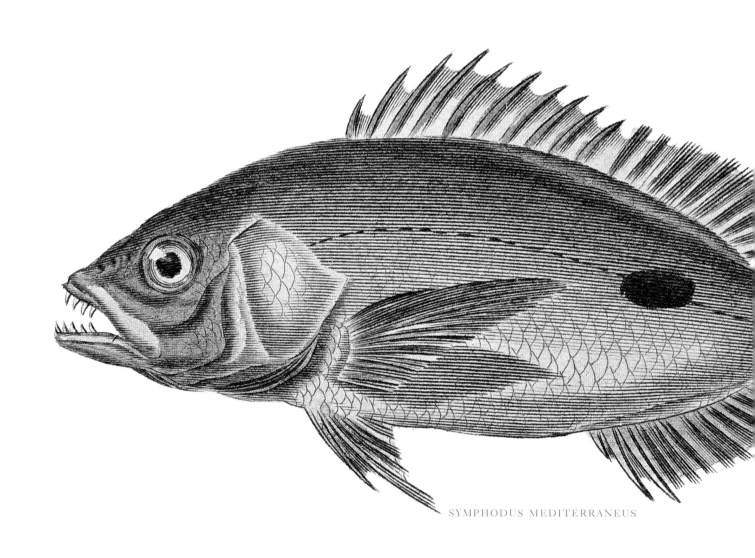

SYMPHODUS MEDITERRANEUS

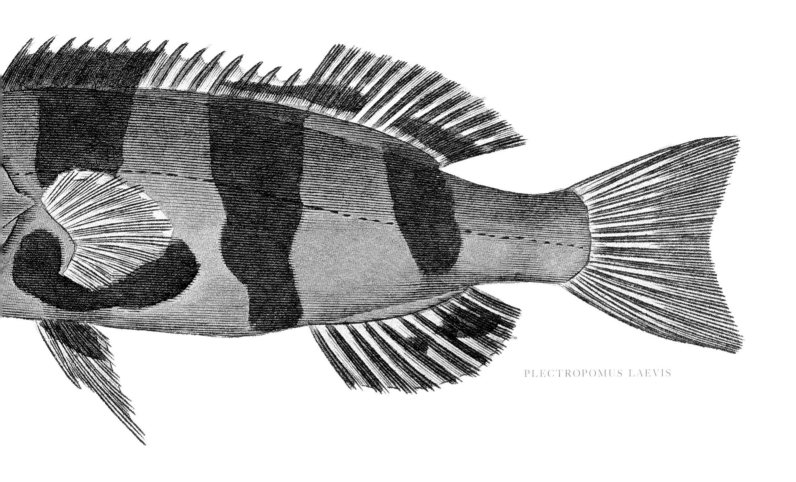

PLECTROPOMUS LAEVIS

"Each animal,
By natural instinct taught, spares his own kind;
But man, the tyrant man! revels at large,
Free-booter unrestain'd, destroys at will
The whole creation, men and beasts his prey,
These for his pleasure, for his glory those."

WILLIAM SOMERVILLE, *Field Sports*

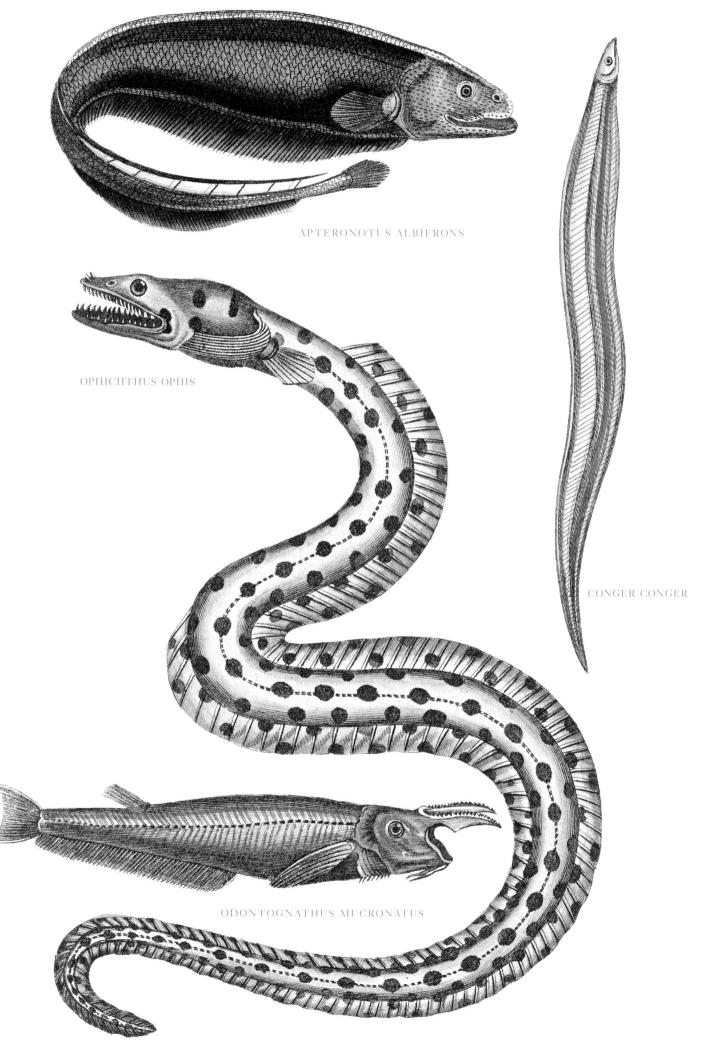

APTERONOTUS ALBIFRONS

OPHICHTHUS OPHIS

CONGER CONGER

ODONTOGNATHUS MUCRONATUS

III

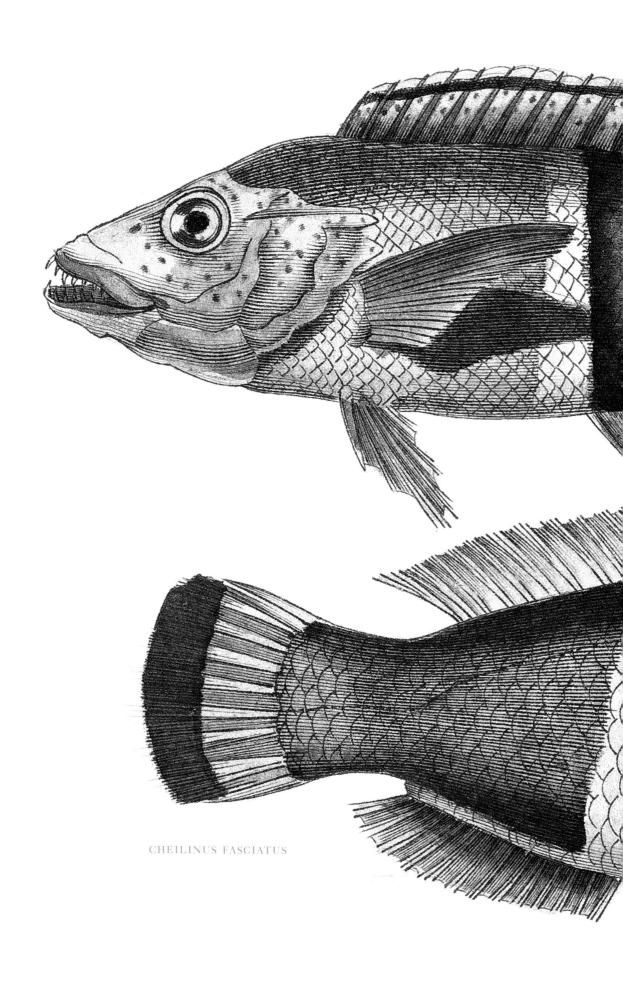

CHEILINUS FASCIATUS

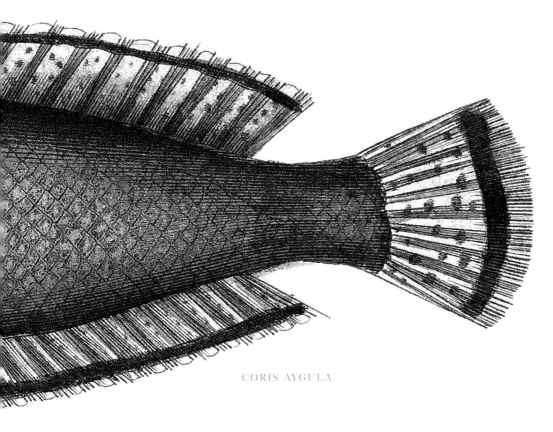

CORIS AYGULA

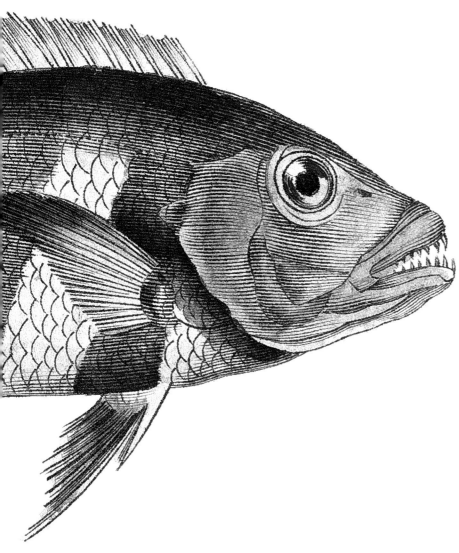

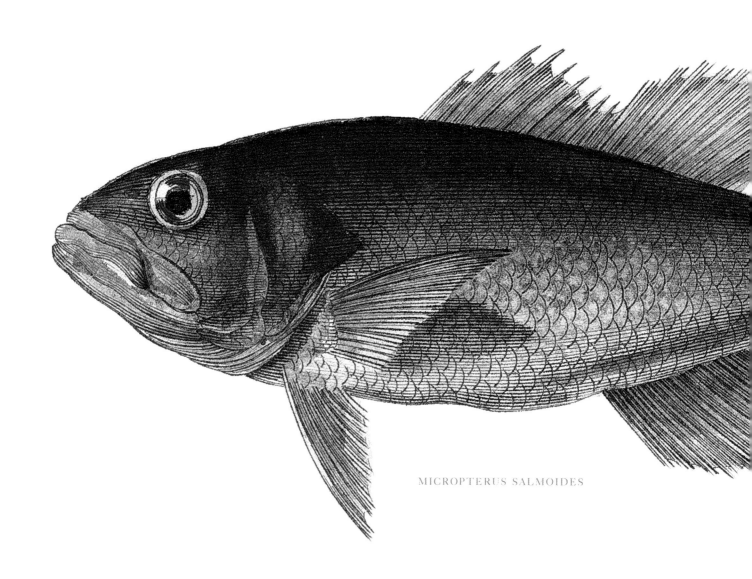

MICROPTERUS SALMOIDES

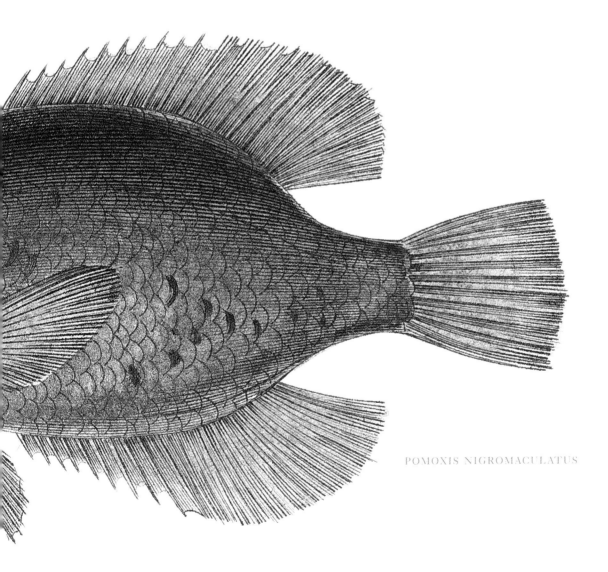

POMOXIS NIGROMACULATUS

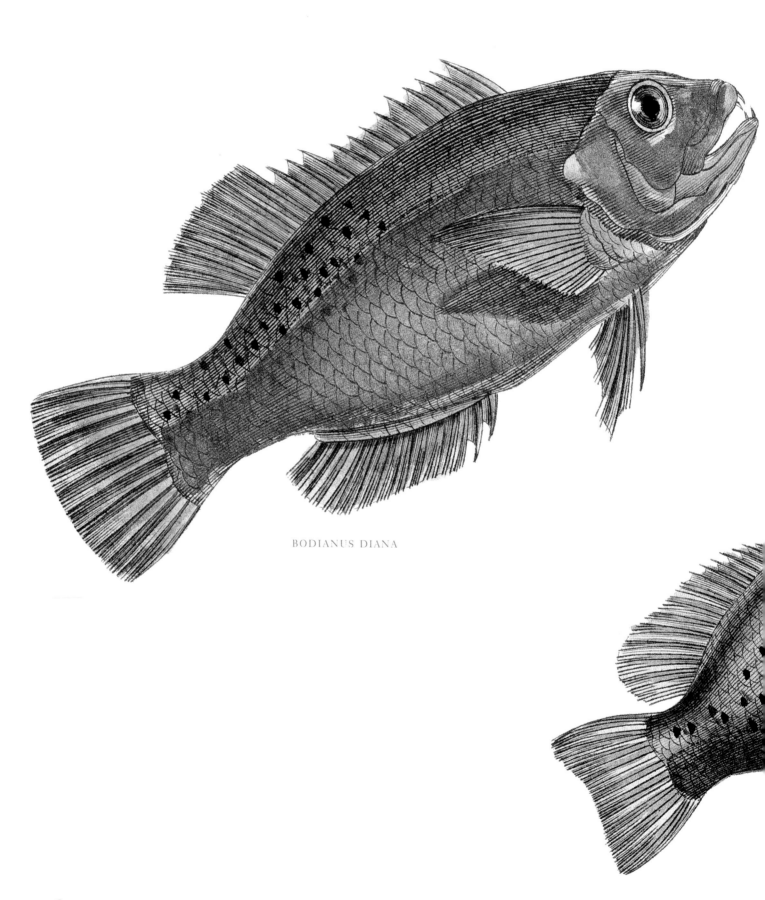

BODIANUS DIANA

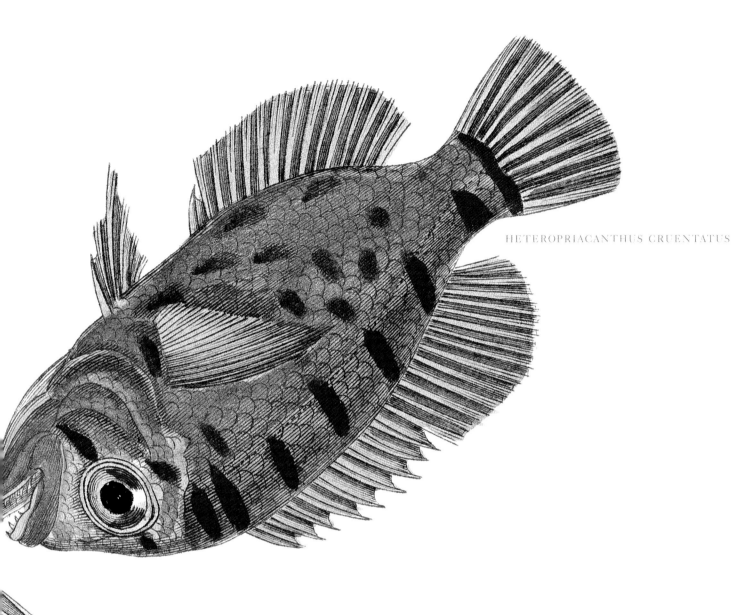

HETEROPRIACANTHUS CRUENTATUS

CENTRARCHUS MACROPTERUS

117

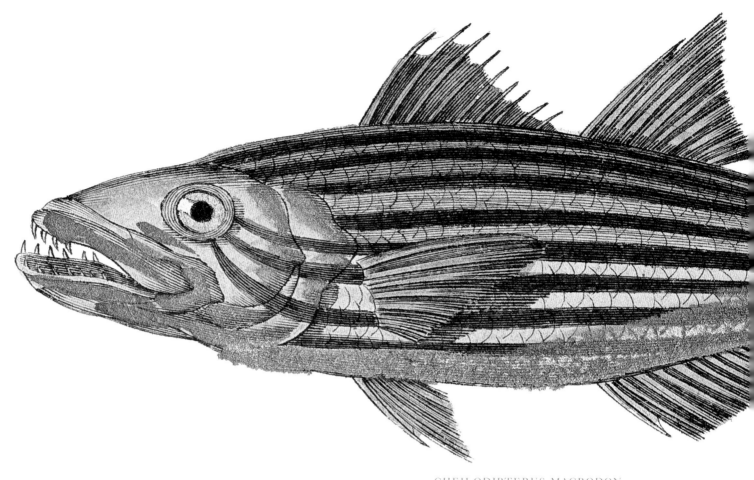

CHEILODIPTERUS MACRODON

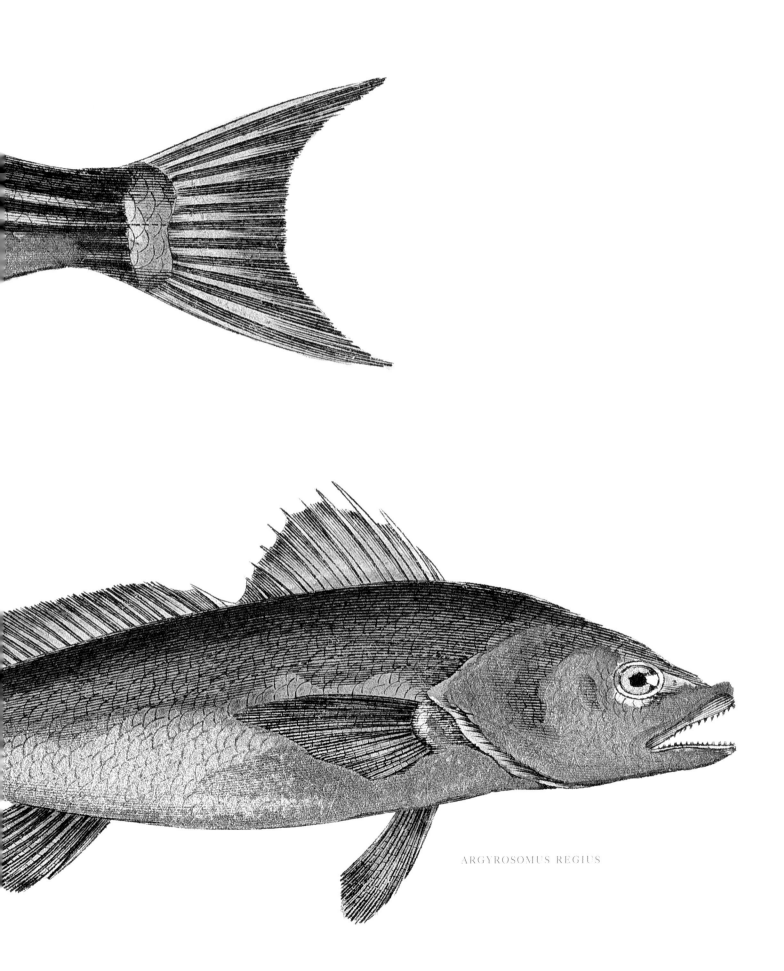

ARGYROSOMUS REGIUS

119

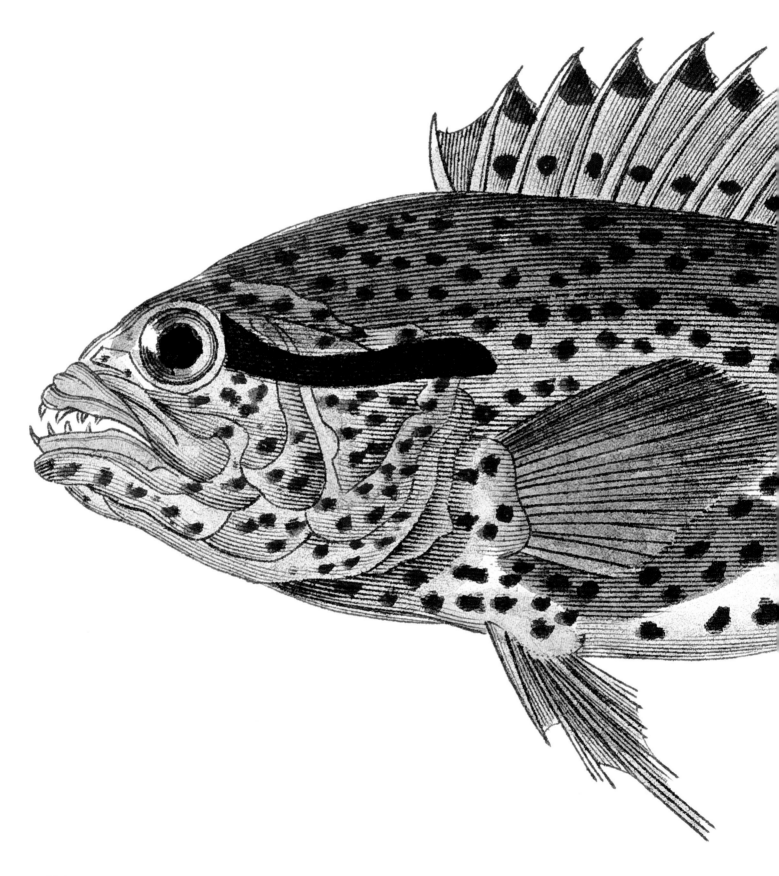

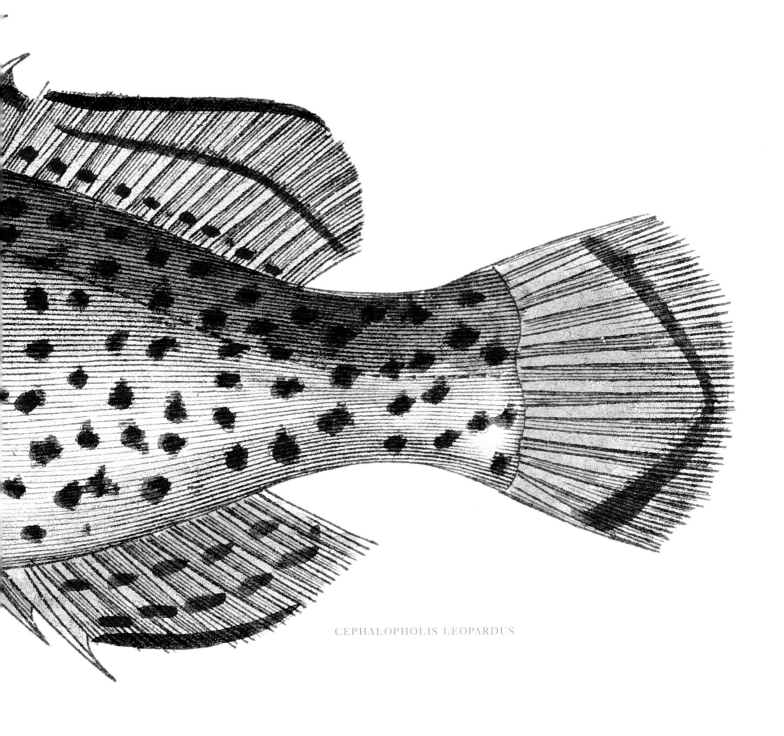

CEPHALOPHOLIS LEOPARDUS

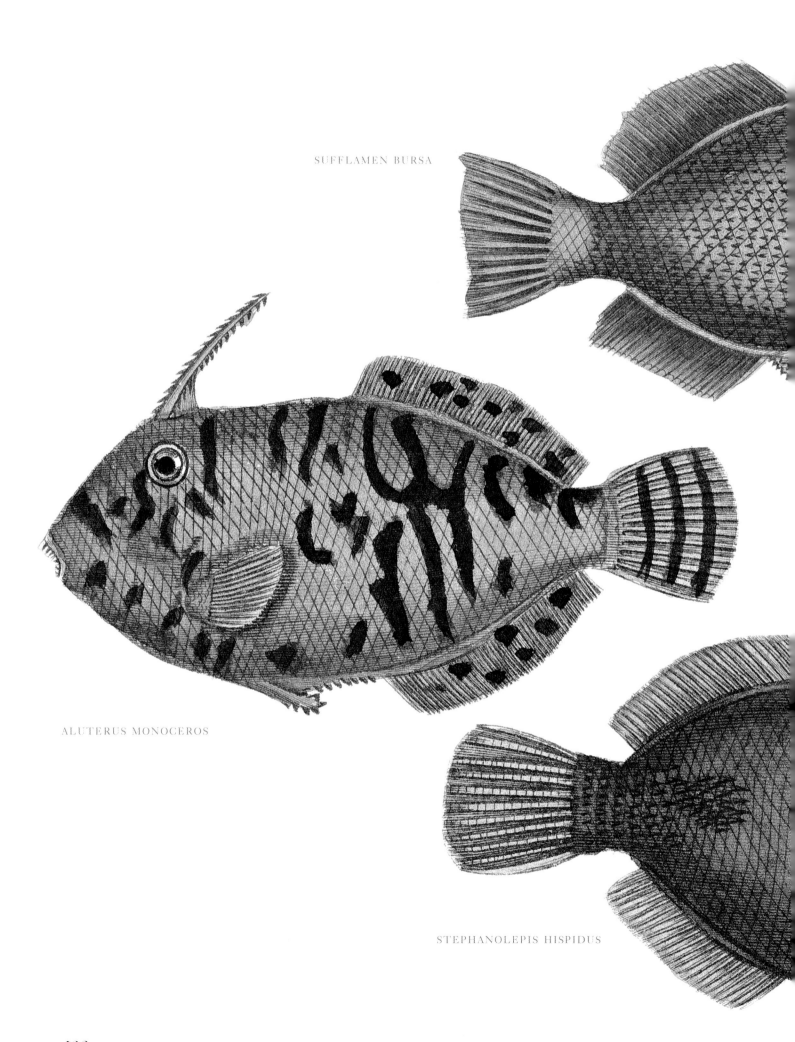

SUFFLAMEN BURSA

ALUTERUS MONOCEROS

STEPHANOLEPIS HISPIDUS

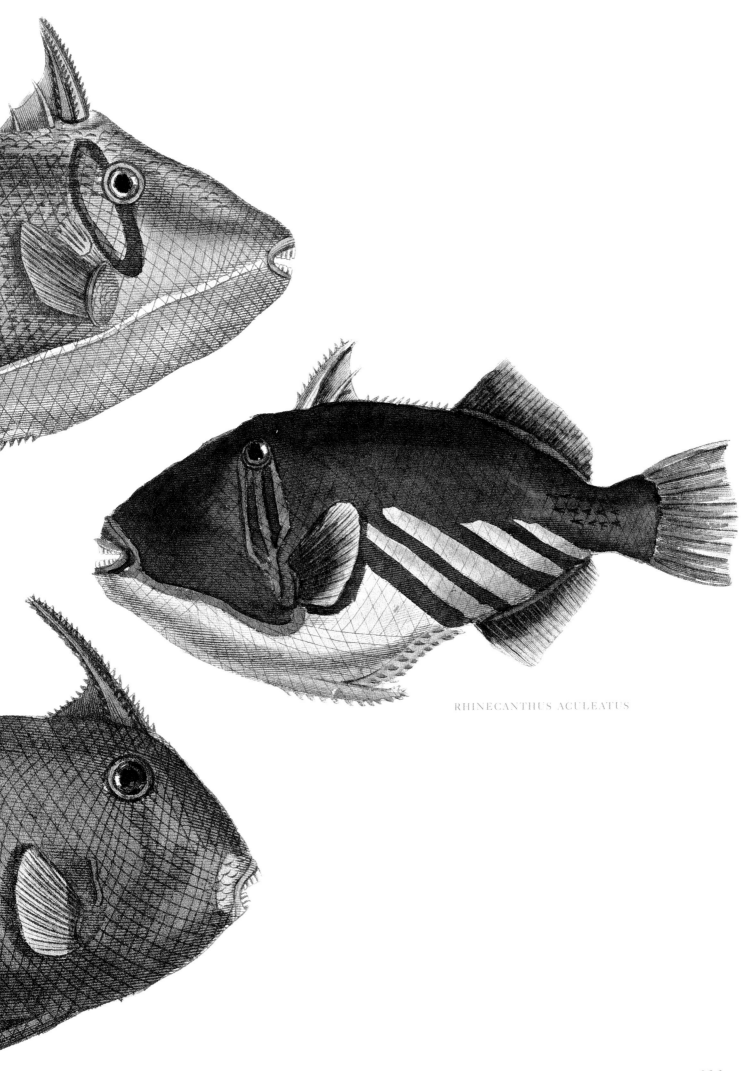

RHINECANTHUS ACULEATUS

123

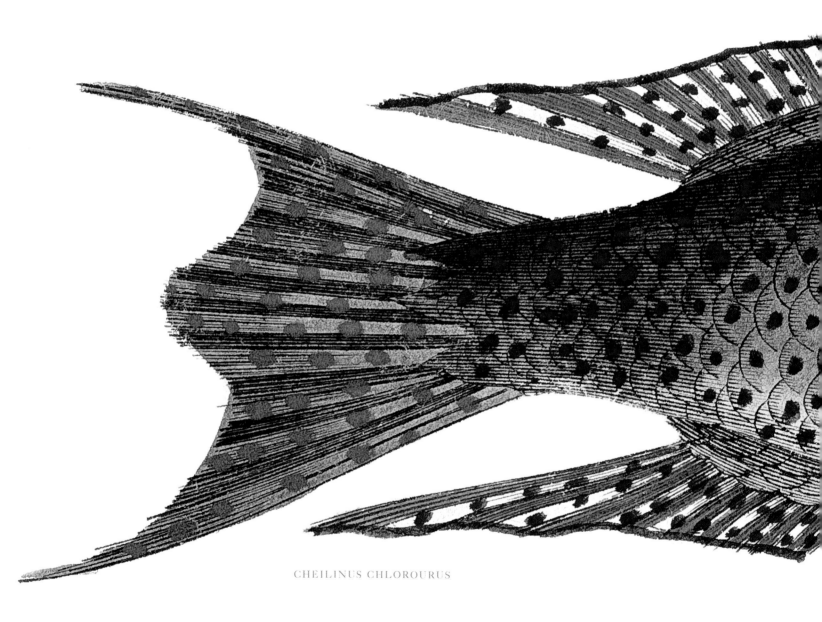

CHEILINUS CHLOROURUS

124

" Only within the moment of time represented by the present century has one species—man—acquired significant power to alter the nature of his world. "

RACHEL CARSON

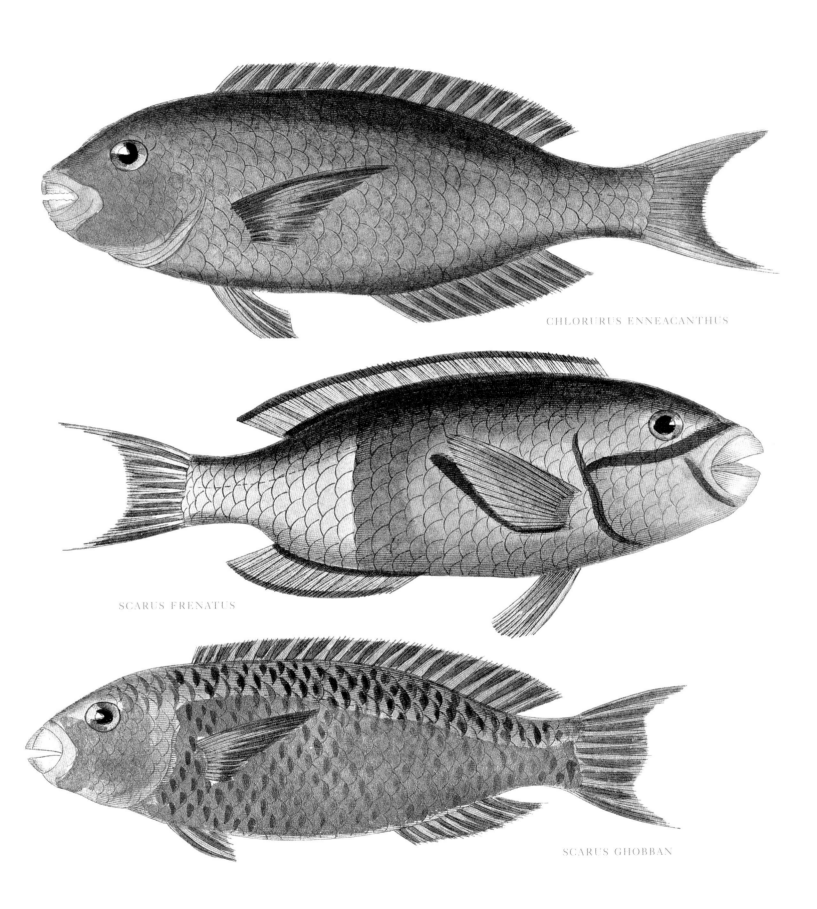

CHLORURUS ENNEACANTHUS

SCARUS FRENATUS

SCARUS GHOBBAN

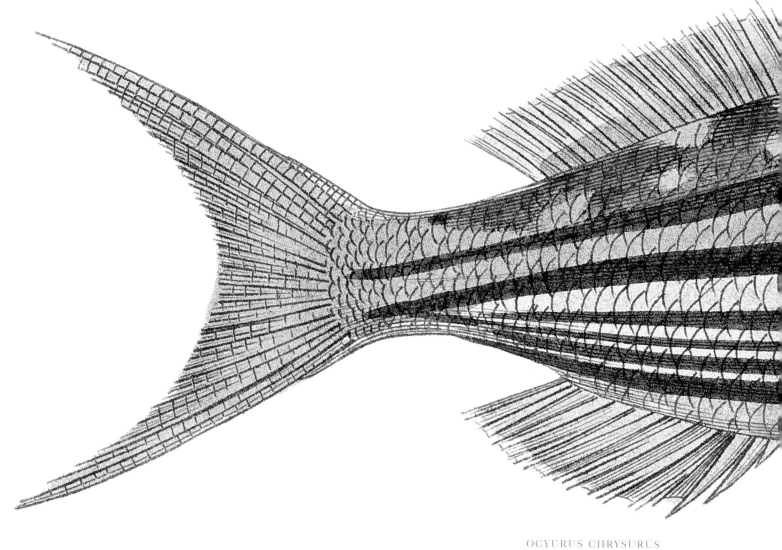

OCYURUS CHRYSURUS

128

" I gave up fishing the day
I realized that when you catch them, fish
don't actually wriggle with joy. "

LOUIS DE FUNÈS

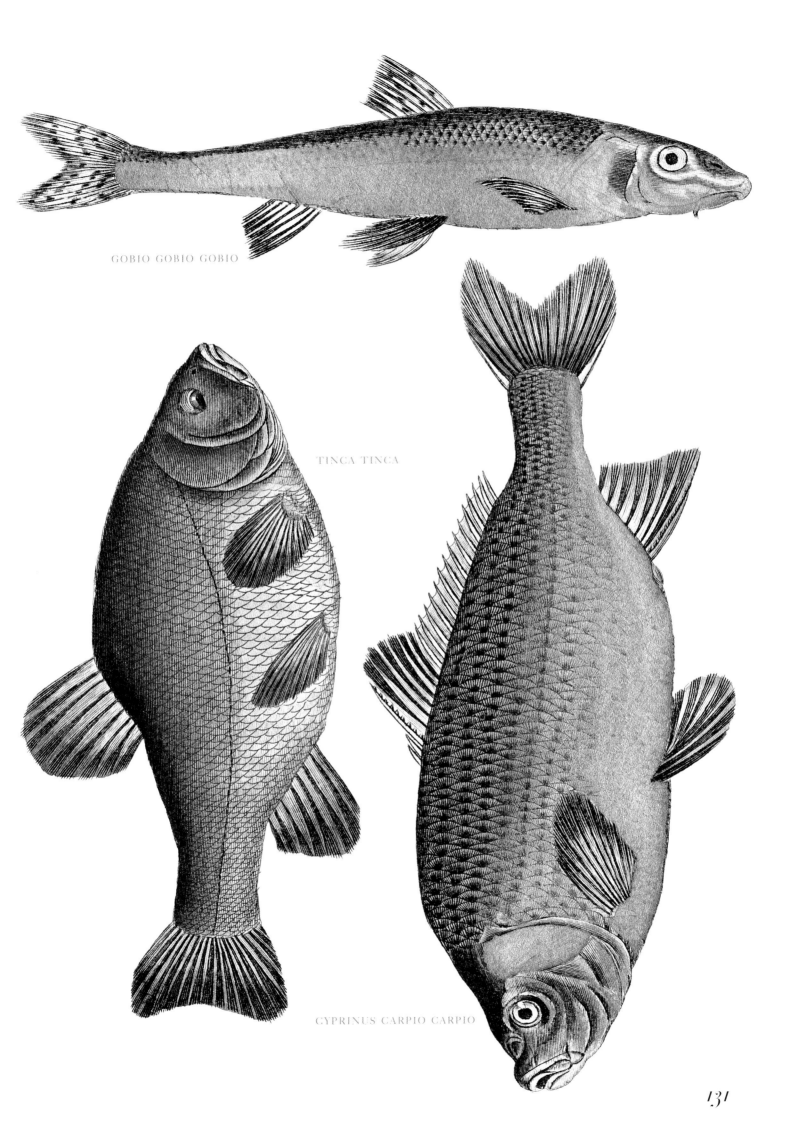

GOBIO GOBIO GOBIO

TINCA TINCA

CYPRINUS CARPIO CARPIO

131

"… these are the times of dreamy quietude, when beholding the tranquil beauty and brilliancy of the ocean's skin, one forgets the tiger heart that pants beneath it; and would not willingly remember, that this velvet paw but conceals a remorseless fang."

HERMAN MELVILLE

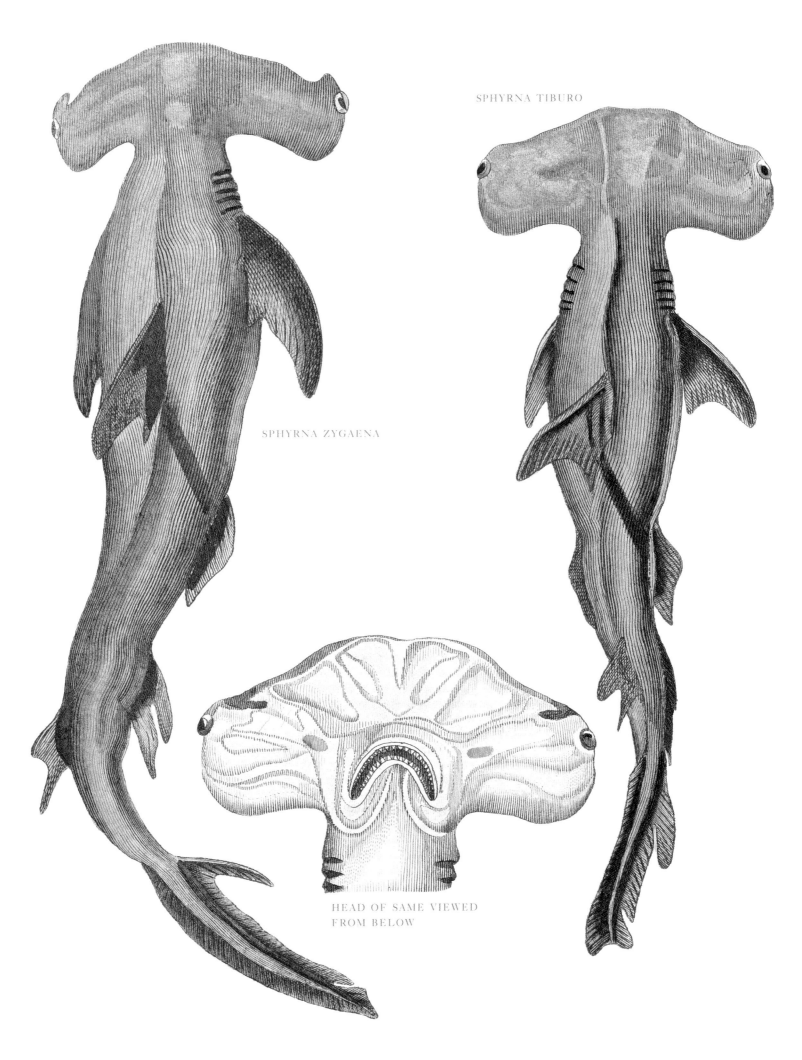

SPHYRNA TIBURO

SPHYRNA ZYGAENA

HEAD OF SAME VIEWED
FROM BELOW

133

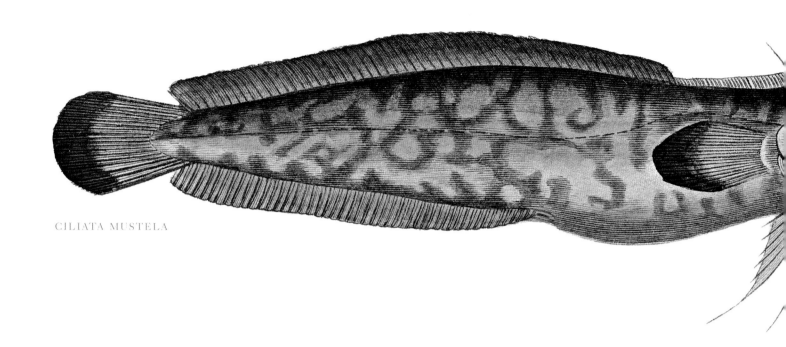

CILIATA MUSTELA

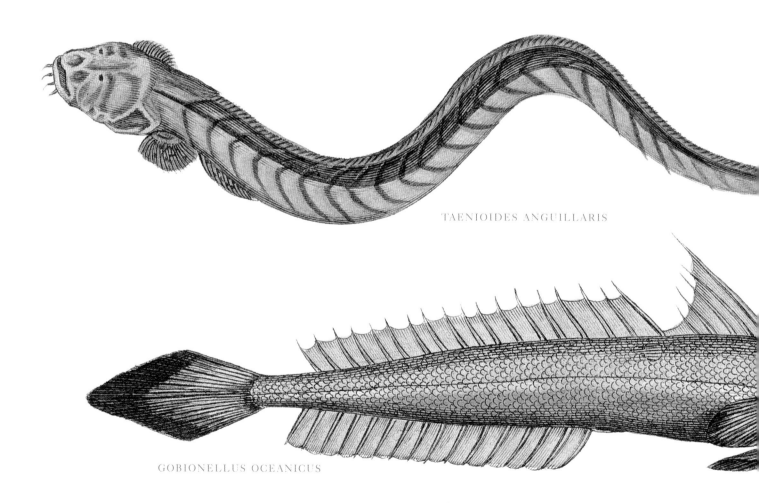

TAENIOIDES ANGUILLARIS

GOBIONELLUS OCEANICUS

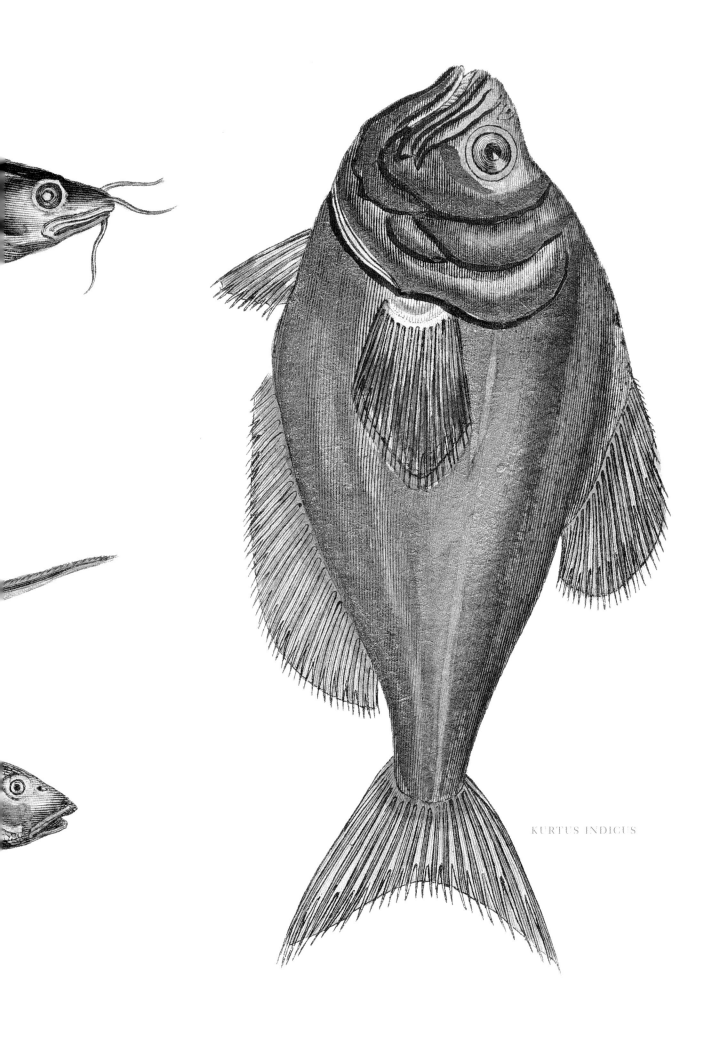

KURTUS INDICUS

135

"I heard the old, old men say,
'All that's beautiful drifts away
Like the waters.'"

WILLIAM BUTLER YEATS,
"The Old Men Admiring Themselves in the Water"

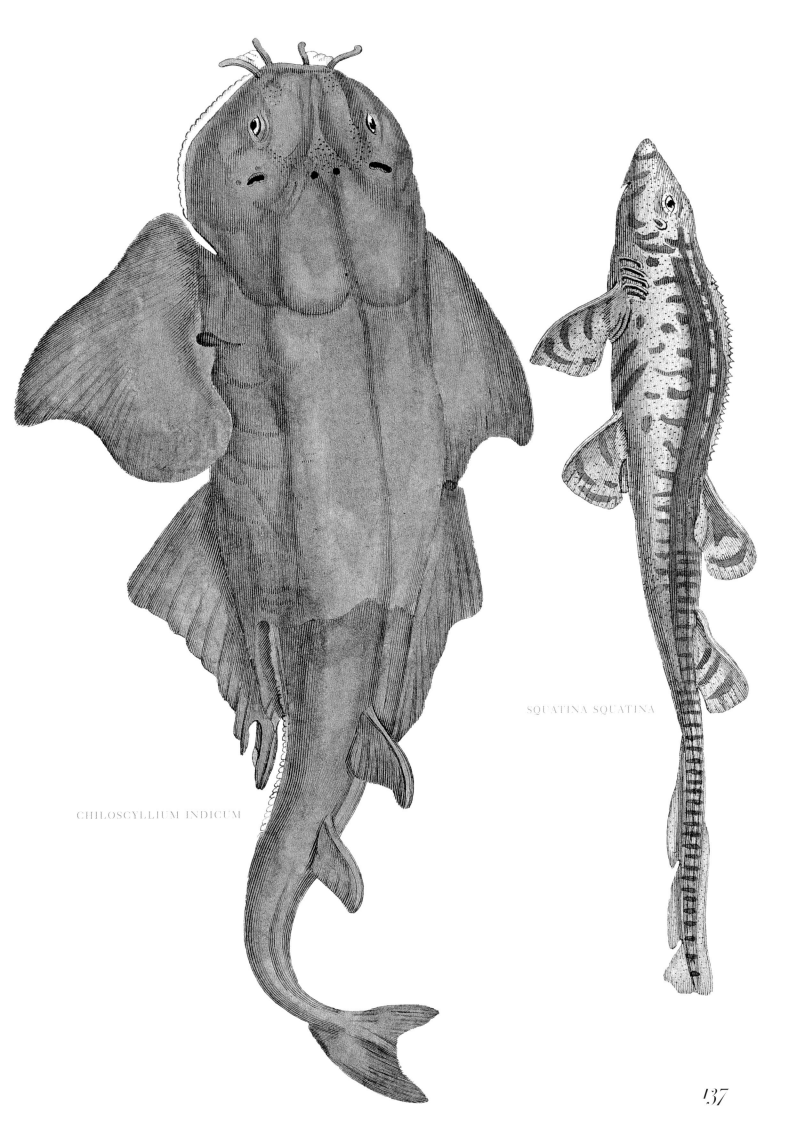

CHILOSCYLLIUM INDICUM

SQUATINA SQUATINA

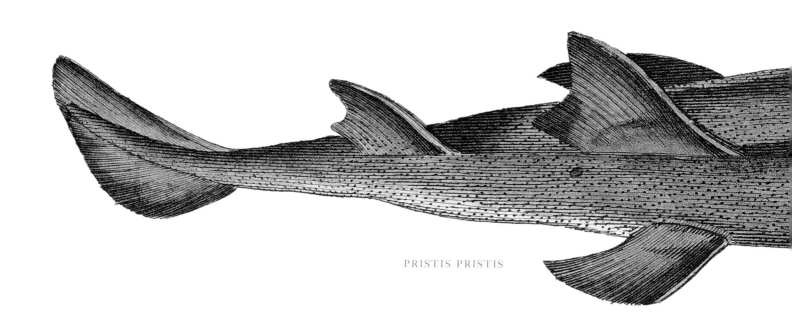

PRISTIS PRISTIS

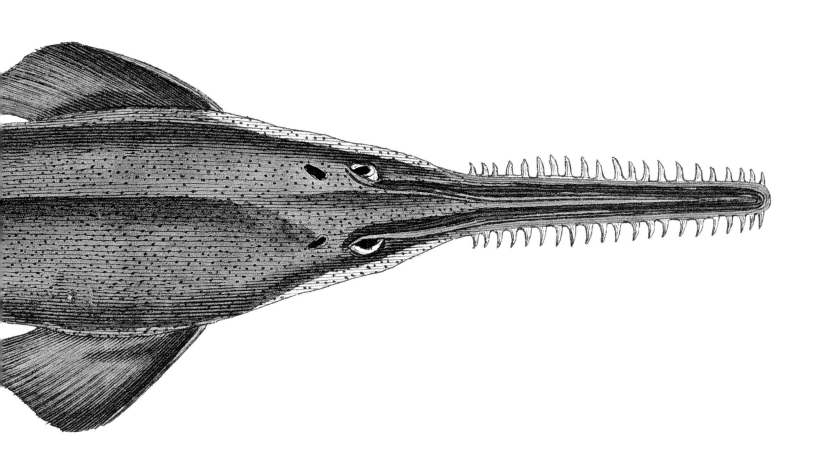

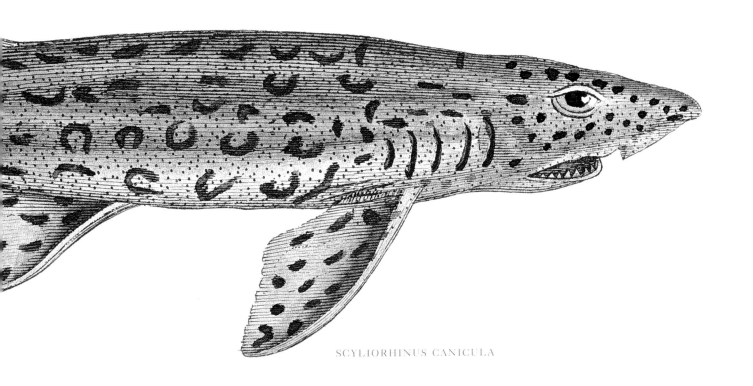

SCYLIORHINUS CANICULA

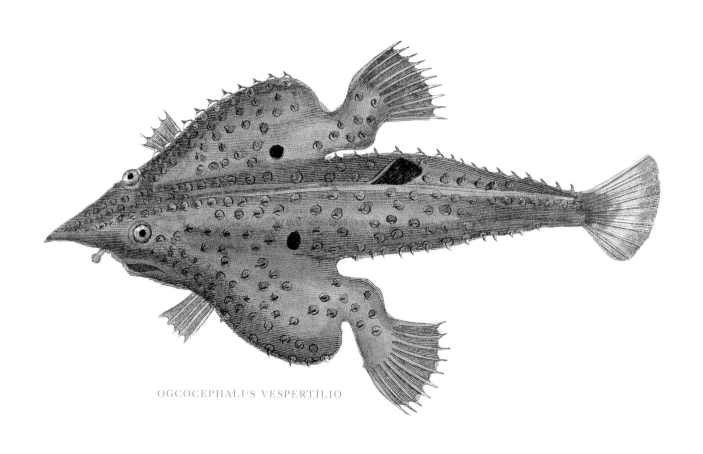

OGCOCEPHALUS VESPERTILIO

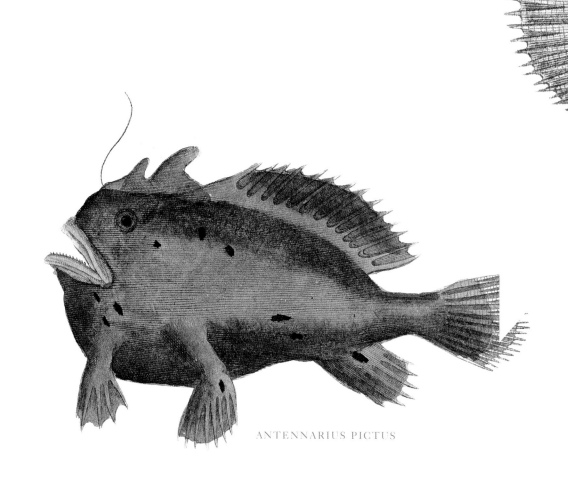

ANTENNARIUS PICTUS

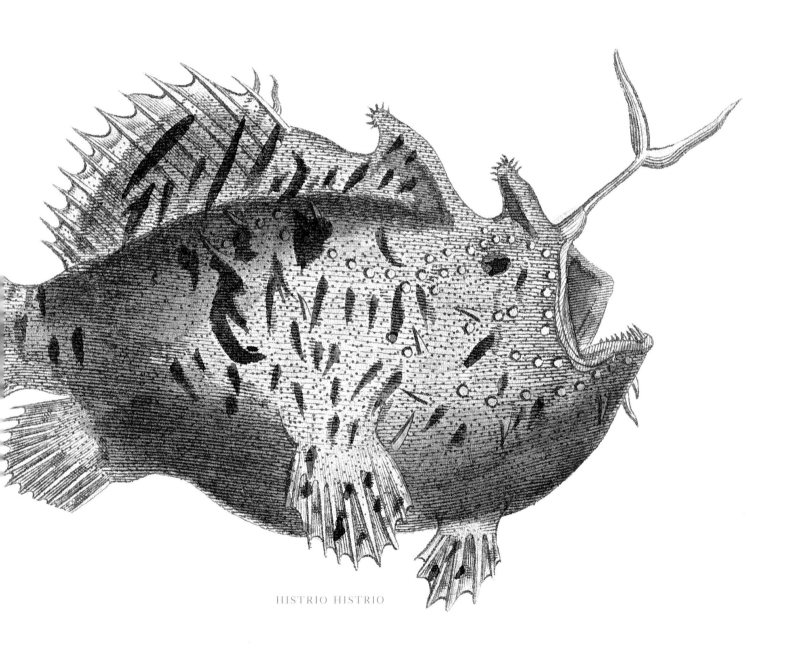

HISTRIO HISTRIO

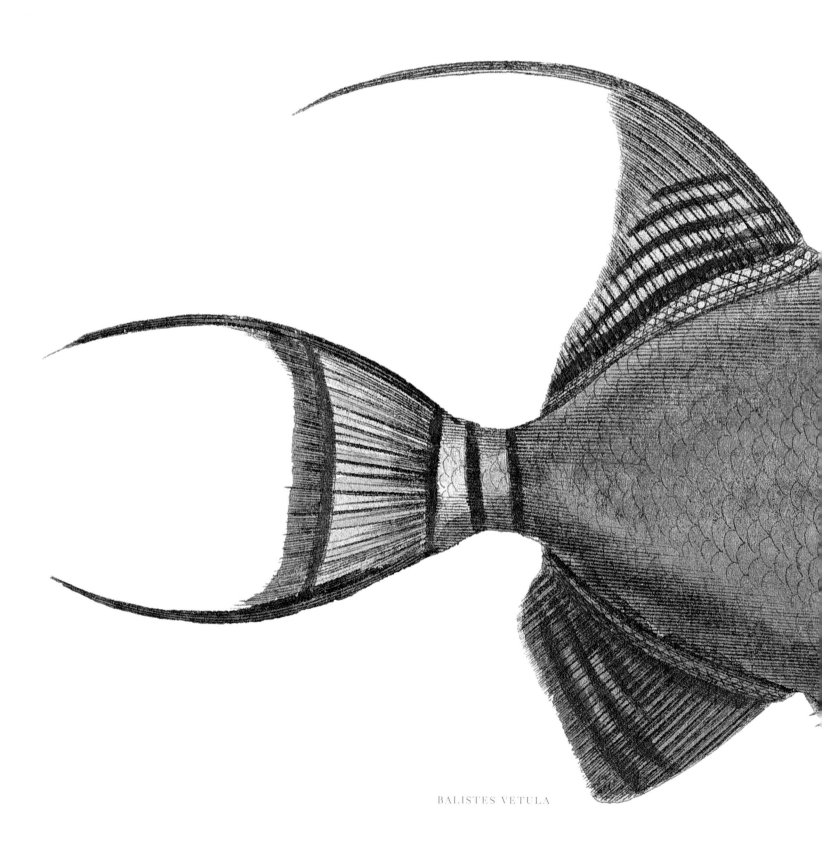

BALISTES VETULA

1/2

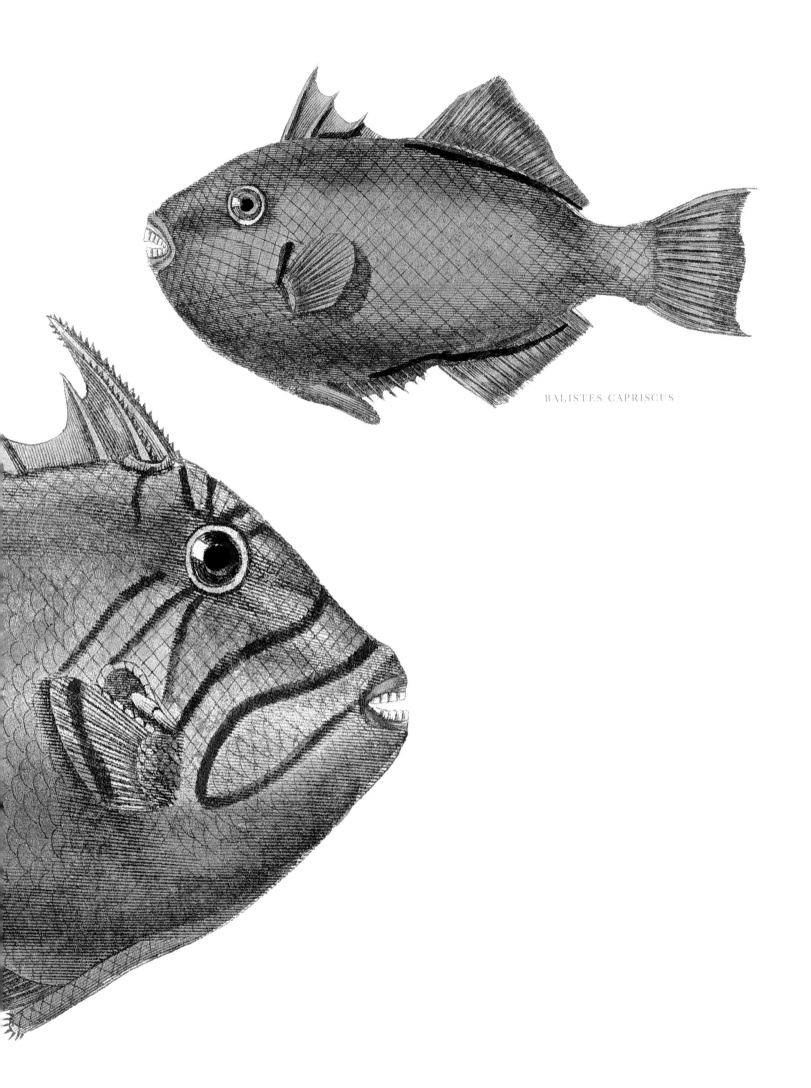

BALISTES CAPRISCUS

143

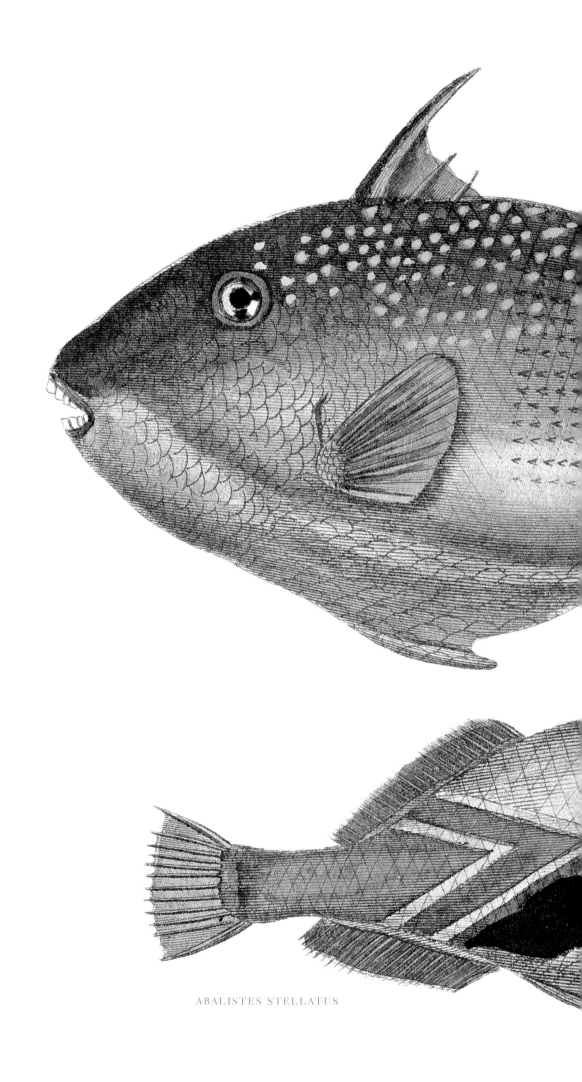

ABALISTES STELLATUS

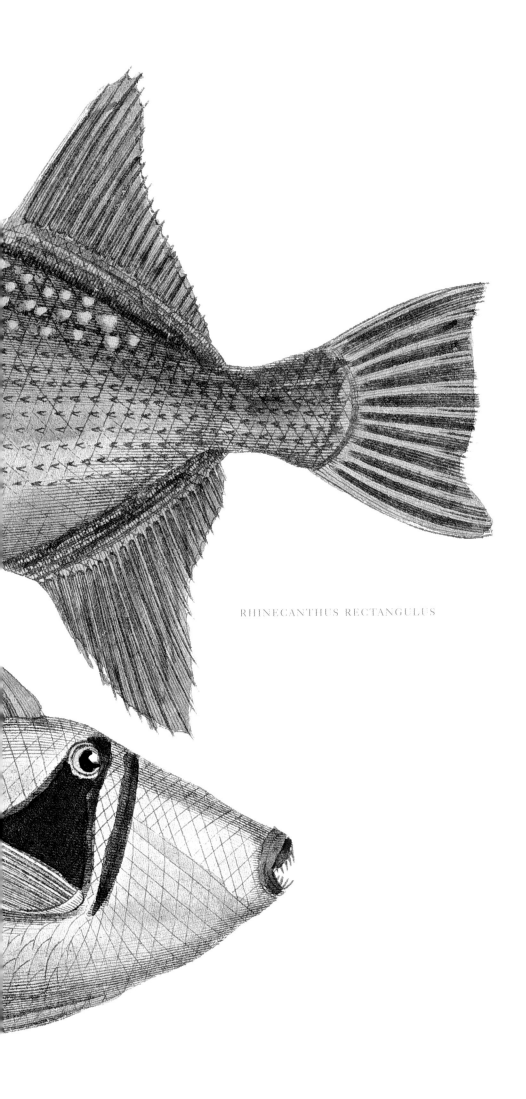

RHINECANTHUS RECTANGULUS

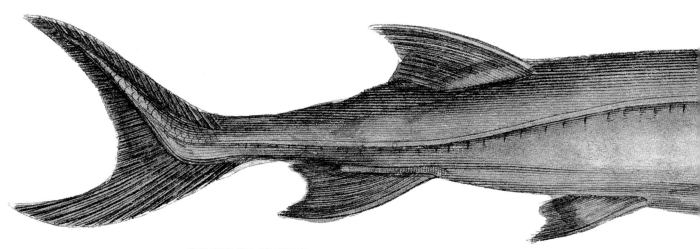

POLYODON SPATHULA

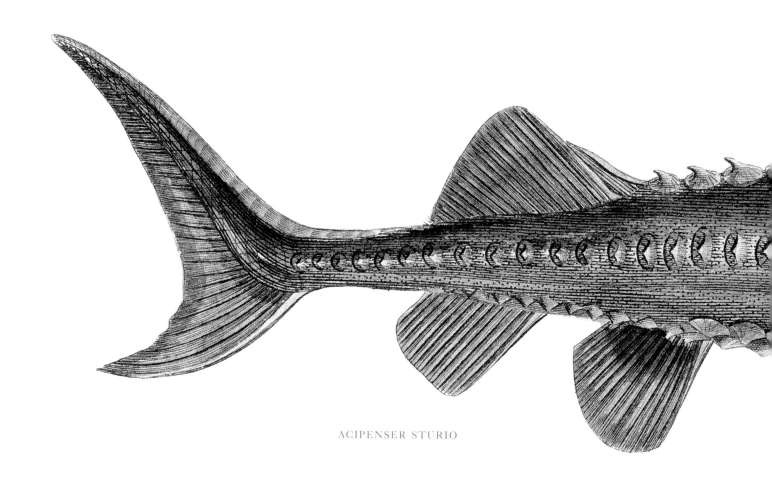

ACIPENSER STURIO

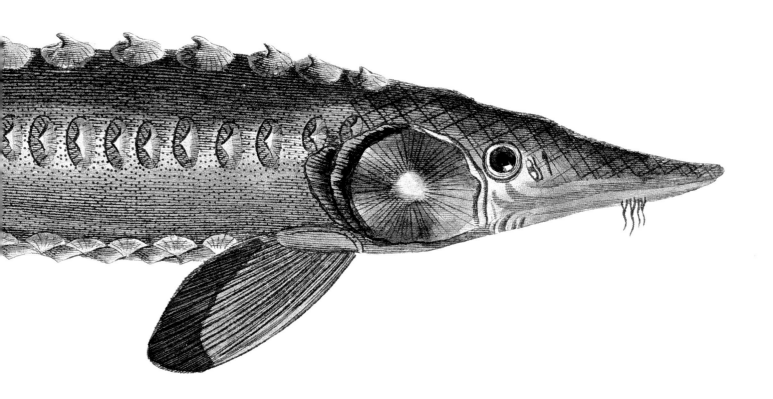

149

" Contemplation rhymes with comprehension. "

NICOLAS HULOT

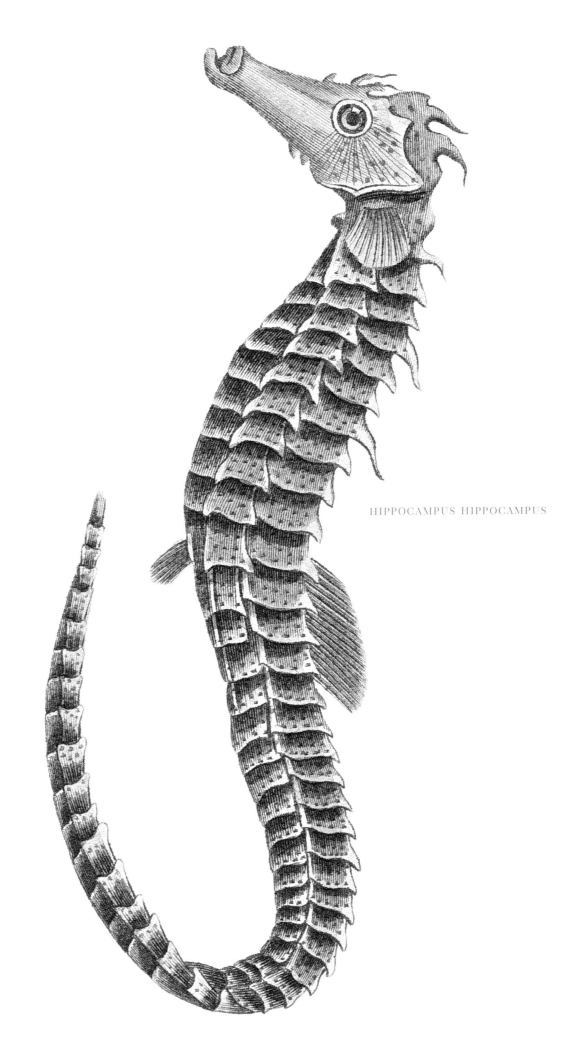

HIPPOCAMPUS HIPPOCAMPUS

149

> "The sea, the great unifier, is man's only hope. Now, as never before, the old phrase has a literal meaning: we are all in the same boat."

JACQUES YVES COUSTEAU

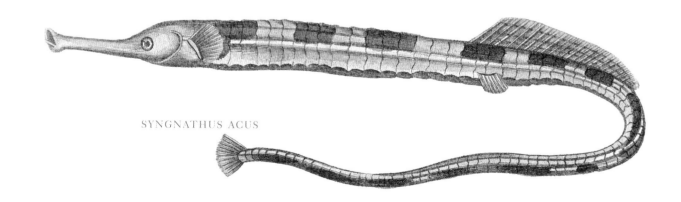

SYNGNATHUS ACUS

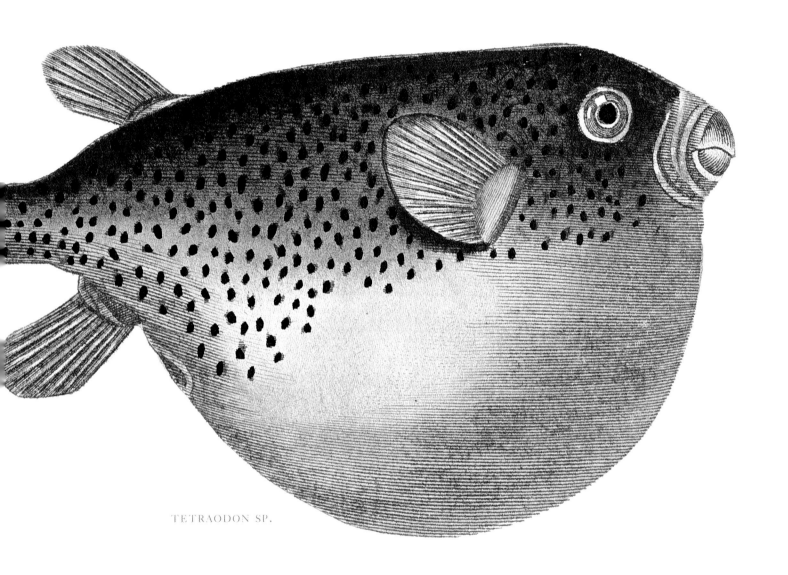

TETRAODON SP.

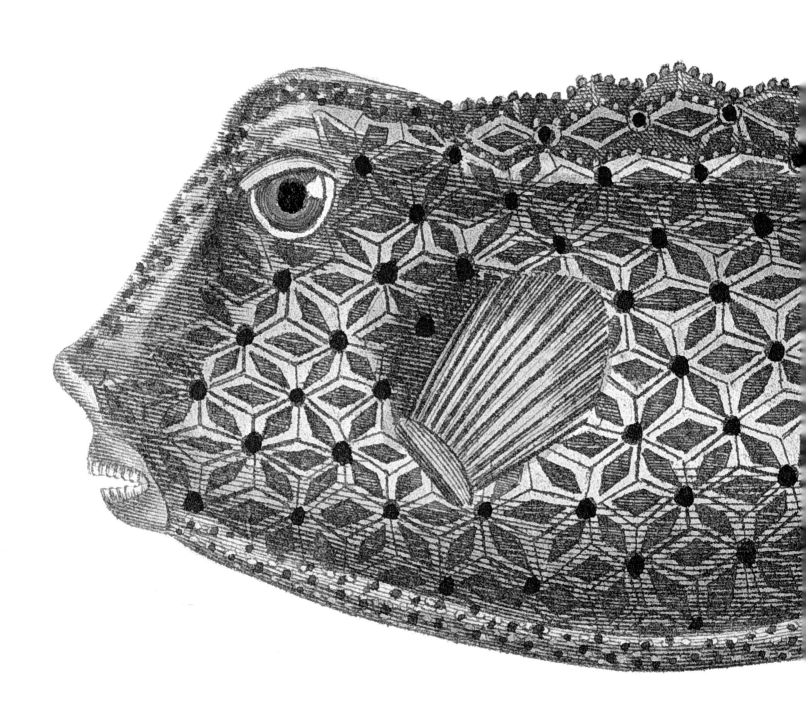

152

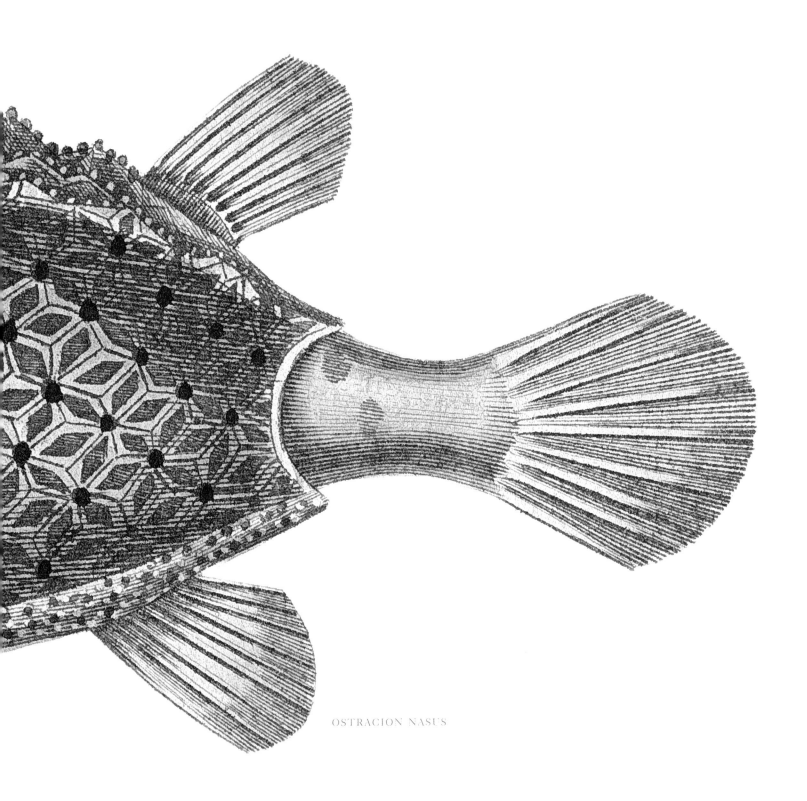

OSTRACION NASUS

153

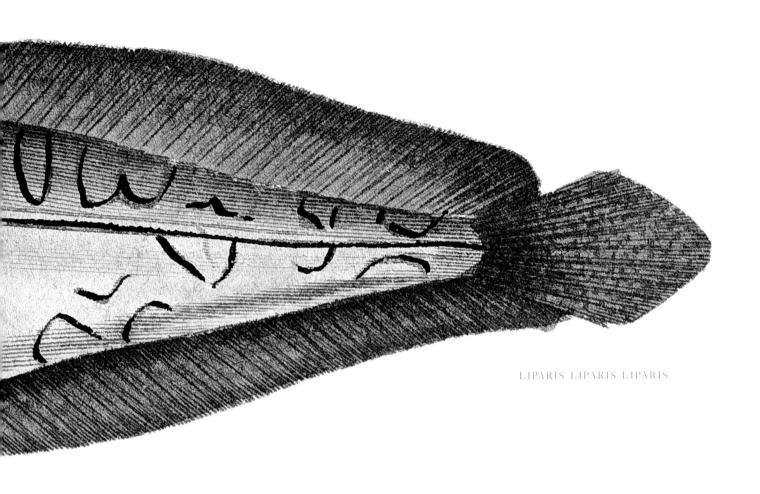

LIPARIS LIPARIS LIPARIS

GOUANIA SP.

" Man has been endowed with reason, with the power to create, so that he can add to what he's been given. But up to now he hasn't been a creator, only a destroyer. Forests keep disappearing, rivers dry up, wild life's become extinct, the climate's ruined and the land grows poorer and uglier every day. "

ANTON CHEKHOV, *Uncle Vanya*

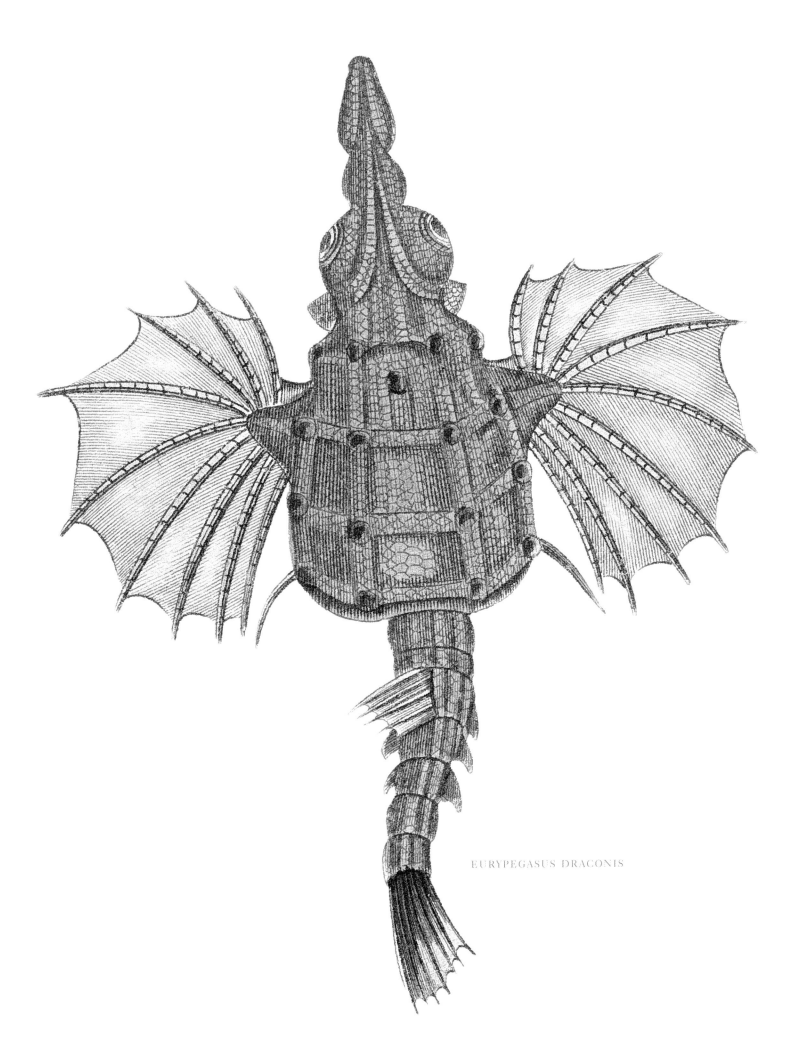

EURYPEGASUS DRACONIS

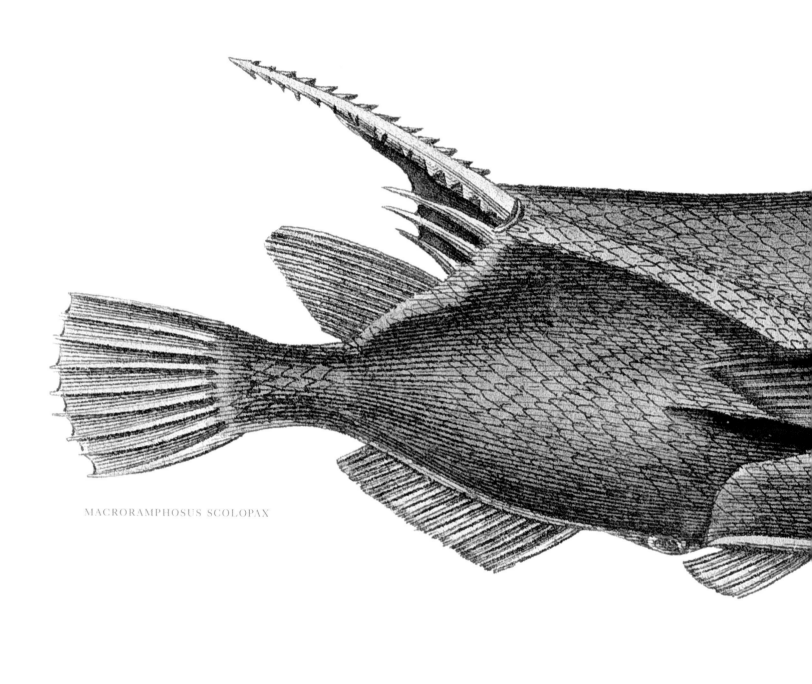

MACRORAMPHOSUS SCOLOPAX

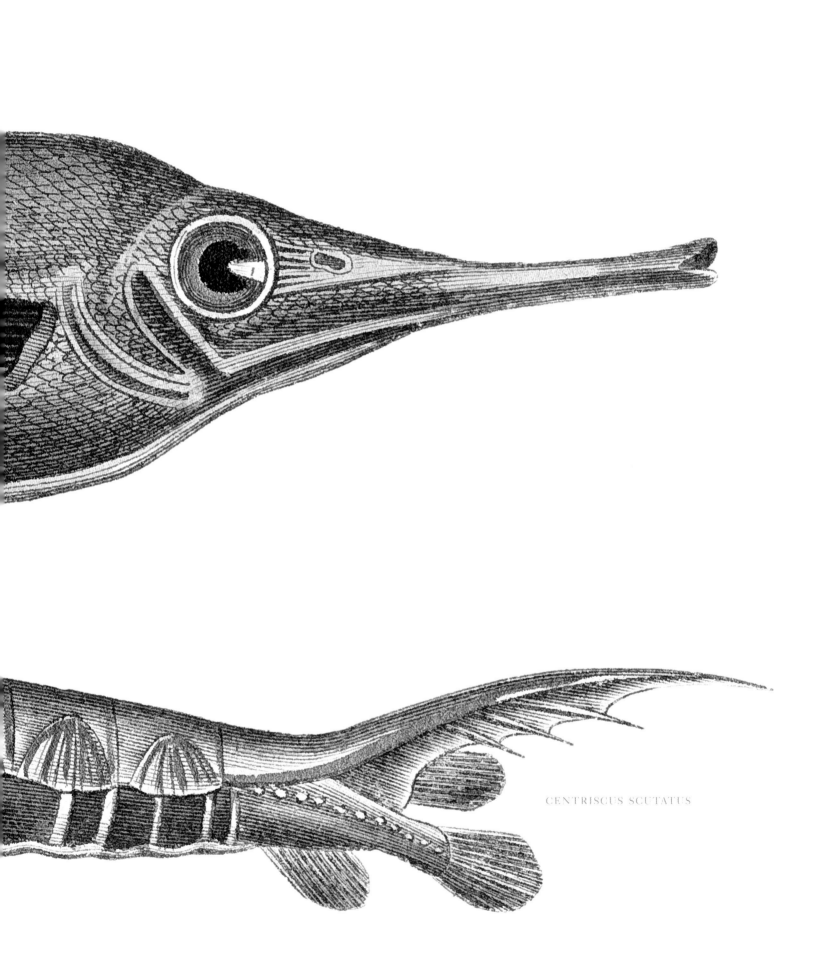

CENTRISCUS SCUTATUS

159

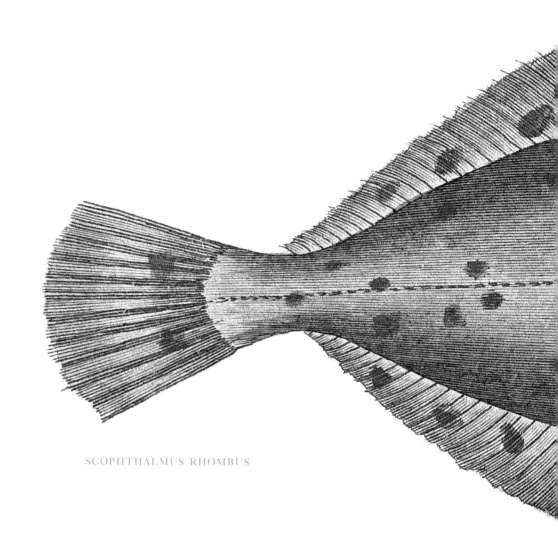

SCOPHTHALMUS RHOMBUS

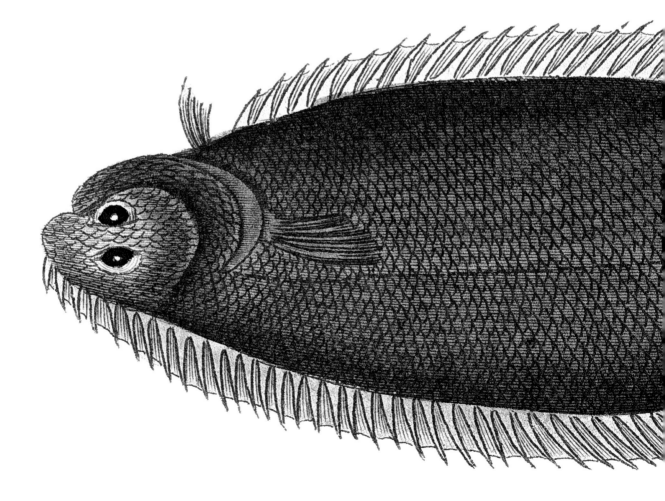

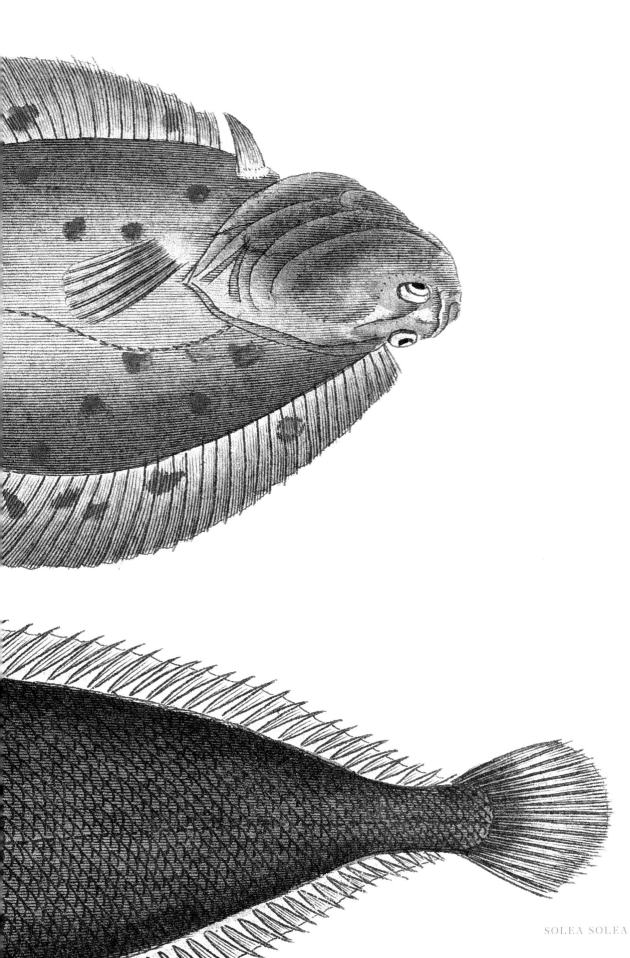

SOLEA SOLEA

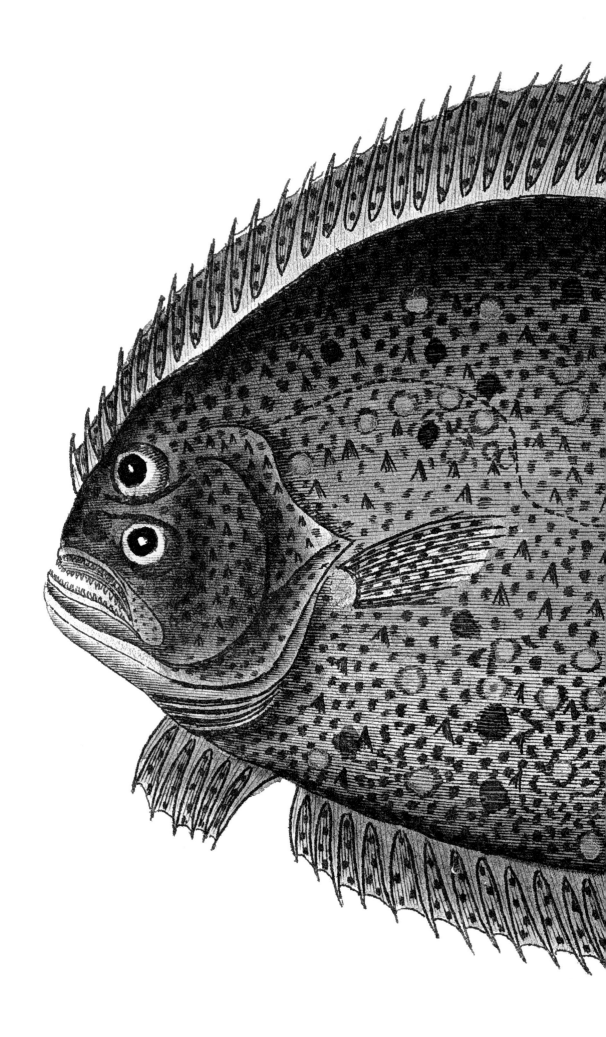

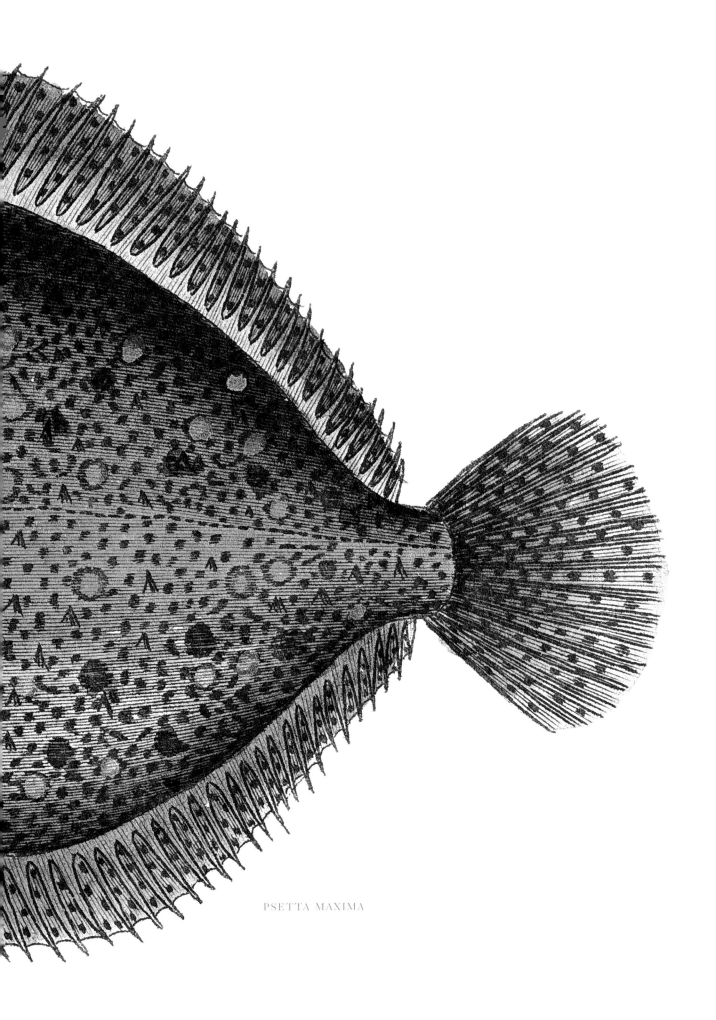

PSETTA MAXIMA

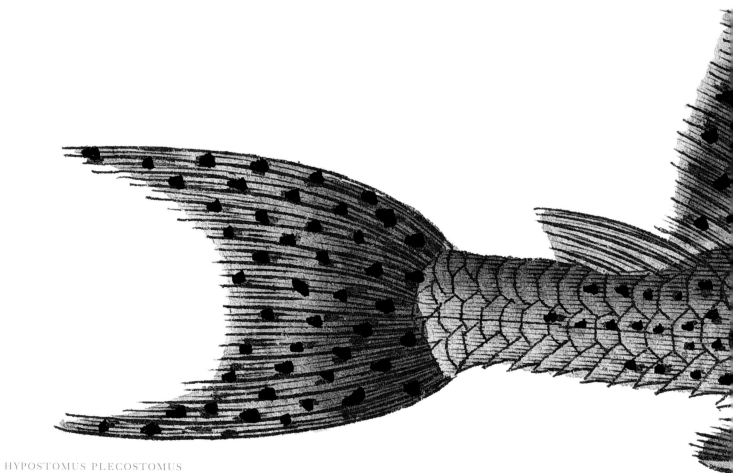

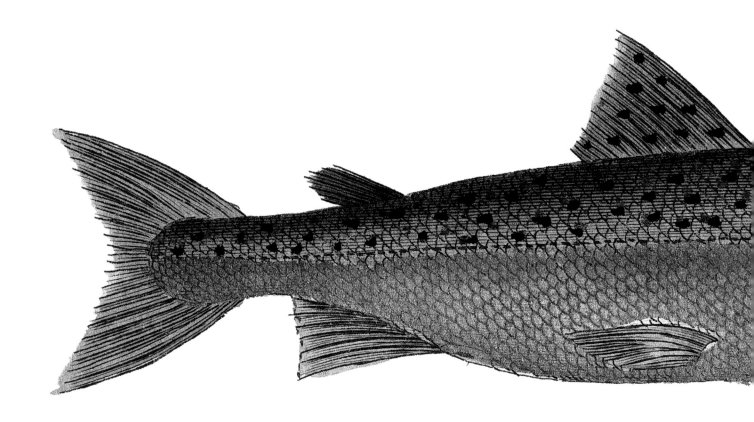

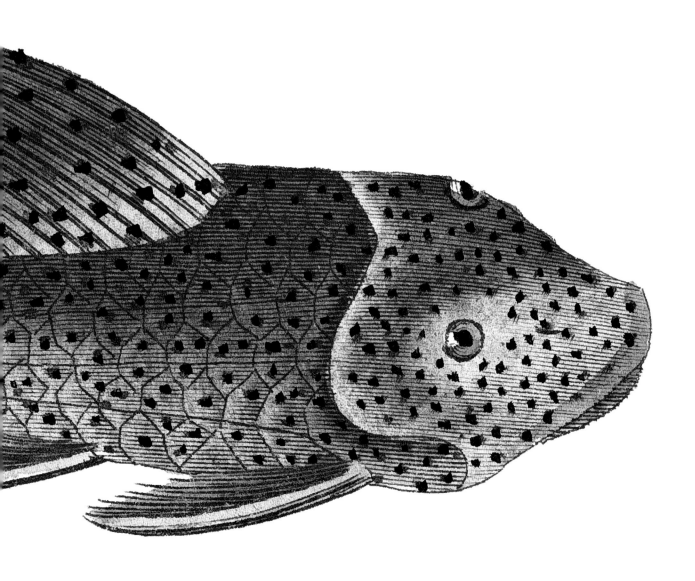

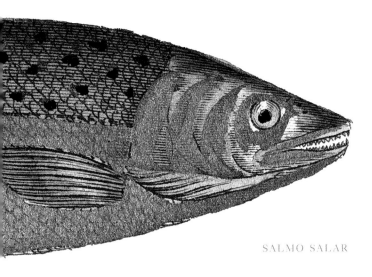

SALMO SALAR

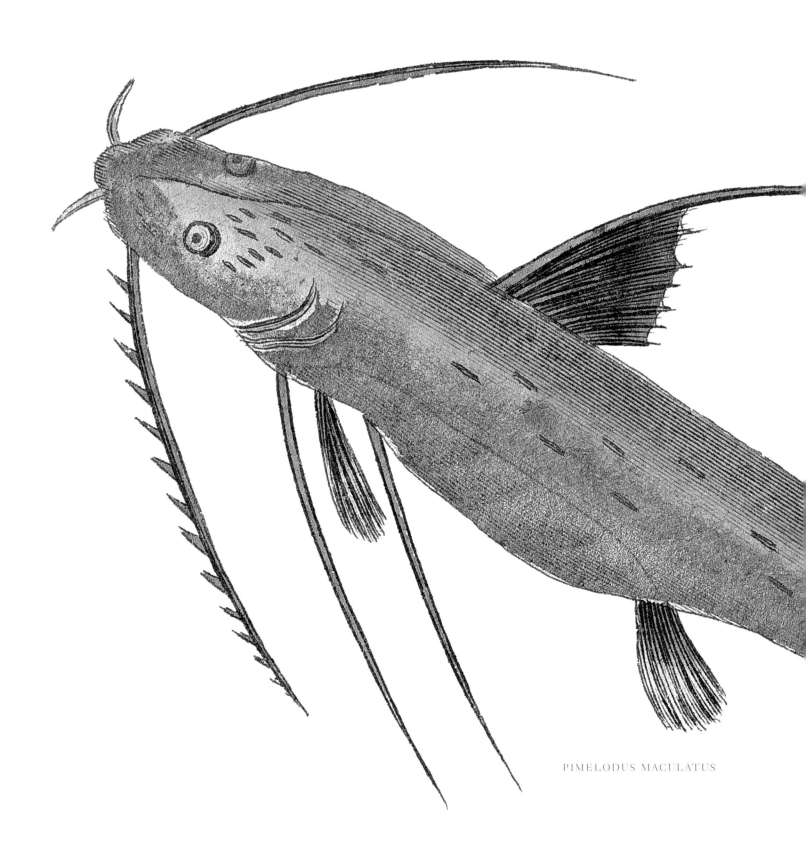

PIMELODUS MACULATUS

> "We are living crucial times and holding in our hands the keys to our future. We are still capable of changing it, for better or for worse, but for how long?"

NICOLAS HULOT

66 Wonderment is the first step toward respect. 99

NICOLAS HULOT

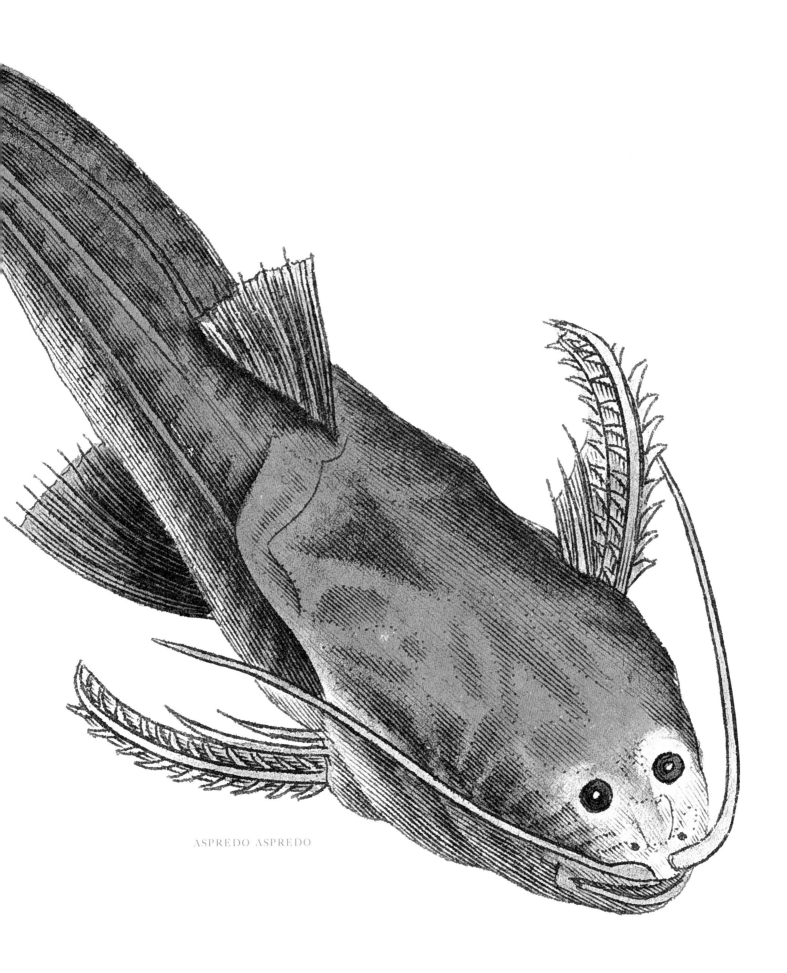

ASPREDO ASPREDO

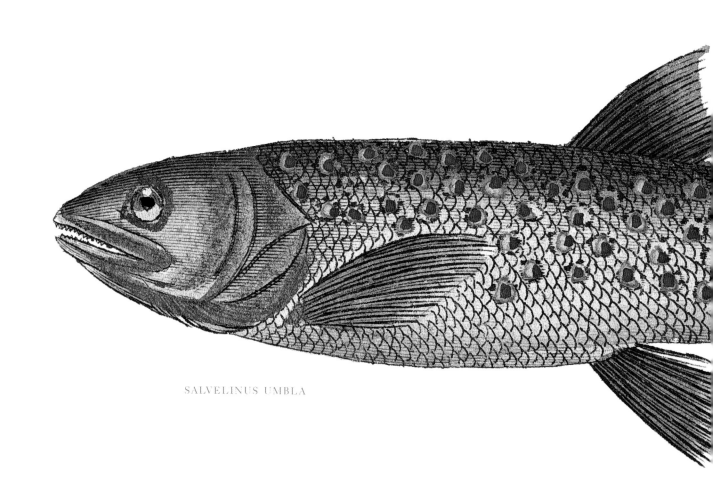

SALVELINUS UMBLA

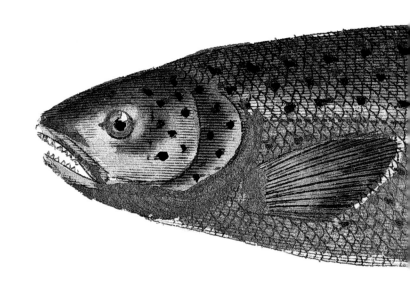

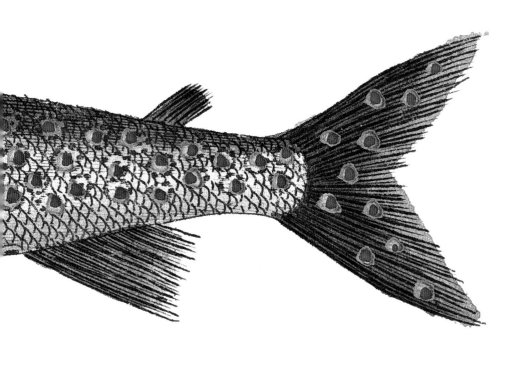

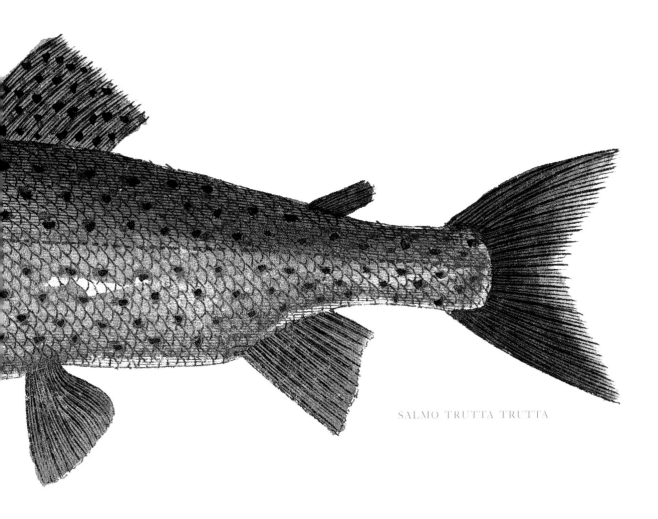

SALMO TRUTTA TRUTTA

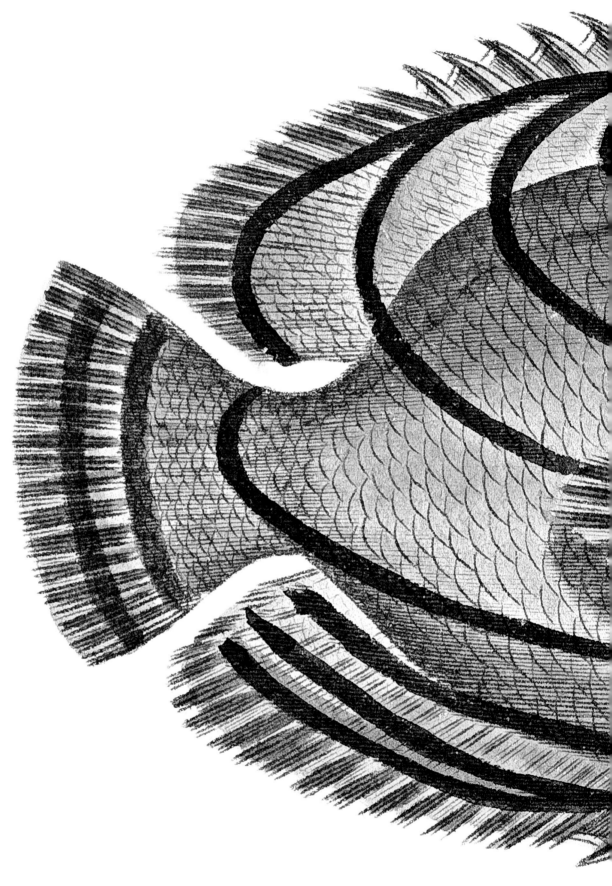

CHAETODON MEYERI

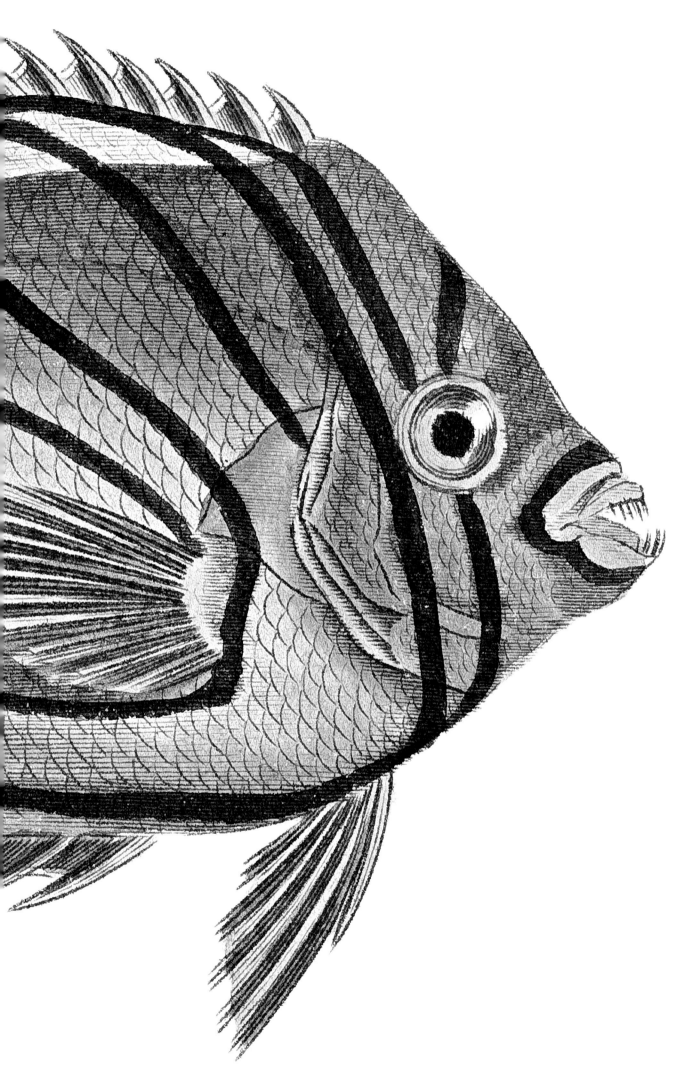

> "Roll on, deep and dark blue ocean, roll. Ten thousand fleets sweep over thee in vain. Man marks the earth with ruin, but his control stops with the shore."

LORD BYRON

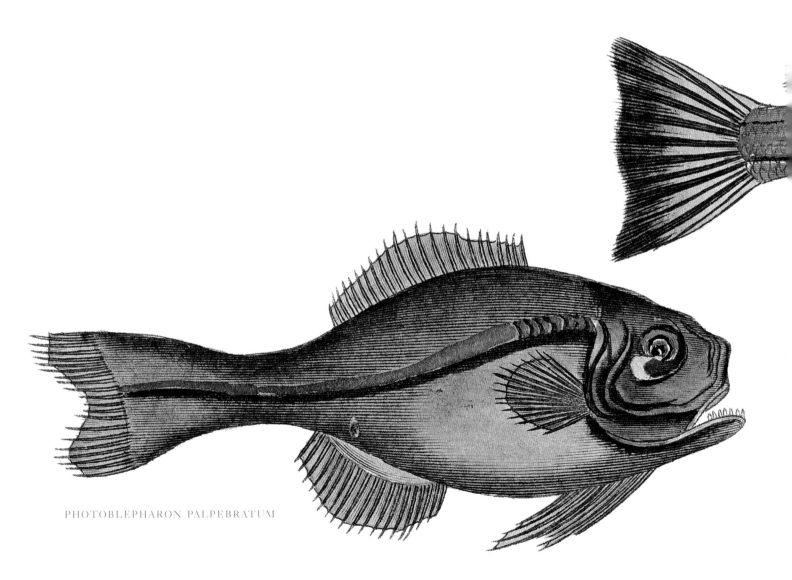

PHOTOBLEPHARON PALPEBRATUM

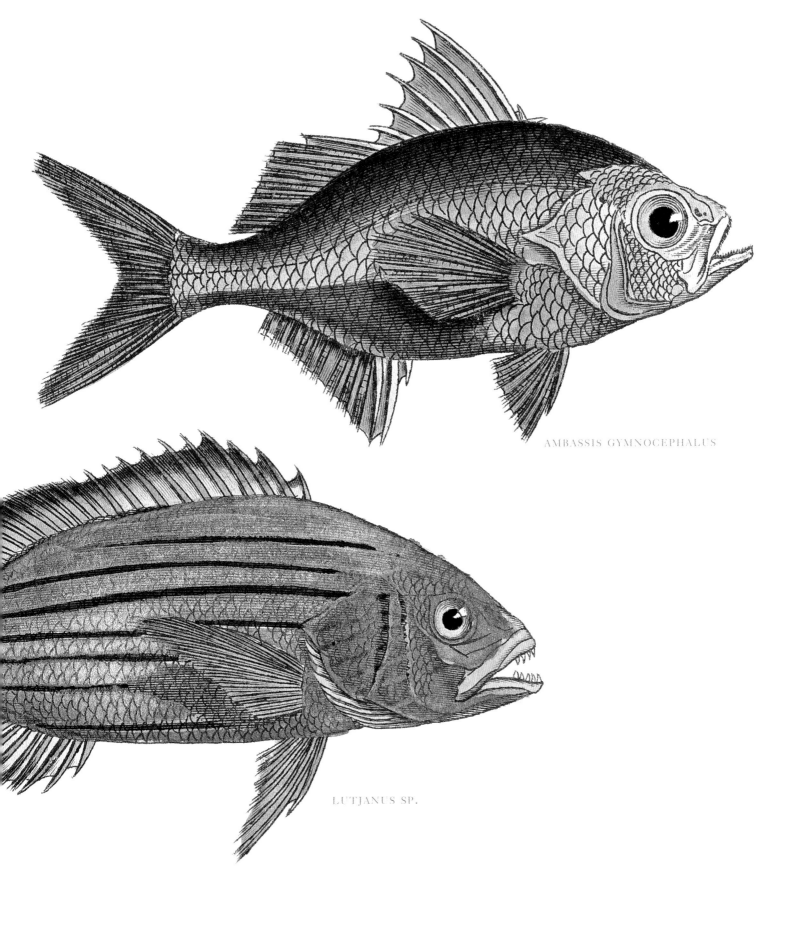

AMBASSIS GYMNOCEPHALUS

LUTJANUS SP.

PLECTROPOMUS MACULATUS

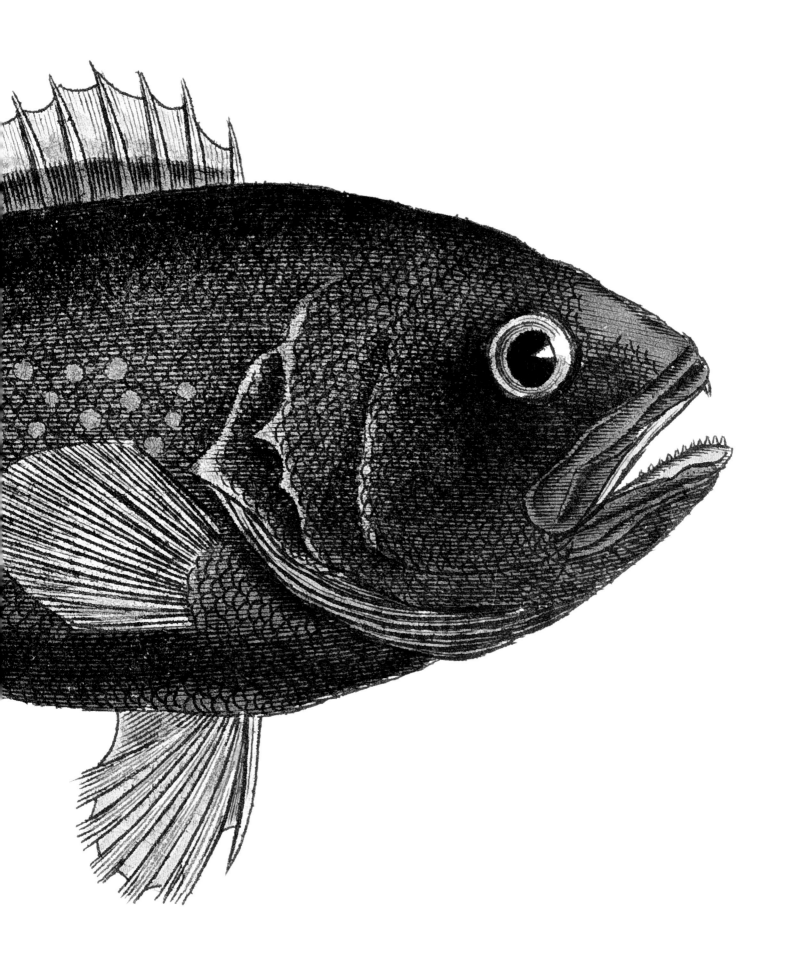

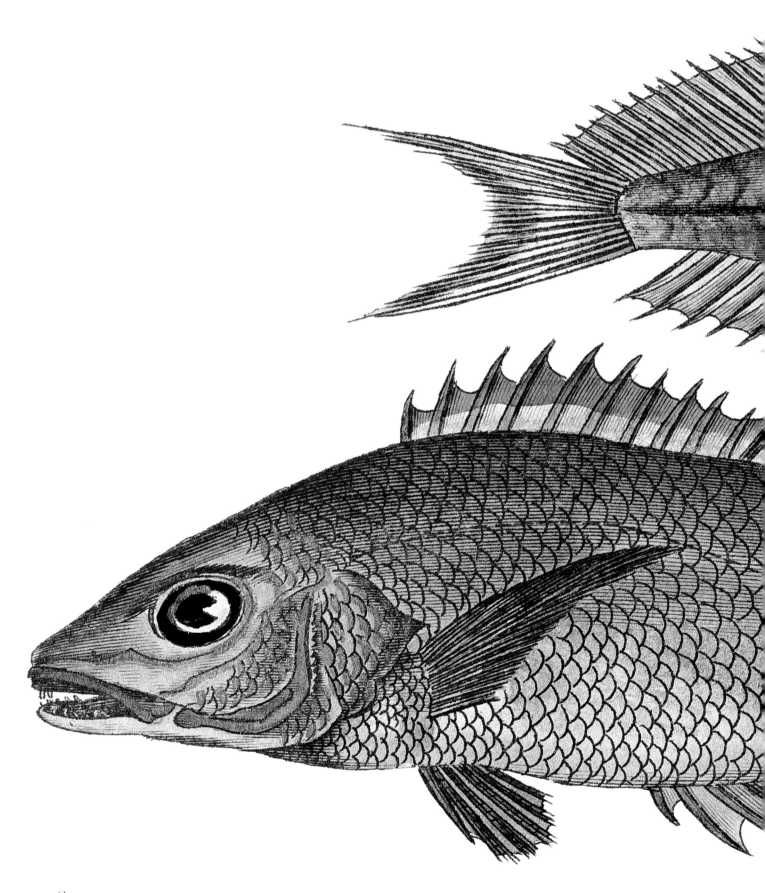

178

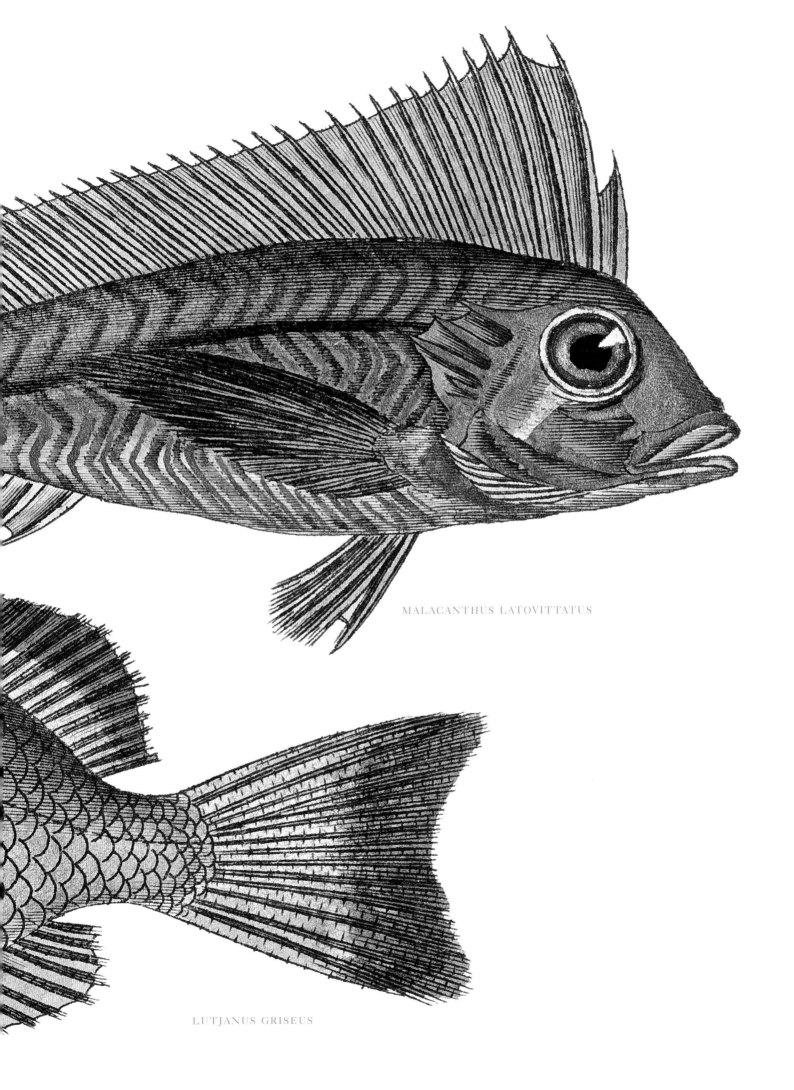

MALACANTHUS LATOVITTATUS

LUTJANUS GRISEUS

179

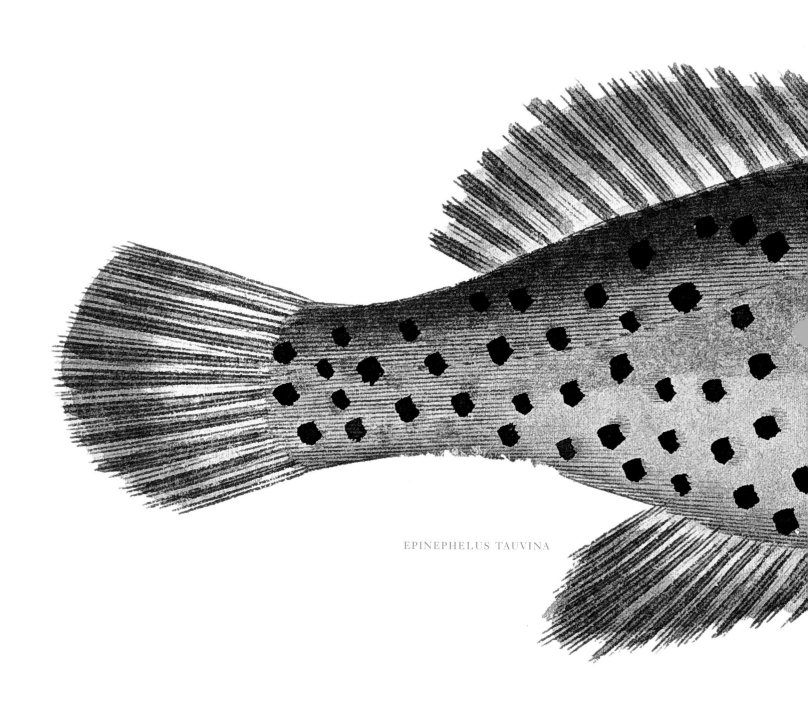

EPINEPHELUS TAUVINA

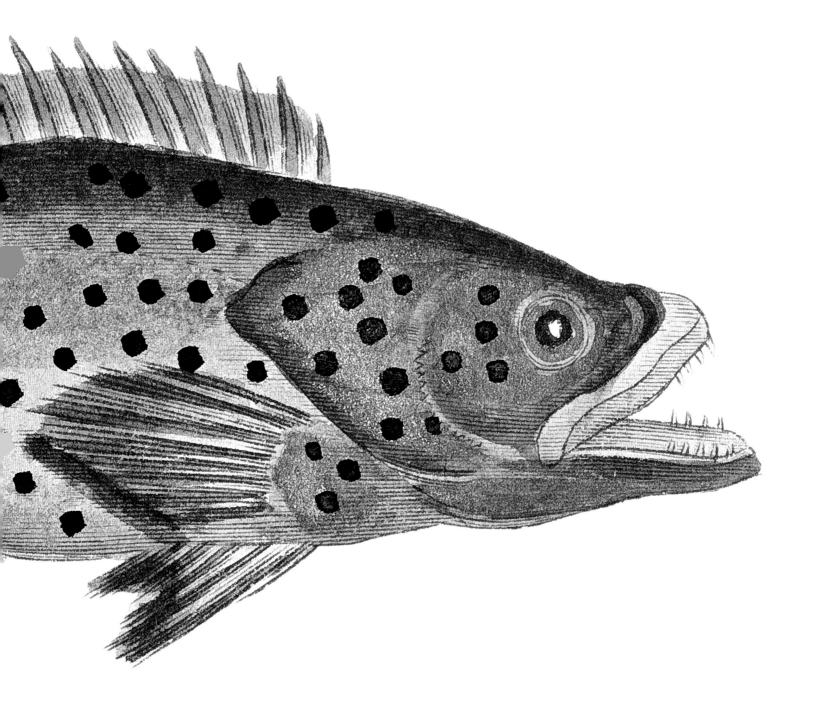

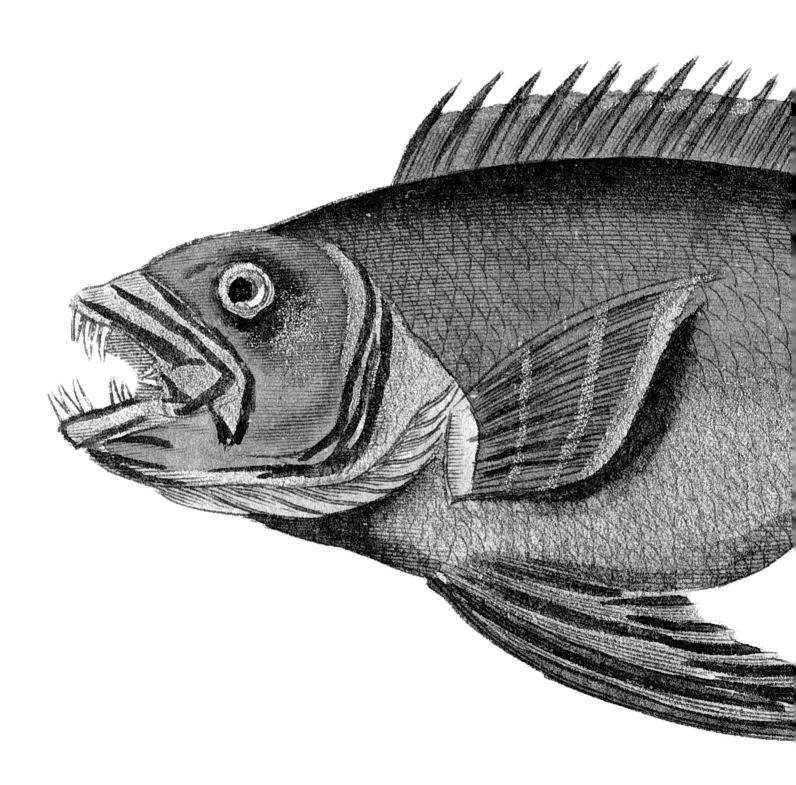

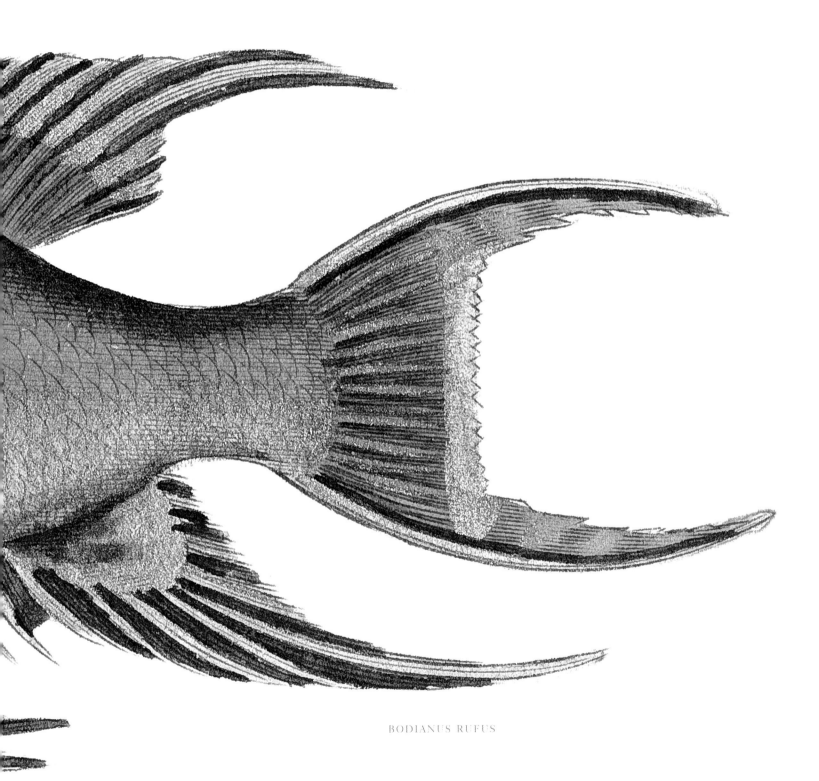

BODIANUS RUFUS

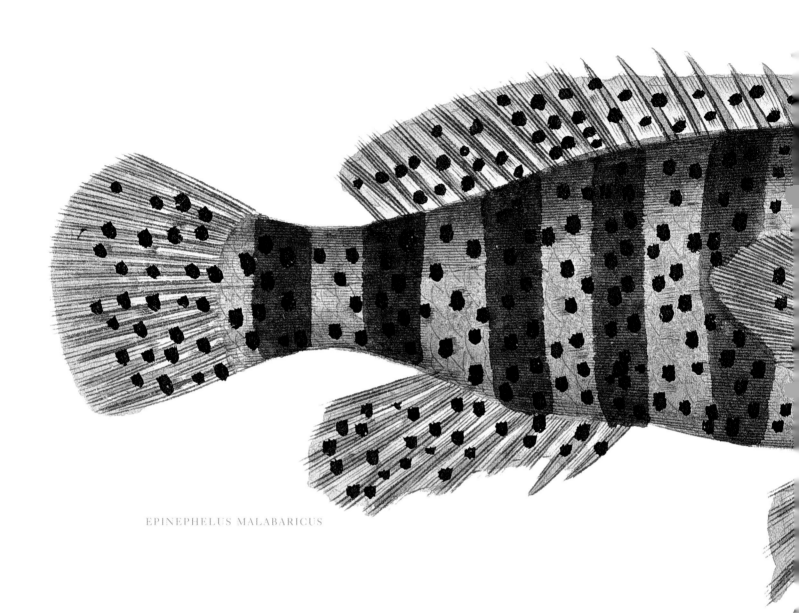

EPINEPHELUS MALABARICUS

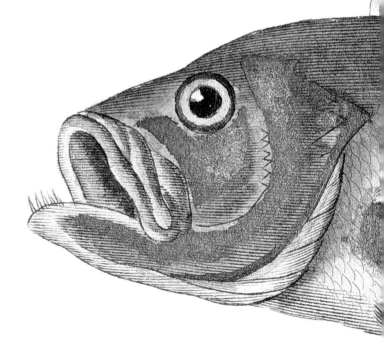

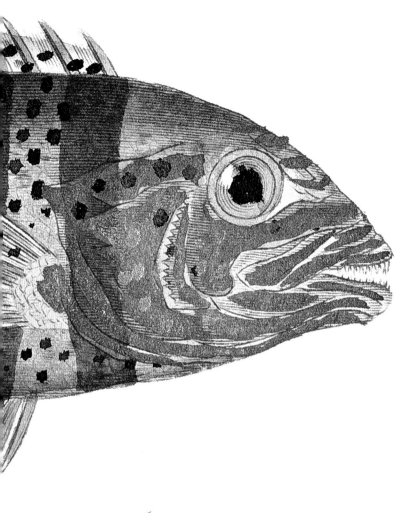

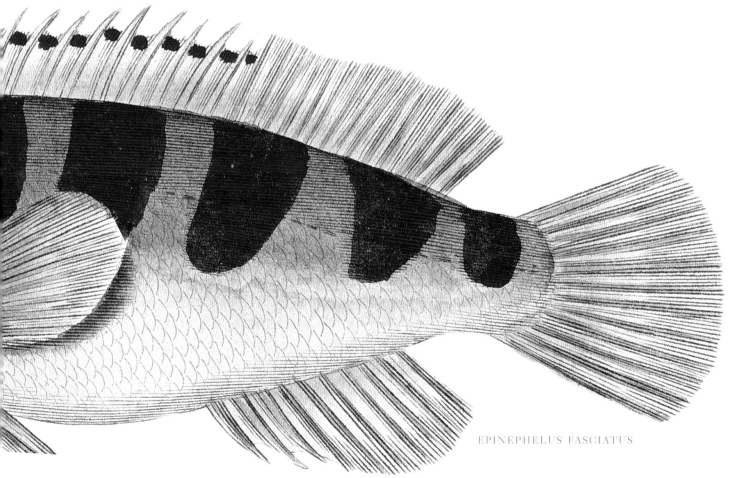

EPINEPHELUS FASCIATUS

185

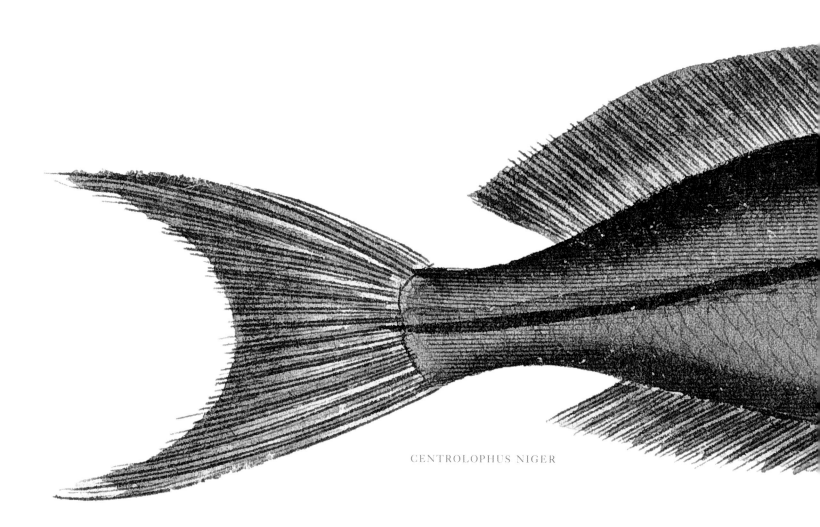

CENTROLOPHUS NIGER

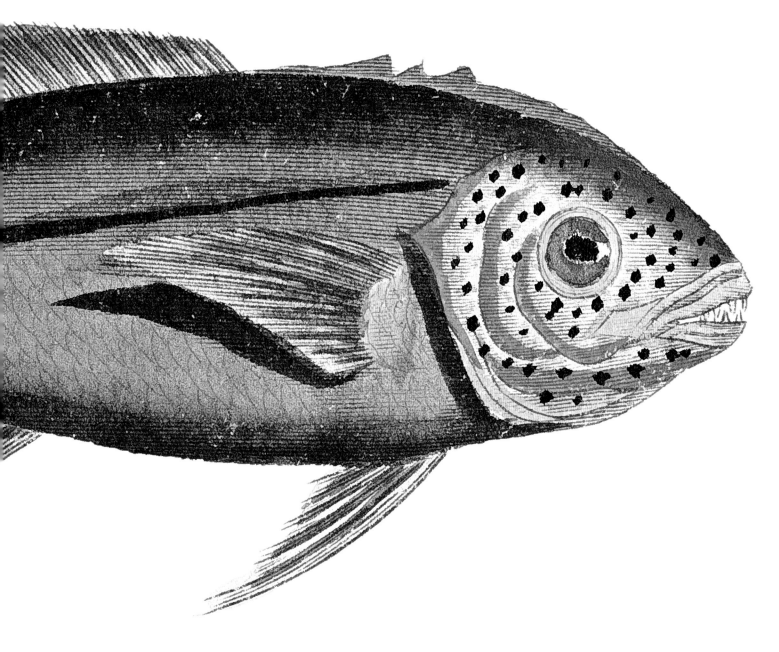

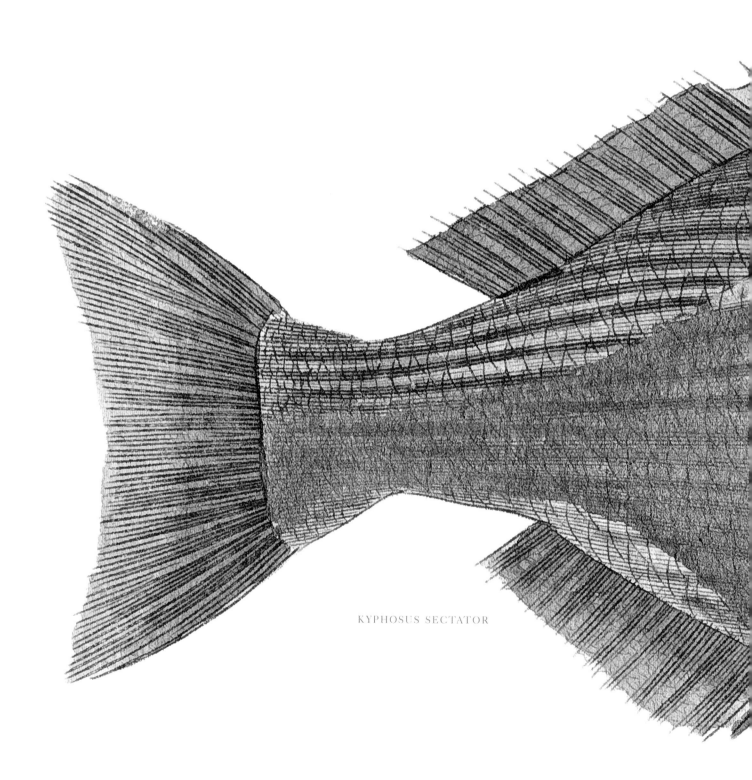

KYPHOSUS SECTATOR

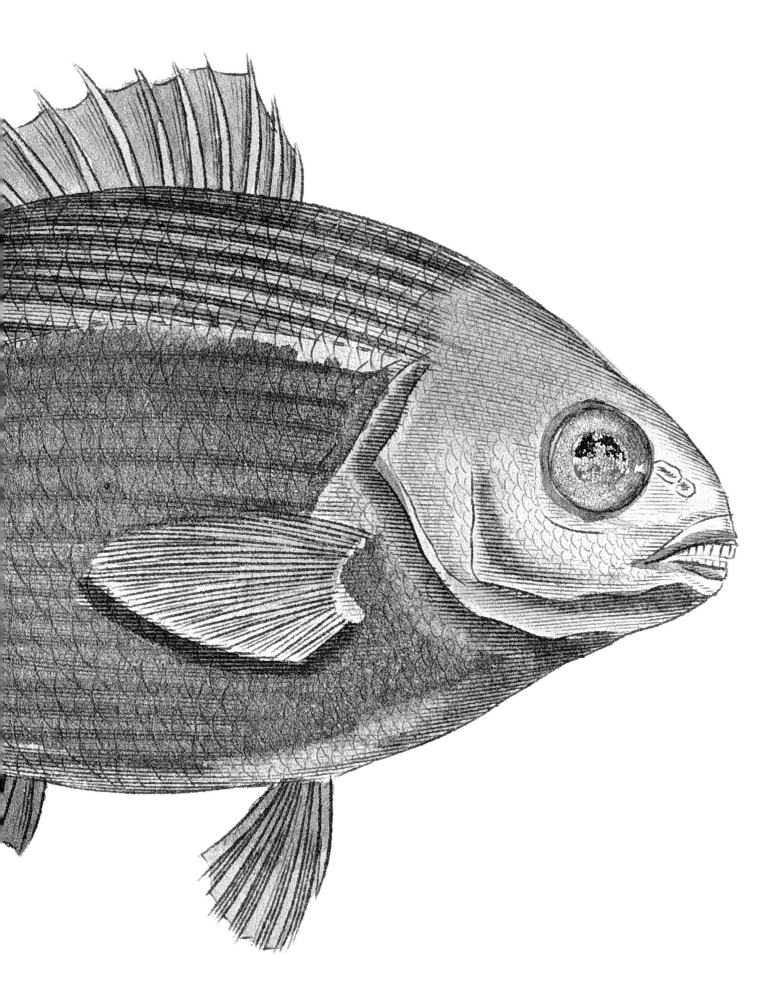

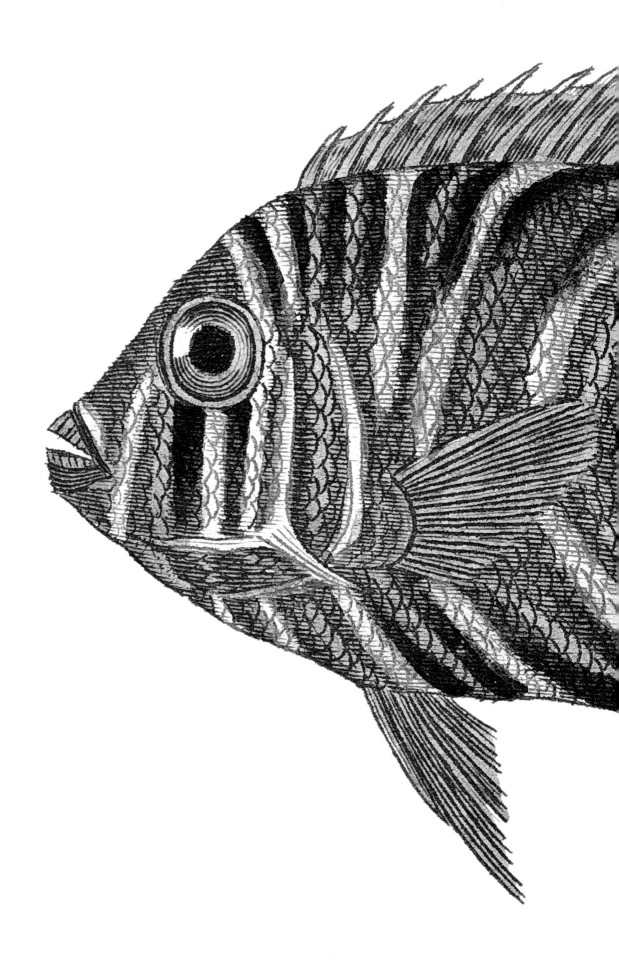

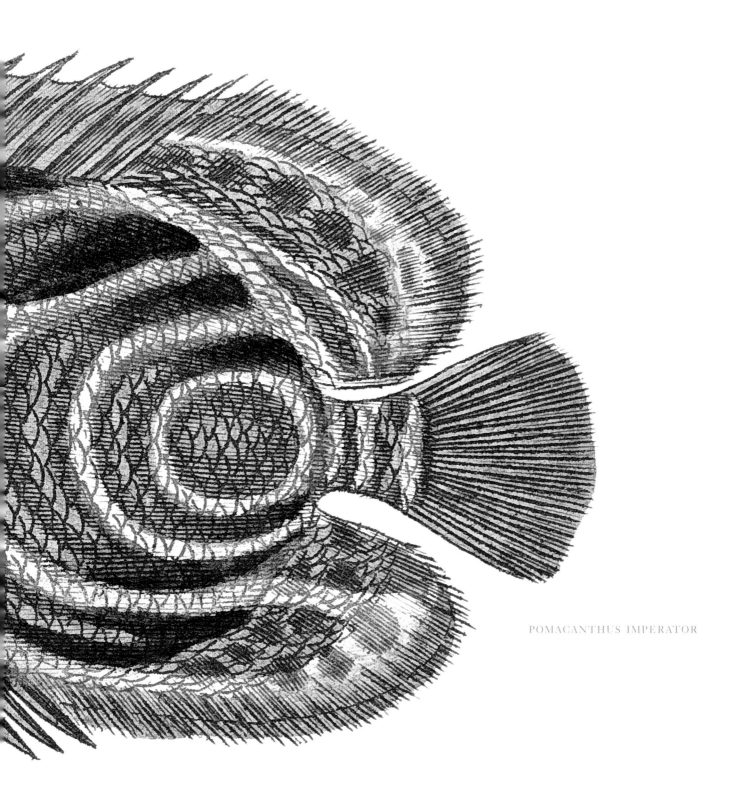

POMACANTHUS IMPERATOR

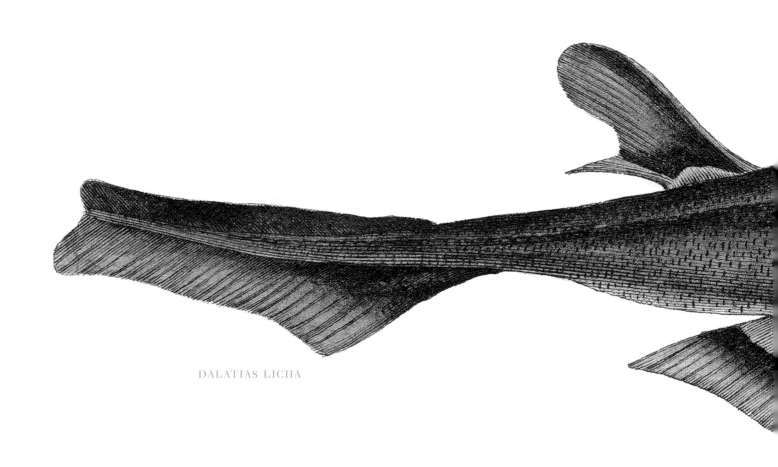

DALATIAS LICHA

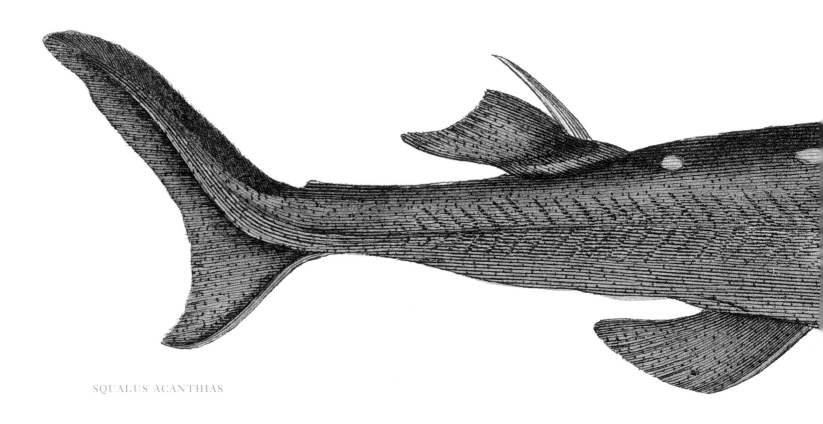

SQUALUS ACANTHIAS

192

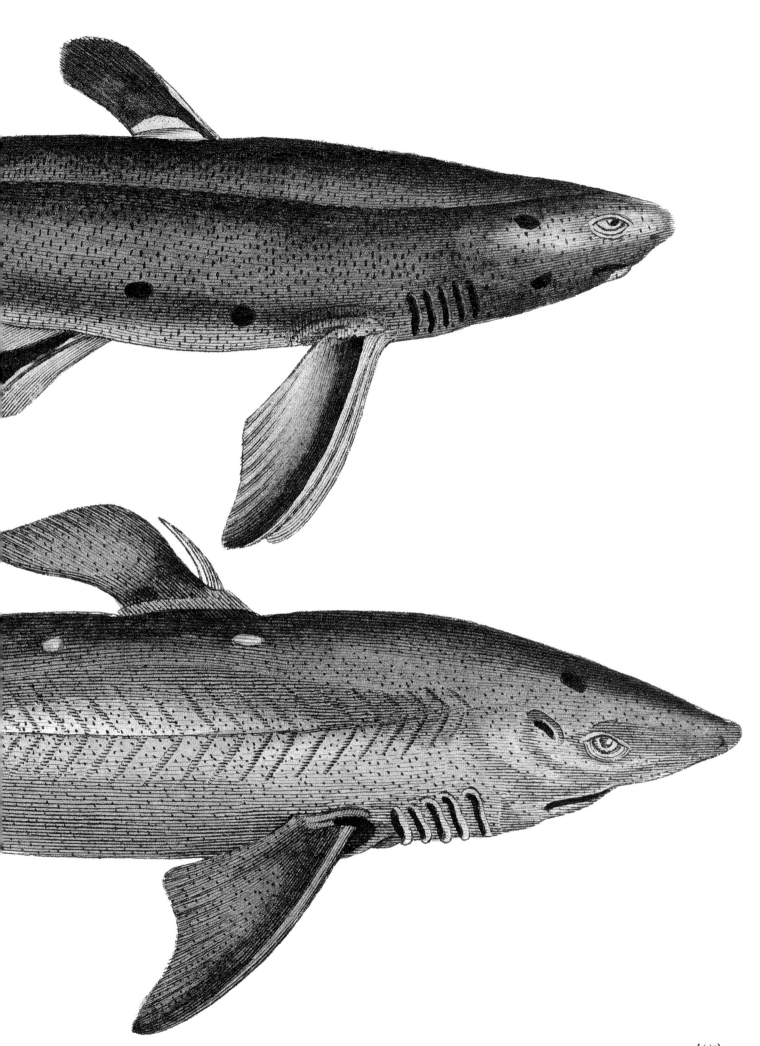

193

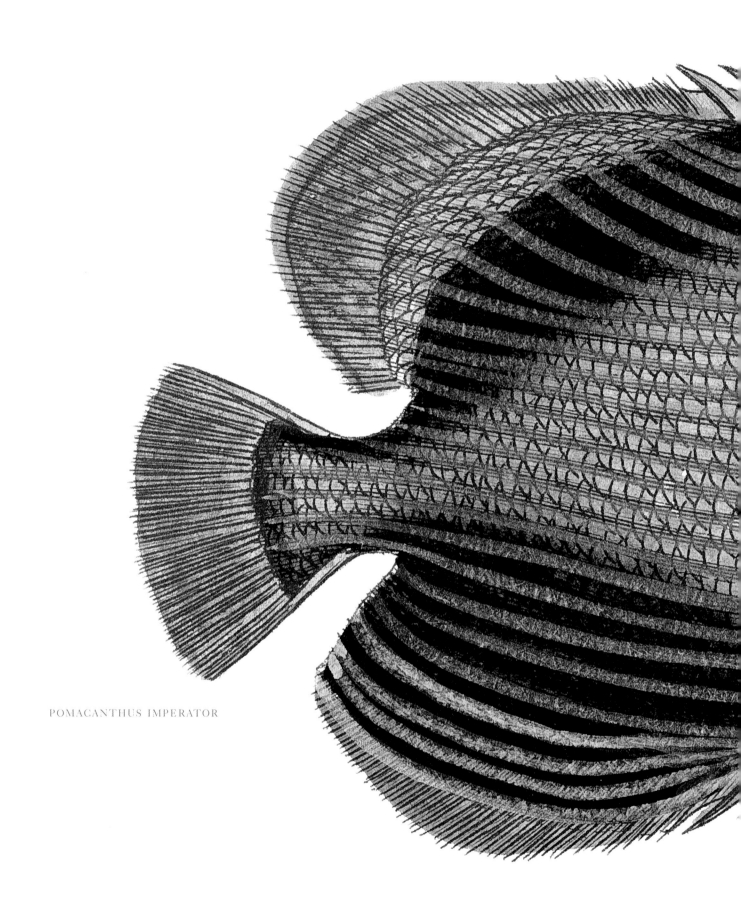

POMACANTHUS IMPERATOR

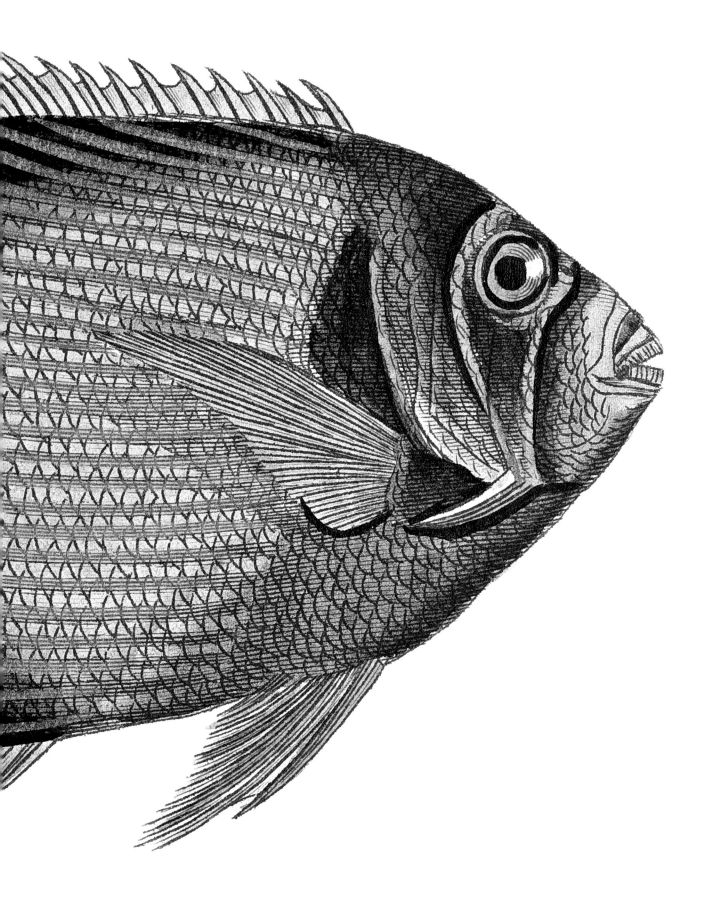

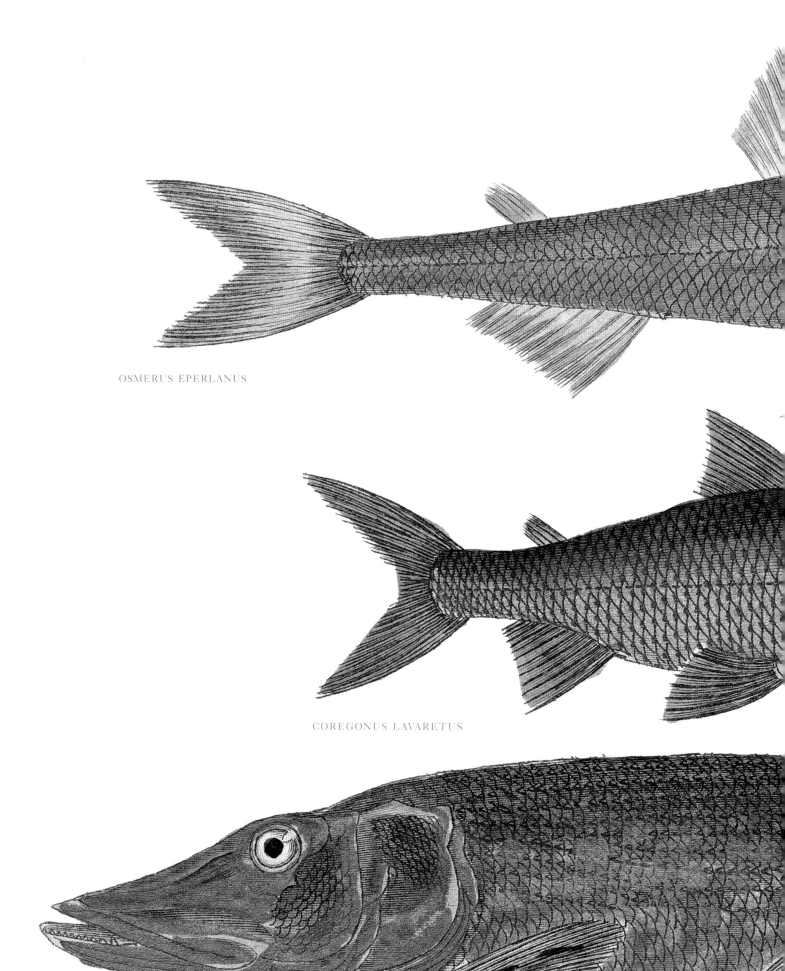

OSMERUS EPERLANUS

COREGONUS LAVARETUS

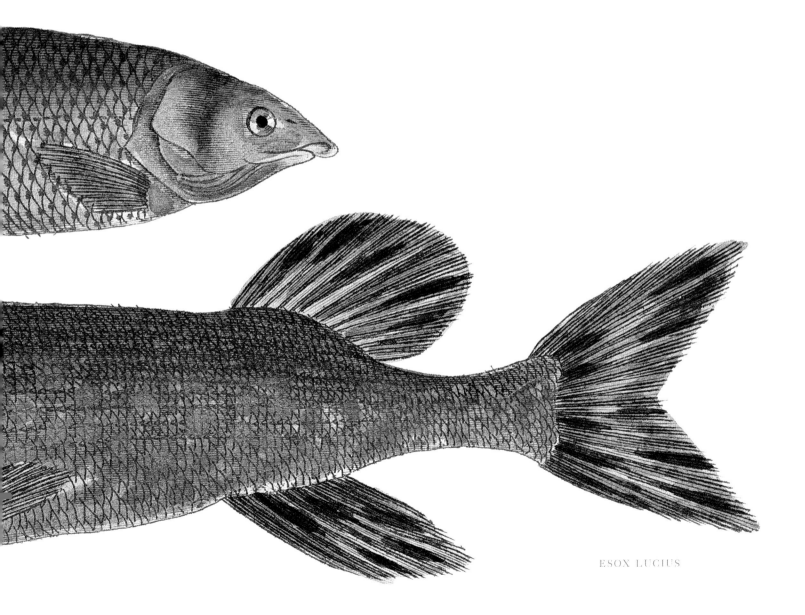

ESOX LUCIUS

197

66 Man, lured by the treasures that dominion over the cetaceans could bring him, has disrupted the peace of their immense solitudes, has violated their retreats, and has slain all those that the icy and inaccessible polar steppes have not stolen from his blows. 99

COMTE DE LACÉPÈDE

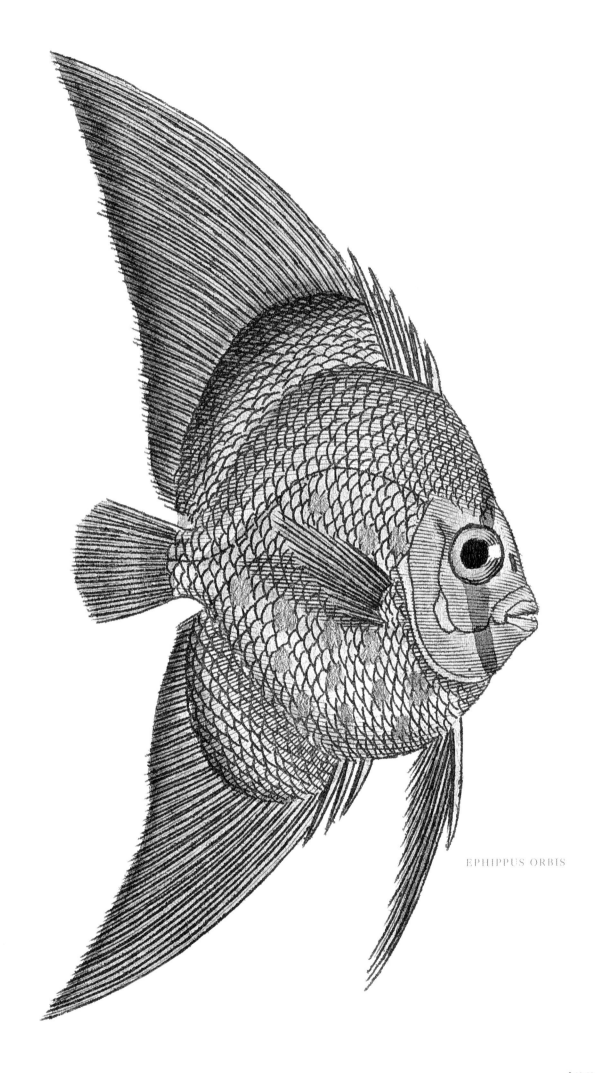

EPHIPPUS ORBIS

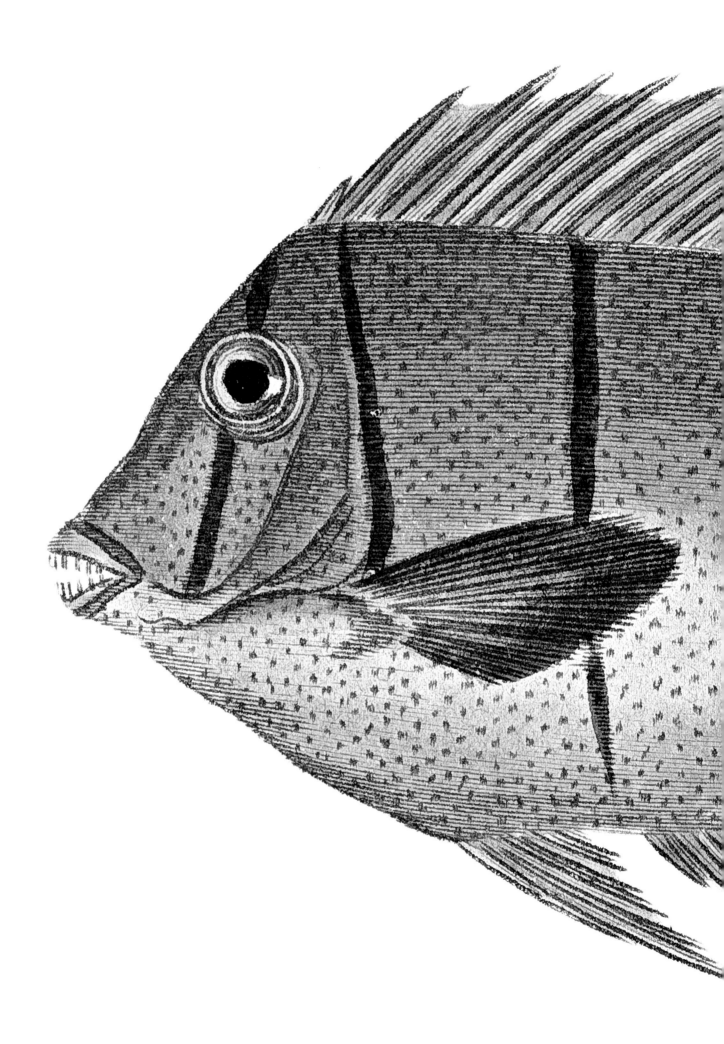

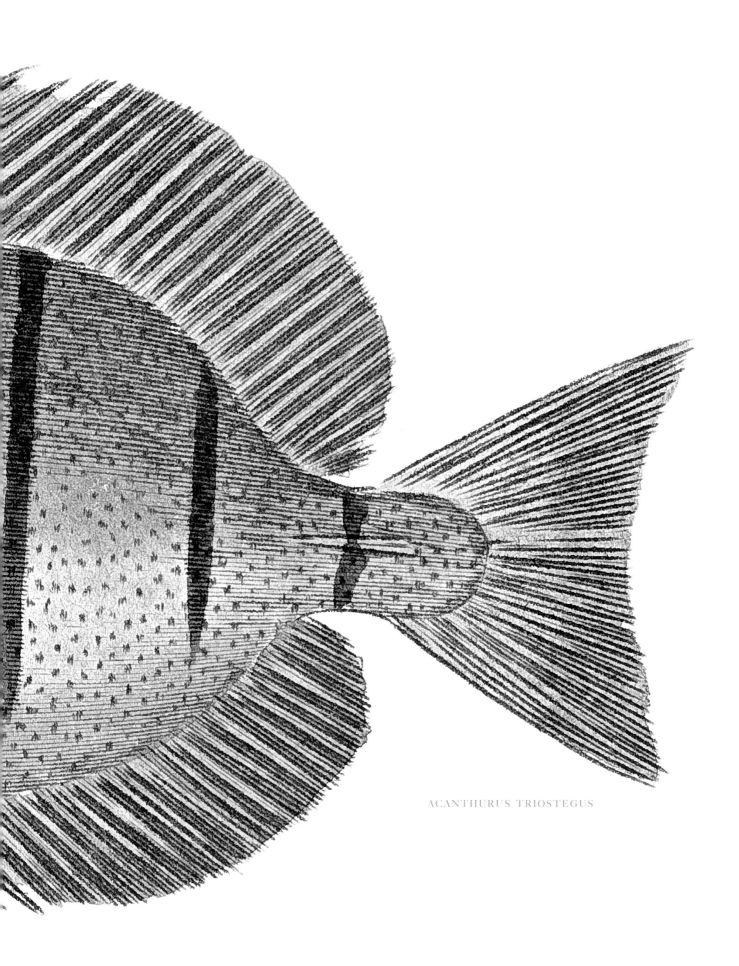

ACANTHURUS TRIOSTEGUS

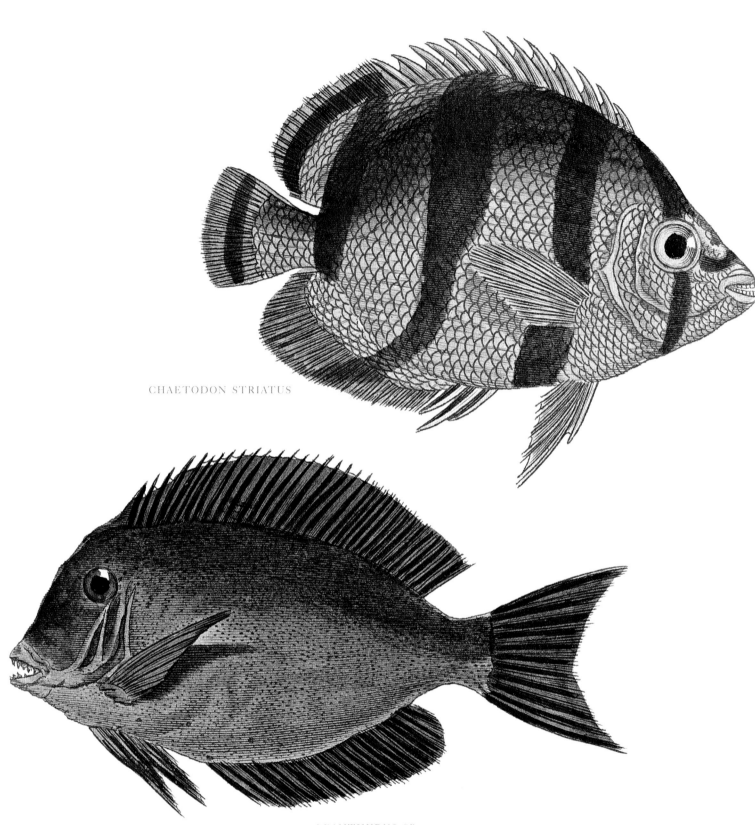

CHAETODON STRIATUS

ACANTHURUS SP.

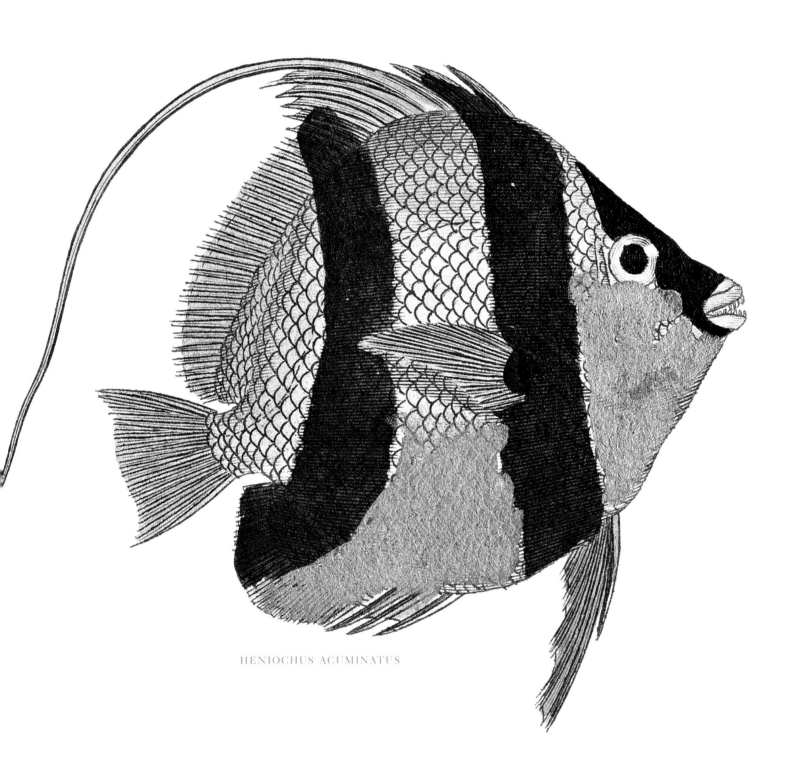

HENIOCHUS ACUMINATUS

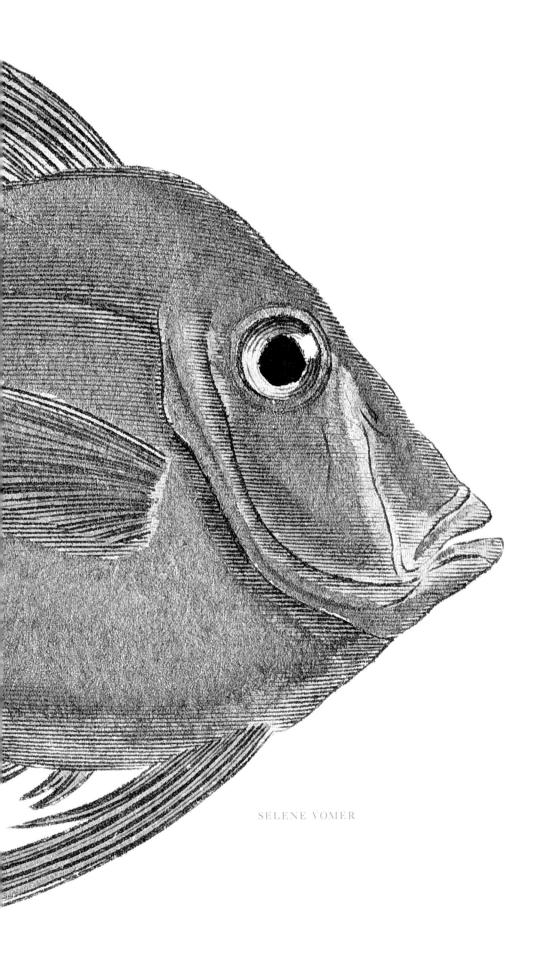

SELENE VOMER

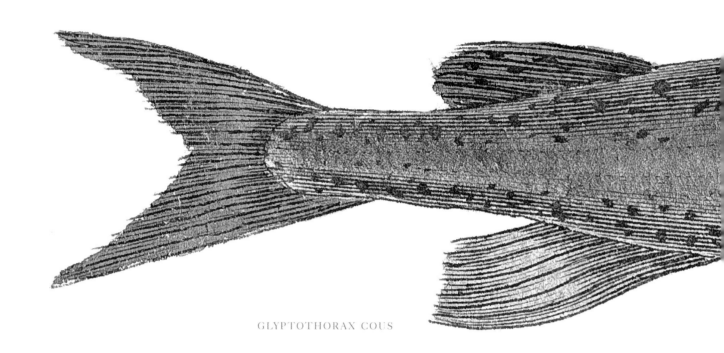

GLYPTOTHORAX COUS

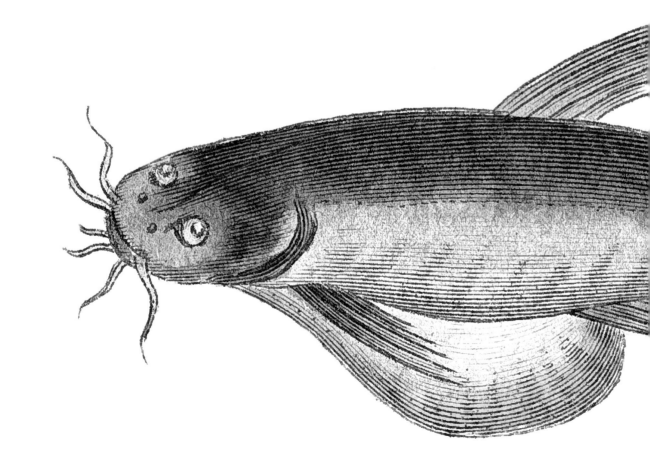

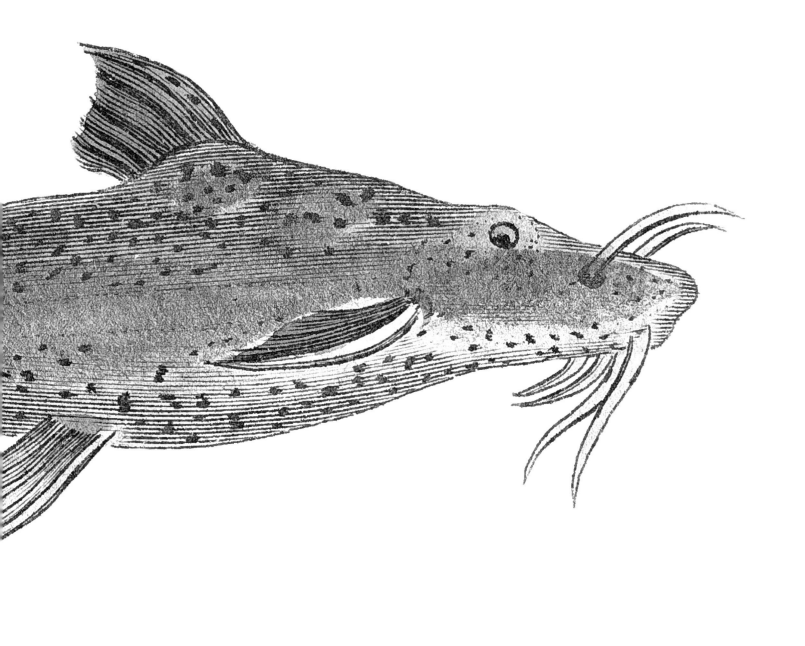

PIMELODUS BLOCHII

A NATURAL HISTORY OF CETACEANS

An Overview of Cetaceans

Let our imaginations transport us a great distance above the globe. The earth turns beneath us, the vast ocean surrounds the islands and continents. Only the ocean appears animated: at this distance, the living creatures that populate the globe's dry surfaces have disappeared from sight; we can no longer see the rhinoceroses, hippopotamuses, elephants, crocodiles, or giant snakes; but, on the surface of the sea, we can still make out numerous groups of animate beings traveling with speed across

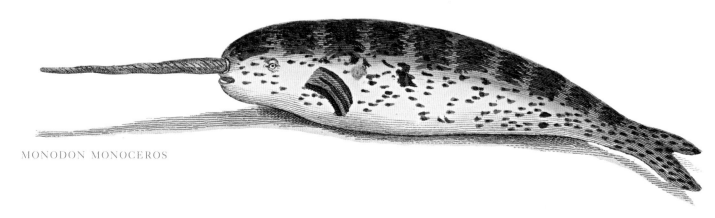

MONODON MONOCEROS

its immense expanse and playing with the watery mountains raised up by the storms. These beings—which, from this vantage, we might be tempted to believe are the globe's only inhabitants—are the cetaceans. Their dimensions are such that we can only apprehend their size by the greatest of terrestrial measurements.

Let us get closer to them; and with what curiosity will we not try to know them better! They live like fish in the midst of the sea, and yet they breathe like earthbound species. They dwell in the cold element that is water; but their blood is hot, their sensibility keen, their affection for their own kind very great, and their devotion to their young ardent and courageous. With milk from their teats, the females feed the young cetaceans they have carried in their flanks, young that see the light of day completely formed, like man and all the quadrupeds. They are enormous and move with great speed; and yet strictly speaking they are without feet—they only have arms. But their habitat has been established in the

66 The blue whale, *Balaenoptera musculus*, is the largest known animal ever to have lived on sea or land. Individuals can reach more than one hundred and ten feet and weigh nearly two hundred tons—more than the weight of fifty adult elephants.

The blue whale's blood vessels are so broad that a full-grown trout could swim through them, and the vessels serve a heart the size of a small car. "

THE SMITHSONIAN INSTITUTION

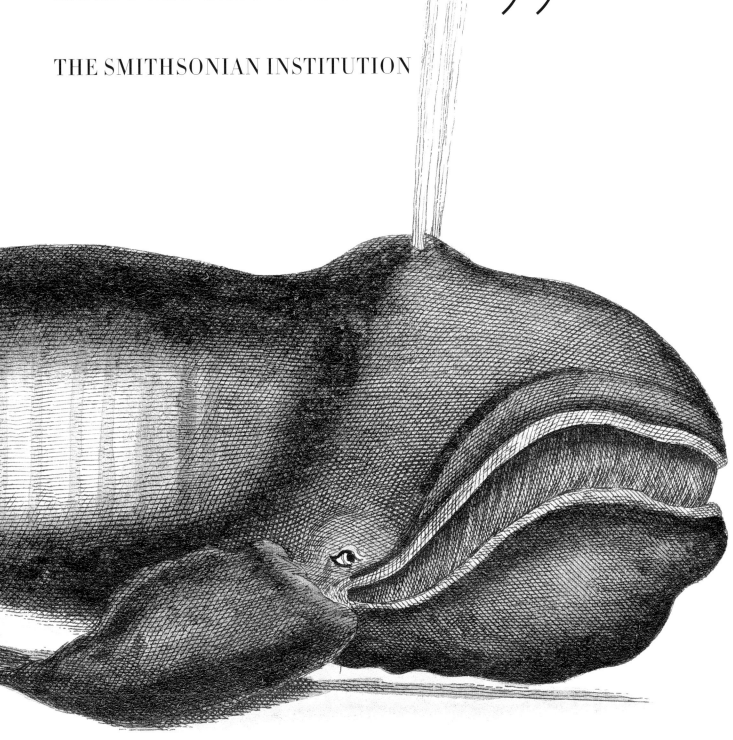

midst of a fluid that is sufficiently dense to support them by its heaviness, is resistant enough to provide a sort of fulcrum for their movements, and is sufficiently mobile to open up before them and raise only a minor obstacle to their progress.

[...] Of all the animals, none has been given such a vast domain: not only does the sea's surface belong to them, but the ocean's abysses, too, are provinces of their empire. The Earth's atmosphere may have been allotted to the eagle, and he can rise to aerial heights equal to the marine depths to which the cetaceans dash with ease, but he can only reach these ethereal regions by battling impetuous winds and a rigorous cold of near-fatal intensity.

The ocean's temperature is, on the contrary, fairly mild, and almost the same in all parts of this global sea that are some distance from the water's surface. The marine layers close to the sea's surface—on which the aerial atmosphere "rests," so to speak—are, in truth, subjected to a very bitter cold, and hardened by freezing at the polar circles and in the regions surrounding these Arctic or Antarctic circles. But even below these vast frozen caps and the mountains of ice that press down on them, pile up on them, solidify upon them and increase the cold that engendered them, the cetaceans find a refuge in the sea's depths that is all the more temperate because—according to the observations of a naturalist whose insight and instruction equal his

intrepidness as a traveler—the ocean's water is colder by two to four degrees in all the navigable shallows than in the neighboring depths.[1]

[...]And what a difference between the duration of the whale and that of the rose! Even man, compared to the whale, lives only as long as the rose. He occupies barely a dot in time, while just a small number of cetacean generations takes them back to the terrible eras of the globe's last and greatest revolutions. The giant species of cetaceans were contemporaries of the dreadful catastrophes that wreaked havoc on the earth's surface; only they remain from those first ages of the world; they are, so to speak, the living ruins of those times; and if the sensitive and informed traveler contemplates with delight, in the midst of the burning sands and bare mountains of Upper Egypt, gigantic monuments of art, columns, statues, and half-destroyed temples presented to him by the earliest history of the human species, with what noble enthusiasm must the naturalist—who, having braved the ocean's storms to increase the sacred accumulation of human knowledge, stands beside the mountains of ice piled up by the cold at the poles—contemplate these living colossuses, these monuments of nature who recall the ancient epochs of the earth's metamorphoses!

In these remote epochs, the immense cetaceans reigned without disturbance over the Antique ocean. Having reached a size far greater than they display today, they watched the centuries pass by in peace. Man's

[1] Letter written by Herr von Humboldt to M. Lalande, from Caracas, dated December 13, 1799.

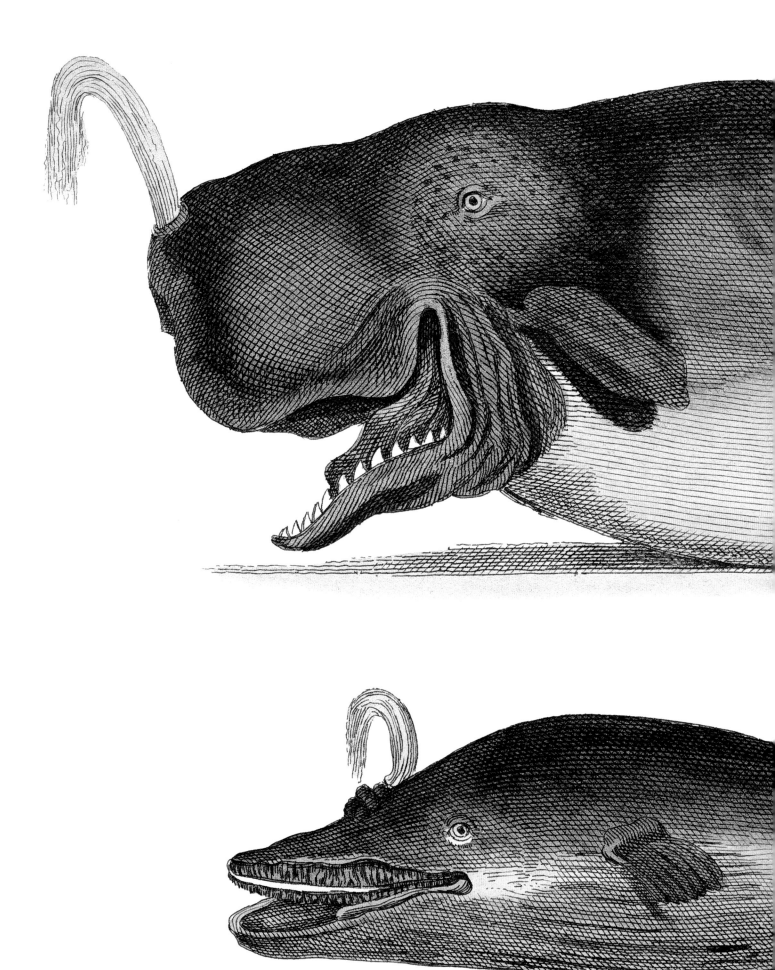

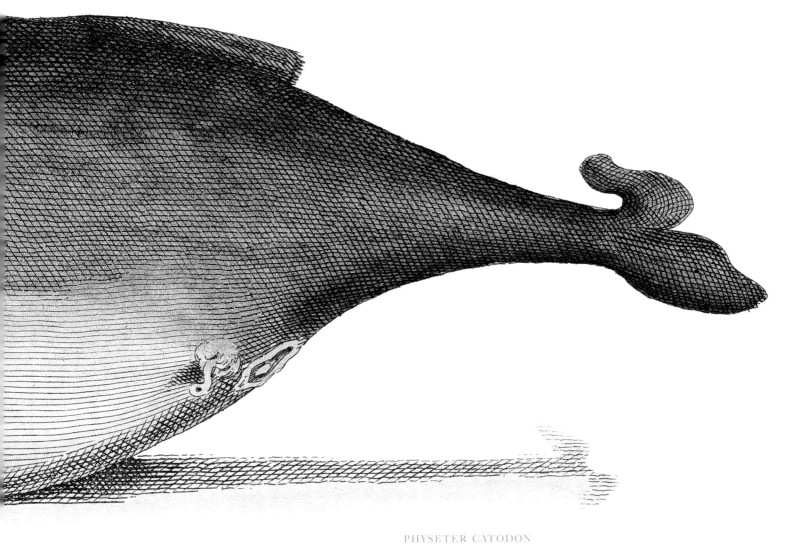

PHYSETER CATODON

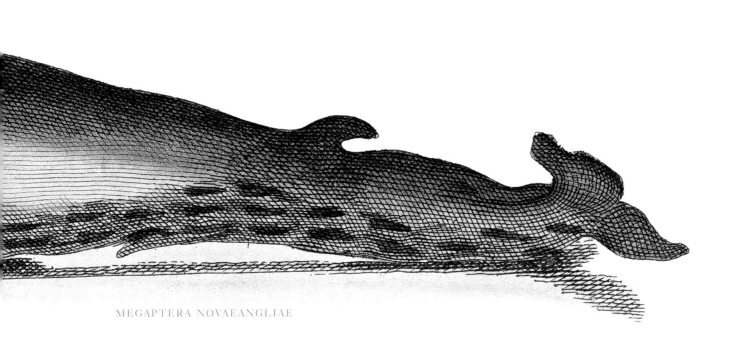

MEGAPTERA NOVAEANGLIAE

215

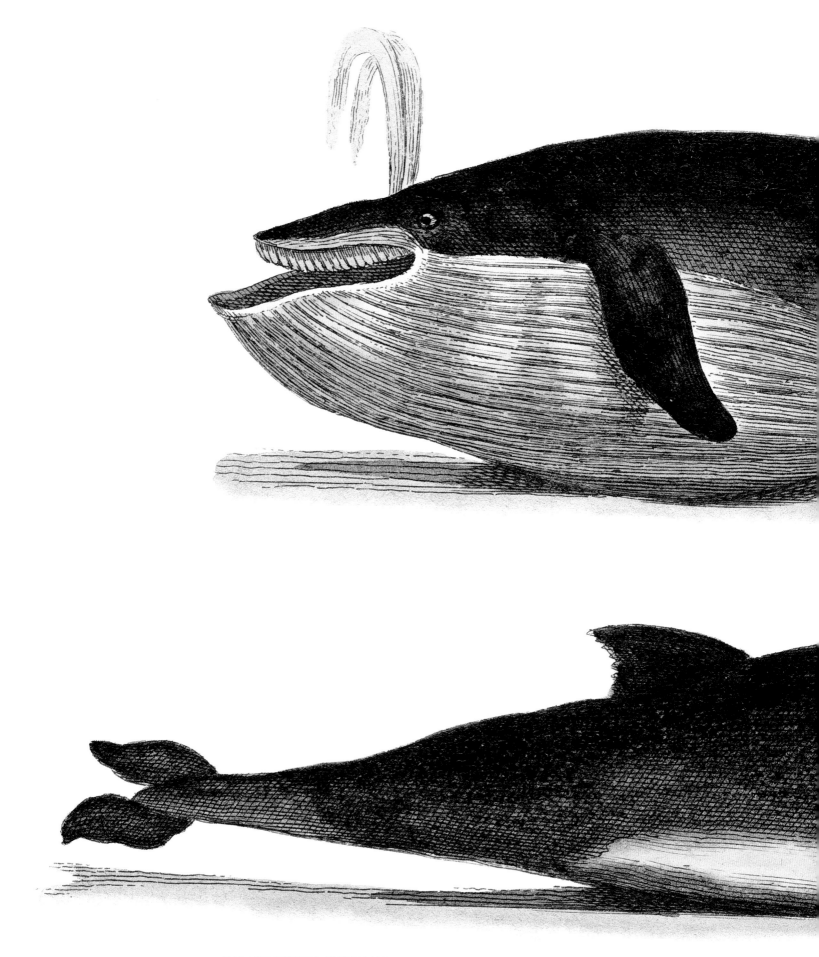

BALAENOPTERA PHYSALUS

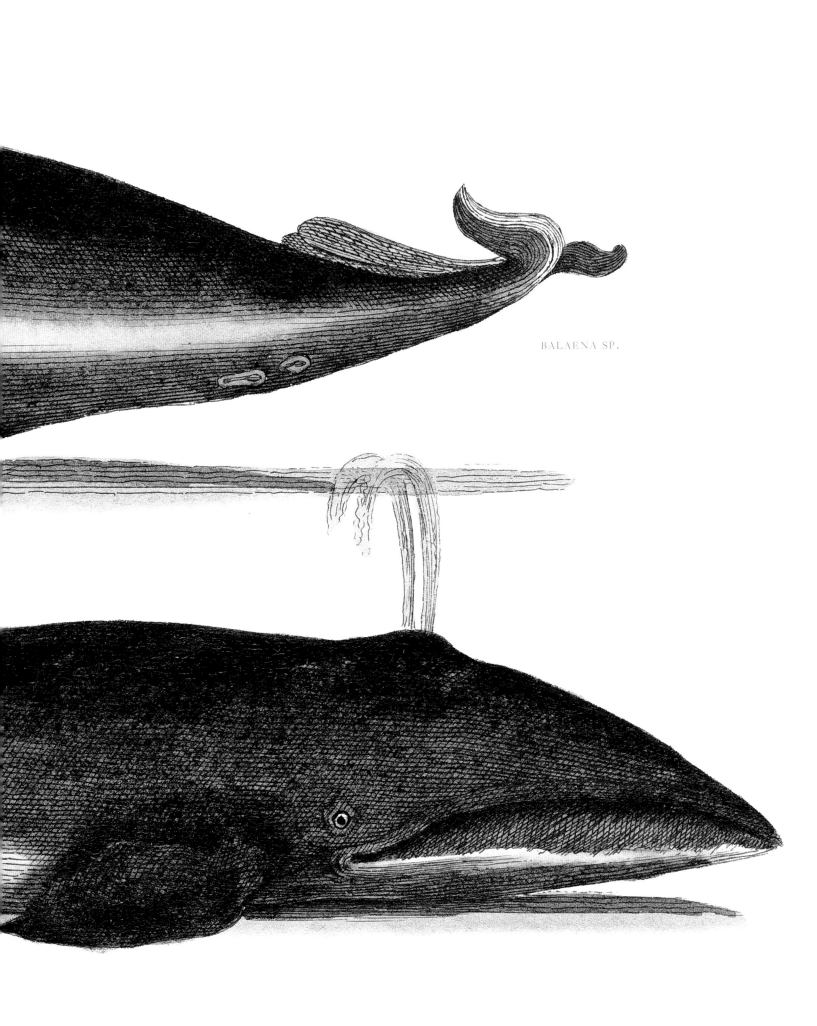

BALAENA SP.

genius had not yet brought him domination over the seas; cunning had not yet robbed Nature of the oceans.

The cetaceans could indulge, without disquiet, in the affection we can still observe between individuals of the same group, between males and females, and between a female and the young she breastfeeds—young on which she lavishes the most touching care, which she raises with so much affection, protects with so much solicitude, and defends with such courage.

All these acts, which are the result of a very keen sensibility, support and sustain the baby cetaceans, and allow them to grow. [...] This habit of being together, of sharing joys, fears, and dangers—a habit that binds so tightly not only cetaceans of the same group, but above all the male and the female, and the female and the fruit of her union with the male—must have added yet further to this instinct we recognize in these animals, in some way have ennobled its nature and metamorphosed it into intelligence.

[...] Man, lured by the treasures that dominion over the cetaceans could bring him, has disrupted the peace of their immense solitudes, has violated their retreats and has slain all those that the icy and inaccessible polar steppes have not stolen. The war he has declared on them is all the more cruel for his having seen that the prosperity of his commerce, the activity of his industries, the number of his sailors, the boldness of his navigators,

the experience of his pilots, the strength of his navy, and the greatness of his power all depend on open-sea fishing.

And so it is that the giants of giants fell before his weapons; and since man's genius is immortal, and his science now imperishable—because he has contrived to make unlimited copies of his thought—these enormous species will cease to be the victims of his interest only when they have ceased to exist. It is in vain that they flee before him: by his ingenuity man travels to the earth's extremities; they have no other refuge than annihilation. [...]

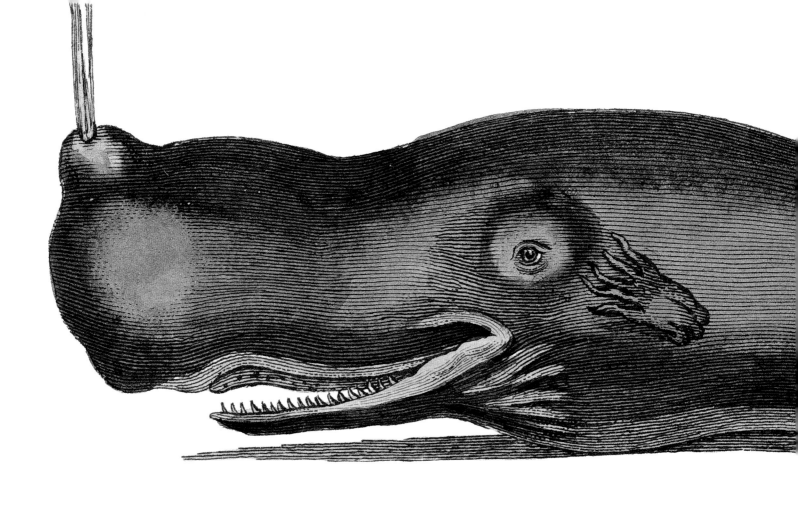

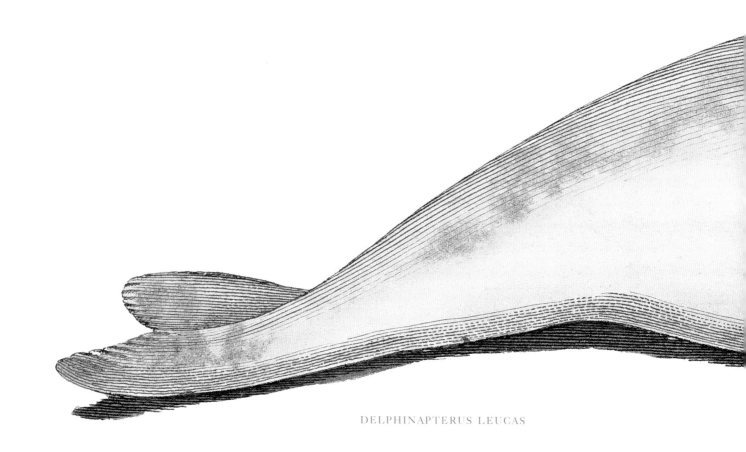

DELPHINAPTERUS LEUCAS

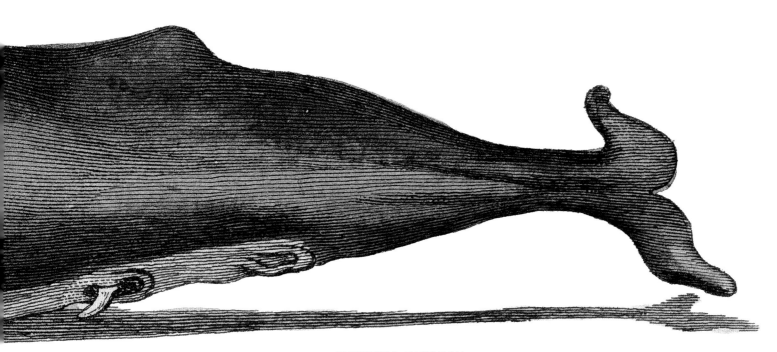

PHYSETER CATODON

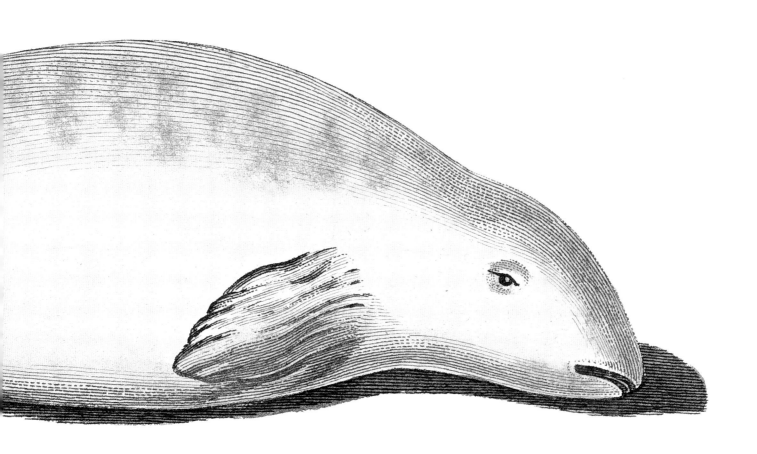

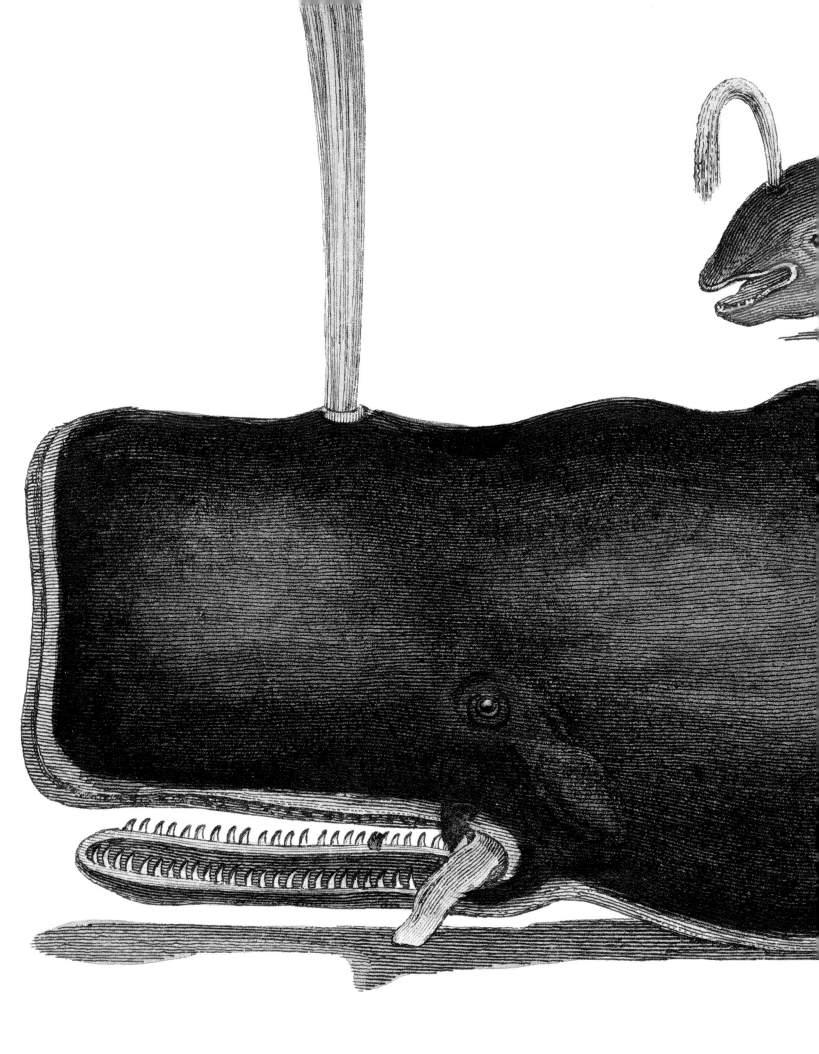

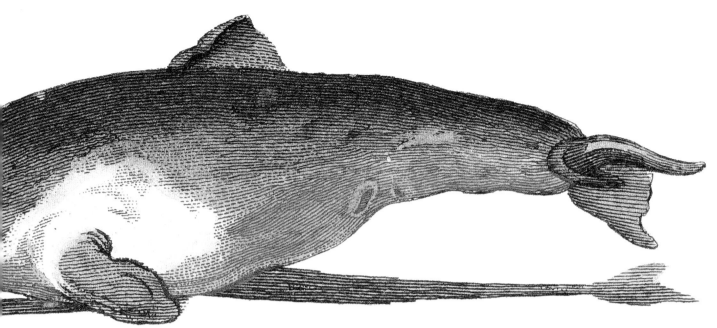

ORCINUS ORCA

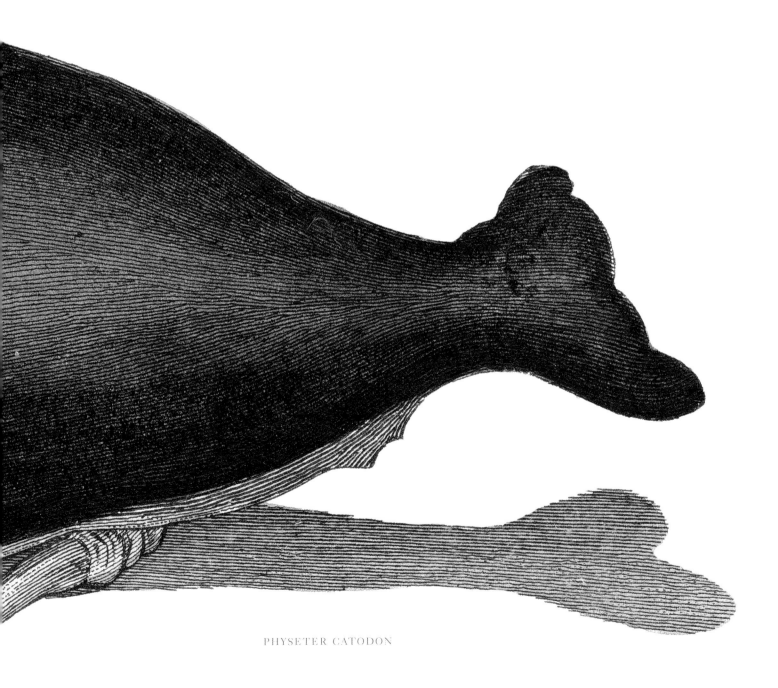

PHYSETER CATODON

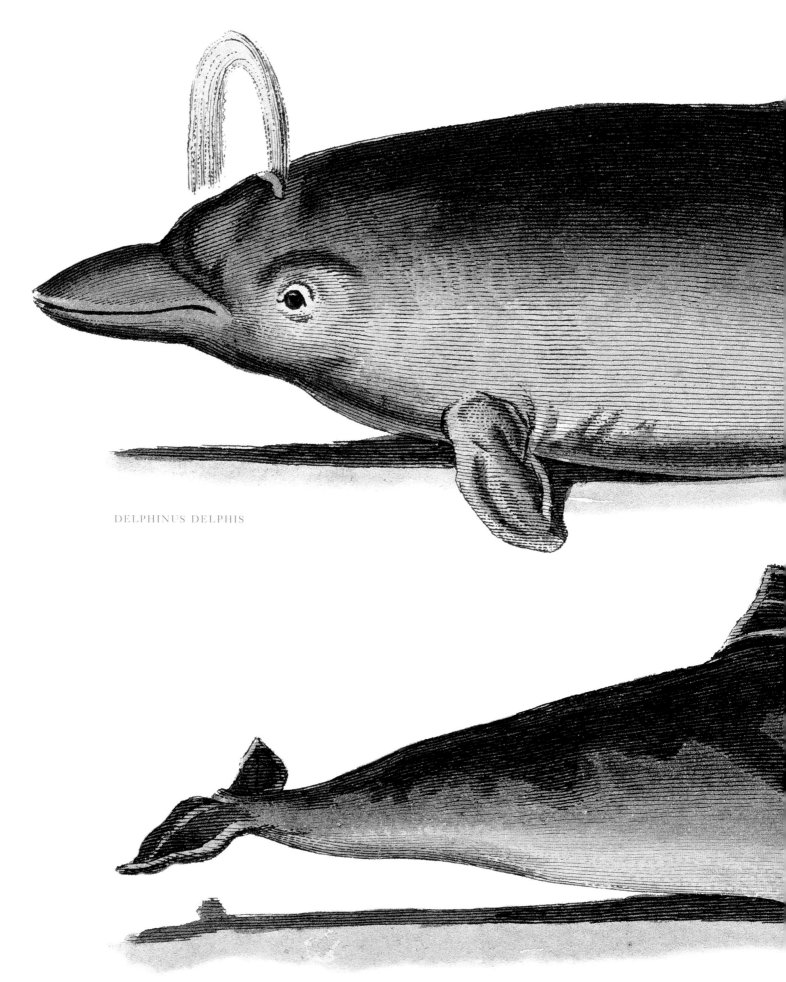

DELPHINUS DELPHIS

DELPHINUS SP.

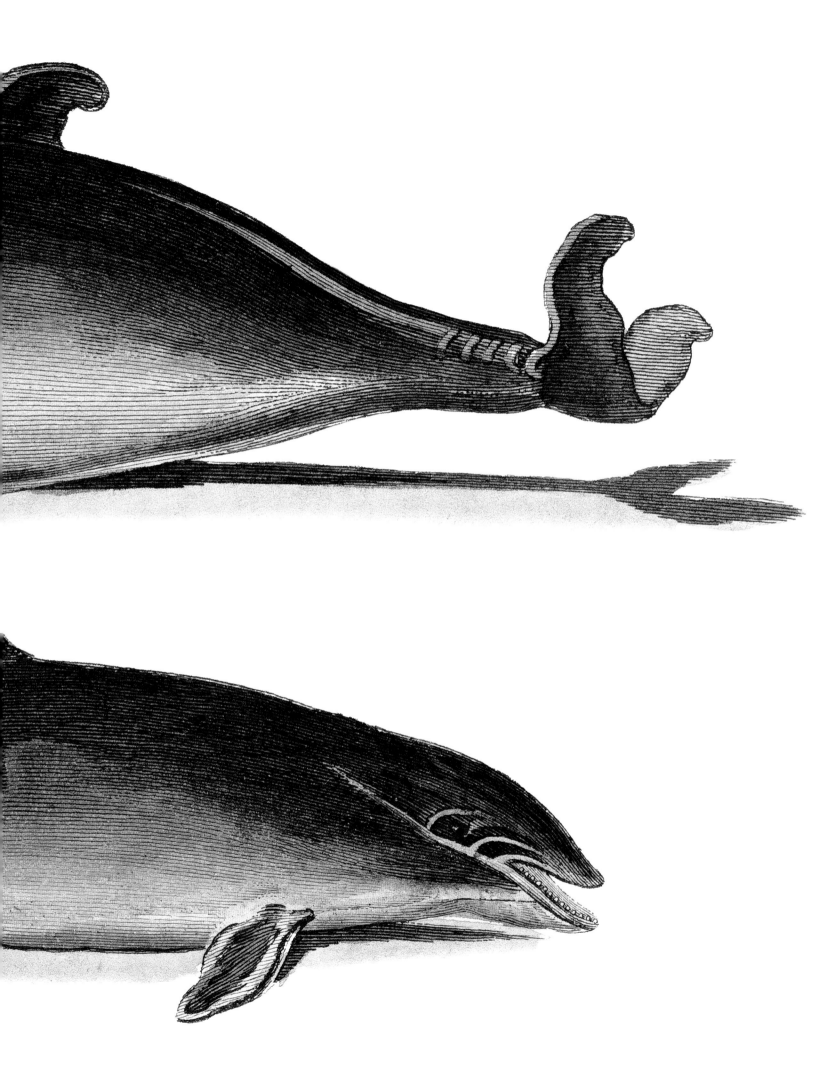

225

> [The dolphins'] fluid maneuvers are excruciatingly beautiful, a living embroidery of motion through the ocean's wrinkled cloth....

CARL SAFINA, *Song for the Blue Ocean*

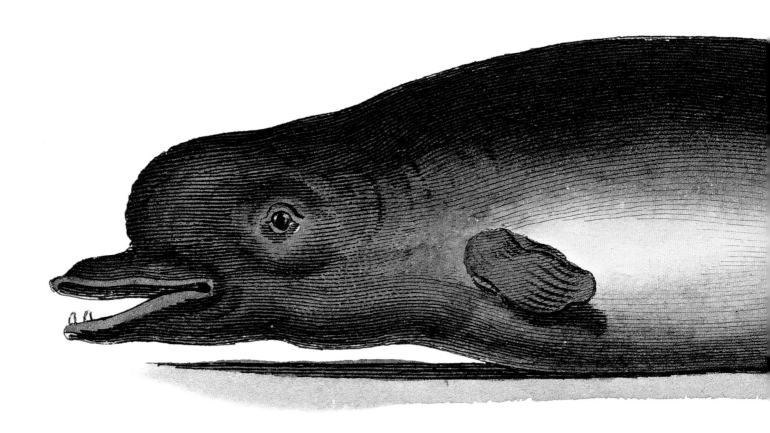

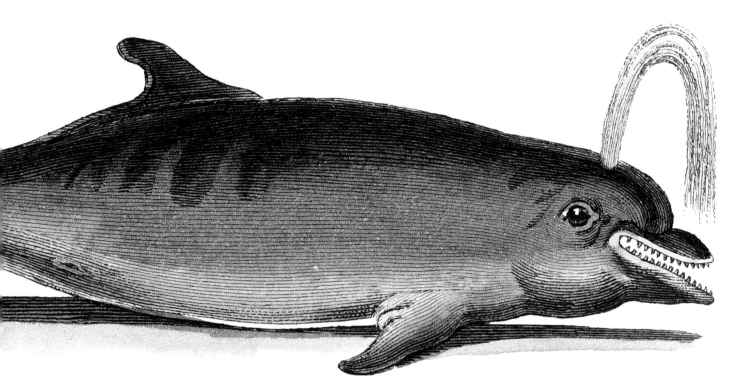

TURSIOPS TRUNCATUS

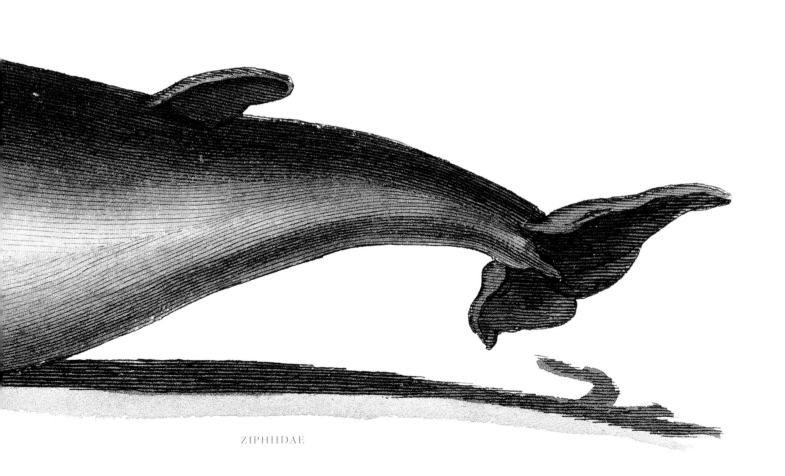

ZIPHIIDAE

INDEX

EDITOR'S NOTE:

The scientific names from the original Lacépède publications have been updated to reflect the current valid taxonomy per Fishbase, W. N.Eschmeyer's Catalog of Fishes, *and other modern sources. In cases where an exact determination was not clear, the name was applied to the lowest taxonomic level, i.e. genus sp. or family. In some instances, species named separately by Lacépède have been reclassified under the same valid name. Names marked with an asterisk are species classified by the International Union for the Conservation of Nature as threatened, endangered, or critically endangered.*

ACKNOWLEDGMENTS

The publishers wish to thank Andrew Ayers, Sandra Ban, Luc-Alexis Chasleries, Mathilde Dupuy d'Angeac, Sarah Hanson, Kristin Henn Esther Kremer, Cyrene Mary, Yann Popper, Kate Rizzo, Perrine Scherrer, and Valérie Tougard for their contributions to the realization of this book. The editors extend their gratitude to Paul L. Sieswerda, aquarium curator of the New York Aquarium, for his valuable consultation.

© 2008 Assouline Publishing
601 West 26th Street, 18th floor
New York, NY 10001, USA
Tel.: 212 989-6810 Fax: 212 647-0005
www.assouline.com

ISBN : 978 2 7594 0392 9

The illustrations in this edition were reprinted from the following original works:
*Œuvres du comte de Lacépède, comprenant l'histoire naturelle des quadrupèdes
ovipares, des serpents, et des poissons et des cétacés,* volumes 1, 5, 6, 7, 8, 9, 10, 11,
and 12, published by F. D. Pillot, 49 rue de Seine-Saint-Germain, Paris, 1832.
Translated from the French by Andrew Ayers.

Introduction: © Elizabeth Kolbert
Pages 8–9: © Réunion des Musées Nationaux/Art Resource, NY